Where Men Hide

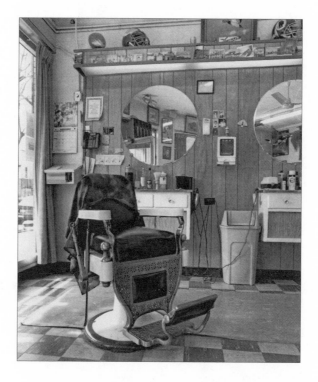

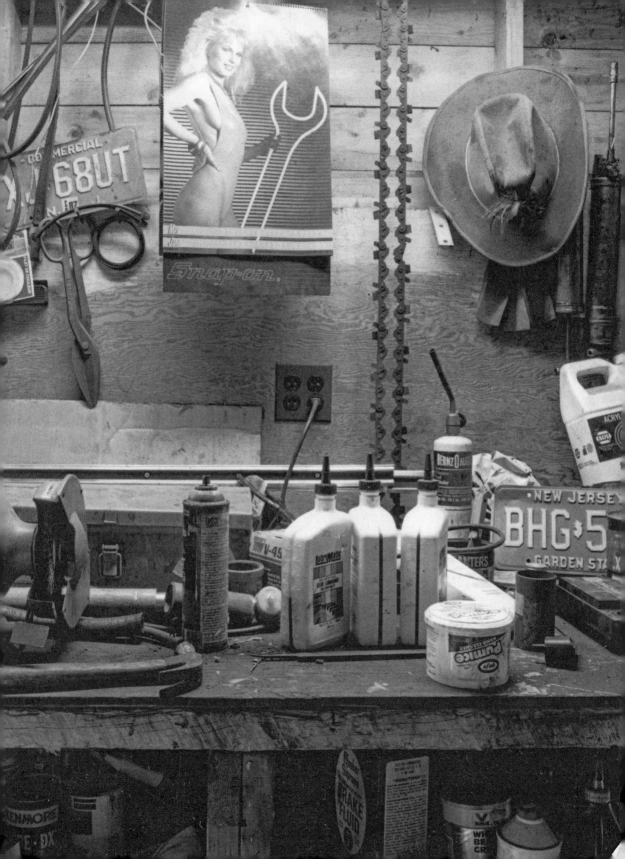

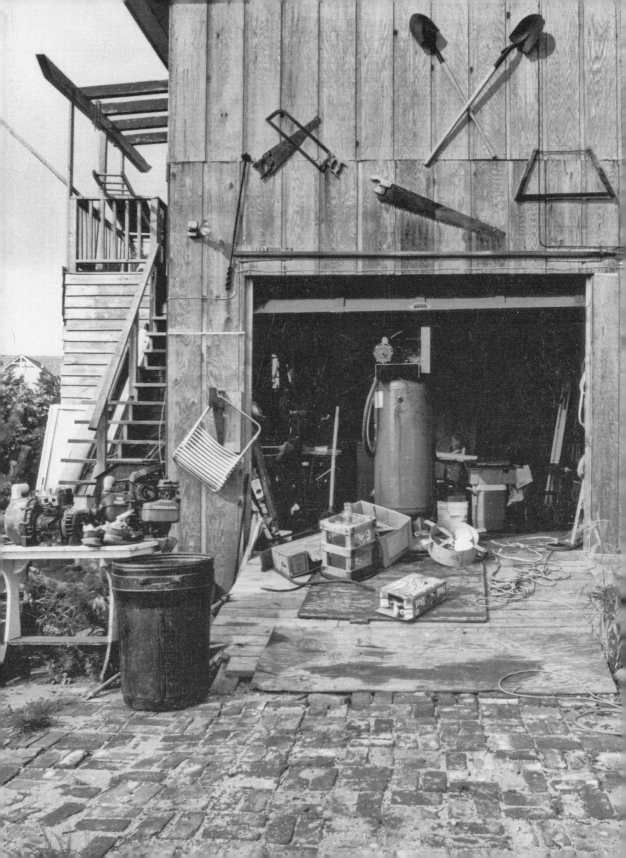

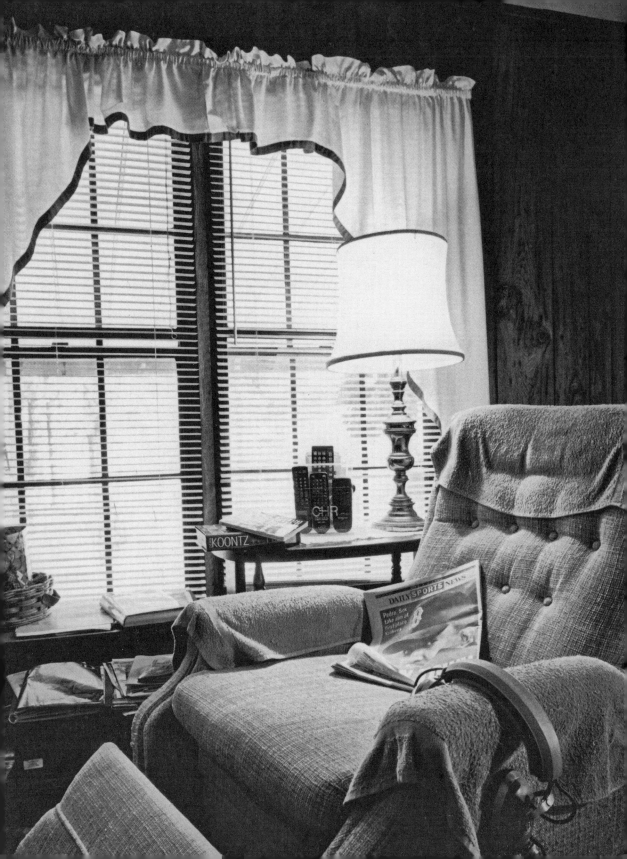

Where Men Hide

James B. Twitchell

Photographs by Ken Ross

COLUMBIA UNIVERSITY PRESS New York

JBT: To My Sisters

KR: To Karen, Matt, Pop, & Johnny

Contents

Where Men Hide

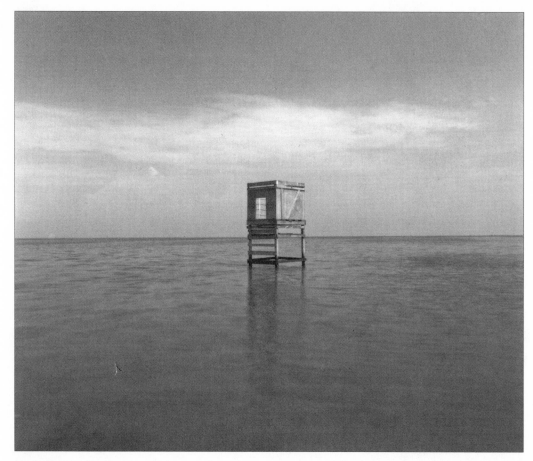

Duck blind, North Carolina

Introduction

If you ask men if they spend any time hiding, they usually look at you as if you're nuts. "What, me hide?" But if you ask women whether men hide, they immediately know what you mean. That is the subject of this book.

Studying the man cave is not how I'm supposed to be spending my time. My usual vocation is teaching Romantic poetry to college students. However, my recent avocation has been studying commercial culture, especially advertising. I realize that sounds paradoxical, but it makes sense to me. I teach what we are supposed to know, but I'm really interested in what we do in fact know. As you will see, advertising has had a profound effect on how I view the world. I believe the often loopy Marshall McLuhan was spot on when he famously said that "historians and archaeologists will one day discover that the ads of our times are the richest and most faithful daily reflections that any society ever made of its entire range of activities."

That belief helps explain how I came to this subject. At the end of the 1990s there was a mini-panic in the commercial world. Young

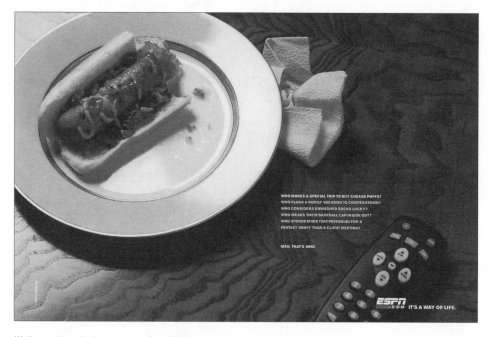

WHO MAKES A SPECIAL TRIP TO BUY CHEESE PUFFS?
WHO PLANS A FAMILY VACATION TO COOPERSTOWN?
WHO CONSIDERS UNWASHED SOCKS LUCKY?
WHO WEARS THEIR BASEBALL CAP INSIDE OUT?
WHO SPENDS MORE TIME PREPARING FOR A
FANTASY DRAFT THAN A CLIENT MEETING?

MEN. THAT'S WHO.

ESPN.COM IT'S A WAY OF LIFE.

We know where the boys are (ads from ESPN, Field and Stream, and Outdoor Life Network)

men suddenly stopped looking at ads. Or so it seemed. They disappeared from the Nielsen radar. They weren't watching enough television, they weren't listening to much more than Howard Stern on the radio, and they didn't seem to be reading anything other than lad magazines like *Maxim* and *Details.* This story was front-page news not only in the trades like *Advertising Age* but in national newspapers and on network TV.

Men have always been tough for advertisers to find. That's why ads on the Super Bowl cost well over $2 million for thirty seconds and why so much professional wrestling and bass fishing appear on TV. That's why Xtreme sports are pushing old-time games out of view, and activities like snowboarding are becoming Olympic events. Paintball may be next. It's one reason why heavy metal and rap are staples of MTV. If you're selling shaving cream, beer, or SUVs you gotta find 'em before you can sell to 'em. And men, especially young men, are hard to find and harder still to hold in place while making a pitch. Ask any parent of sons.

But if young men were hiding from advertisers, I could certainly see them—at least for a while—in class, and so I asked them what they did outside class. I was intrigued to find out that many were going back to their DSL-wired dorm rooms, their fraternities, or gaming cafes, to play complex video games. Admittedly, this generation grew up in the video arcade at the mall, but today's games were not just difficult to master; they involved players all over the world. Online poker was huge for many of these young men, and they knew more than I ever would about how to play the odds. They were also disappearing into the Internet, not just to download music and consume eyefuls of porn but to communicate with their friends in new ways, using, for instance, Instant Messenger. Many of them seemed to have a cell phone attached to an ear and a finger on text messenger at all times. So they were there, all right; they just weren't in the crosshairs of Time Warner, Viacom, and News Corp., as they had been in the 1980s. ESPN, *Field and Stream*, and the Outdoor Life Network gleefully claimed to know where they were and how to bring them back alive.

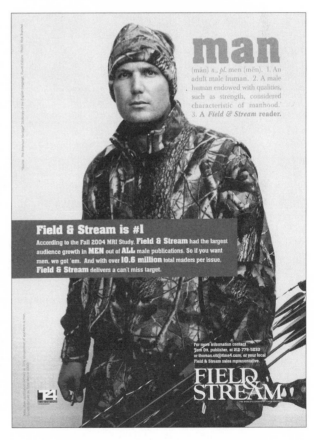

While I was thinking about the history of the disappearing male (for the programmers of commercial culture have seen the male as disappearing since the '60s), I happened to get my hair cut. I go to Colen's, a unisex styling boutique in the

5

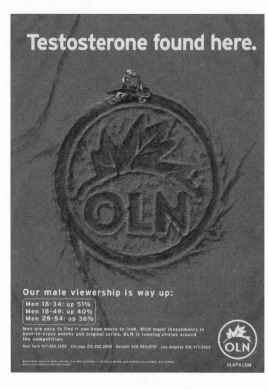

small college town where I live. In fact, as a sign of the times, on the window out front it's called "Hairstyling for Men and Women." I picked up a tattered copy of *Esquire* from March 1999, and while flipping through it, I saw a half-page layout about a show called *Men's Rooms* by a photographer in New Jersey. *Esquire*'s headline: "Where We Go: Portraits of the Places Men Without Women Inhabit" (Montali, p. 52). I was attracted by the images and the complexity of the caption.

I soon understood what was so compelling about the pictures. To have my hair cut I remove my eyeglasses, and I remember lifting the magazine up to my nose to look closely at the pictures. As I did, David, who always cuts my hair, stopped cutting and looked at the images too. I knew he too was curious. But we didn't say a word. Was it because in the chair next to me was a woman getting her hair tinted? We weren't looking at the *Sports Illustrated* swimsuit issue, for goodness' sake. All we were looking at were pictures of a midget race car in a garage, an empty boxing ring, and a model train set, but we both felt strangely "in the know."

Barbershop behavior has completely changed in my lifetime. As a kid at the Bank Street Barber Shop in downtown Burlington, Vermont, I heard plenty of chatter. Barbers would talk with one another and the customers with a kind of easy familiarity. You would wait for your barber, and if your turn came and you passed in order to wait for Jerry Merola to cut your hair, you would have to endure the good-natured ribbing of the other barbers. "Oh, so only Jerry can cut your hair," the other barbers would mock. And everyone would

smile. There was no such thing as an appointment. You looked at magazines you could never have seen at home. Then in the 1960s women started appearing in barbershops, and things went silent. *Argosy* and *Police Gazette* disappeared. A haircut became a private event. Scissors replaced the plastic cattle-catcher at the end of the electronic clippers. You whispered. In fact, chances were good that a woman was cutting your hair.

So, in the modern mode, David and I didn't say a word. I realized that what I was seeing in these pictures was a kind of road map of where males go and the stuff they take with them. Looking at the pictures, I was feeling real tranquility; I could understand those spaces and feel myself as part of them. These were places to hang out, be myself. And I wondered: could you understand male behavior by a close reading of these images? In other words, is there enough text (whoops, there's the English professor) in these images to generate a narrative of masculinity? Or, as they say in the current academic cant, if masculinity is constructed, is some of the stuff that makes it up captured in these pictures?

So I called Ken Ross, the photographer, and asked him if I could see more of the pictures that he had taken of this male space he called *men's rooms*. He sent me some and then some more, and I realized he had generated a topography of space that fit many things together. Motifs and symbols seen in one space were picked up in other images. A certain kind of visual language of things that moved across the various narratives, moved across Mars, as it were.

When I looked at his images in toto, however, I couldn't help but feel a kind of dreariness, a sense of darkness and even foreboding. Male space is not a Happy Meal, that's for sure, no matter what Hemingway and the beer commercials say. Mars is really lonely and strangely bleak. But if I could see the images as moments of respite, corners in which the male went to do nothing, places where he could safely tinker and fool around, refectory spaces made inhospitable to women not because of any overt antagonism but just because the male seems to need do-nothing time, then they were jolly enough.

I decided to write about these images just as Ken had recorded them. I would not gin up a scene by having him shoot stuff that I

understood, but I would gloss what was already there, do an inventory. And there would be no steam-hammer thesis to pile-drive the pieces together into a manifesto. *Where Men Hide* would be a kind of commercial ethnography, a place advertisers might ponder if they really wanted to find their quarry, a few spots women might consider in trying to understand men. As the project progressed, I did ask for specific shots. For instance, I became convinced that one of the reasons that the megachurch had become so powerful was because these massively impersonal churches offered men a chance to meet with other men fully protected from the charge that women were being excluded. After all, doing the Lord's work is unassailable. So off Ken went to take the shots.

One more event made me want to write this book. In late December 2003, Saddam Hussein was captured in his *spider hole* beneath a little farmhouse across the Tigris River from one of his marble palaces. His *rat's nest*, as it was also called, was just a few miles from his birthplace in Awja. He had burrowed in and made a hidey-hole, with a suitcase stuffed with $750,000 and two AK-47s. Above him in the house was a curious mixture of male squalor and yearning. American servicemen found a selection of domestic items that had been carefully chosen to support a life on the run, among them a shampoo that promised to keep the dictator's matted hair from drying out. But books were also scattered about, including Dostoevsky's *Crime and Punishment*, some poetry, and a volume on the interpretation of dreams. The kitchen mess included orange marmalade, tea, candied figs, and baklava. When you look at just the outlines of his hideout, however, most men can immediately see the attraction. Surrounded by high walls is just a bedroom, an indoor/outdoor kitchen, a little courtyard, and a hole in the ground to duck into. This is prime-time guy space.

More interesting for my purposes was that the *New York Times* ran a front-page story in the Houses and Home section called "House at the End of the Line." Reporter Christopher Hawthorne mused about how men seem to like these little hiding places. And other men like to look at them. So Hitler's concrete bunker, the Unabomber's cabin, or Thoreau's shack holds the male imagination still and

makes us wonder about what such a life might be like. How would life be without women? Of course, Thoreau didn't call it that. The mantra of male asceticism is Thoreau's furiously famous paragraph in *Walden; Or, Life in the Woods*:

> I went to the woods because I wished to live deliberately, to front only the essential facts of life, and see if I could not learn what it had to teach; and not, when I came to die, discover that I had not lived. I did not wish to live what was not life, living is so dear. . . . I wanted to live deep and suck out all the marrow of life.

The *New York Times* reporter suggests that the yearning to get away and live deliberately (without women?) goes back to the Romantic movement. I wonder. Hasn't this been a male yearning since Ecclesiastes? Doesn't it animate the vision of Marcus Aurelius, the religion of Saint Francis, and the social order of the Puritan fathers? But we start seeing the *image* of the melancholy outcast, the recluse, the natural man just after the French Revolution. Admittedly, the first hint of constructing a do-it-yourself temporary man cave out in the woods goes back to 1753, when the Frenchman Marc-Antoine Laugier published the soon-famous illustration of a primitive hut fashioned from four tree trunks. He struck a nerve. Who can look at the German and English Romantic painters like Carl David Friedrich, Francisco Goya, and John Martin and not be aware that this man-in-hiding had become a trope of Romantic art? Little huts, grottos, and bosky dells are all over the place.

Not only did the *Times* think Saddam's spider hole was a House and Home story, other editors all over the world did too. The name they gave it, along with *spider hole* and *rat's nest*, was *redoubt*. A redoubt is a room in a fortification where the *last stand* is made. It is the last holdout, the last place to hide when you are *it*. The modern redoubt is the *safe room*, now a standard of the paranoid's McMansion or McTriplex, where you go when assaulted. In the 2002 movie *The Panic Room* we see such a room, constructed by a rich, disabled, paranoid man: steel walls, camera system, its own phone line, emergency supplies, ventilation. You get the picture—it's the final refuge and really quite dreary.

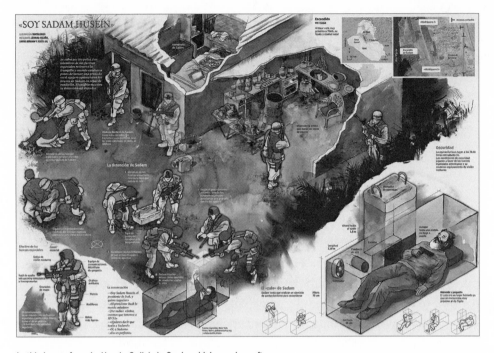

In this image from *La Voz de Galicia* in Spain, which ran days after the capture, there is almost a Richard Scarry use of imaginary detail, complete with a cutaway of Saddam's aboveground bedroom.

But the *redoubt* is compelling not just as a concept but also as a word, coming to us indirectly from the Latin *reductus*, a concealed place, a form of the Latin verb *reducere*, to withdraw. Hiding out, in other words, means cutting back, getting to the essentials. It means living life, again in Thoreau's words, deliberately, very deliberately indeed.

What happened when the story of the capture of Saddam broke across the world is revealing of the conflicted male yearning for separation. Since initially no video of the hole was available, and no descriptive text aside from a few vague paragraphs from the U.S. Army, each graphic artist had to produce his own idea of the last male stand, or in this case, the last lie-down. As Gert K. Nielsen says on his Web site (http://www.visualjournalism.com/index.html), the most interesting conclusion that can be drawn by looking at the worldwide infographics is that "not one of them got it right." Many thought the air vent was a urinal, even though that use would be physically impossible for such a big man. And most images had the

tunnel as an L-shape, not a T-shape. Once the graphic artists had videograbbed enough imagery from the television, they finally drew the correct image. It took about a week to clear out the imagined view from the real one. In other words, each culture generated its own version of the last-chance redoubt, and each was reluctant to give it up.

Of course, the last hideout of a desperado hardly provides the makings of a universal observation of what men desire, but it's a start. Were women also interested in this lair? I doubt they cared much. I remember being galvanized when I saw a full-scale mock-up on MSNBC. My wife reached for the remote.

There are a few truisms about where Saddam hid that seem almost universals. Men hide on the low-down. Literally. They burrow. Not by happenstance did young males of early-twentieth-century urban gangs (made famous by the film *The Gangs of New York*) hollow out meeting spaces called *caves* in the basements of tenements. To be sure, no one else wanted to use the furnace room, and the space aboveground was already rented, but men seem to be comfortable belowdecks.

In fact, the word that came from these male lairs was *dive*. A dive was an illegal den, or other disreputable place of resort, often situated in a cellar,

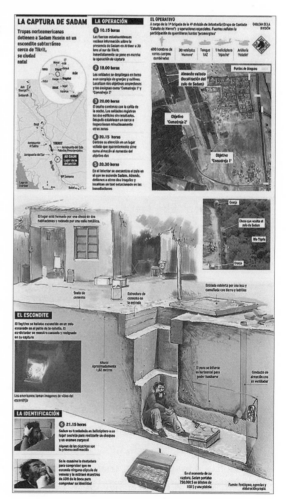

This highly active and informative graphic from the Spanish *El Correo* is almost pastoral in its relaxed mode.

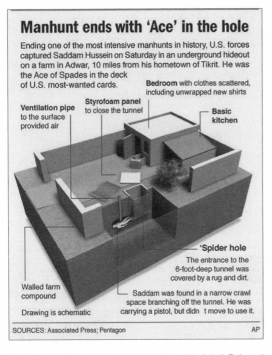

Manhunt ends with 'Ace' in the hole

Ending one of the most intensive manhunts in history, U.S. forces captured Saddam Hussein on Saturday in an underground hideout on a farm in Adwar, 10 miles from his hometown of Tikrit. He was the Ace of Spades in the deck of U.S. most-wanted cards.

Bedroom with clothes scattered, including unwrapped new shirts

Styrofoam panel to close the tunnel

Ventilation pipe to the surface provided air

Basic kitchen

'Spider hole The entrance to the 6-foot-deep tunnel was covered by a rug and dirt.

Walled farm compound

Drawing is schematic

Saddam was found in a narrow crawl space branching off the tunnel. He was carrying a pistol, but didn t move to use it.

SOURCES: Associated Press; Pentagon AP

The Associated Press finally gets it right—the spider hole is T-shaped and includes the Styrofoam panel used to close the hole.

basement, or other half-concealed place, into which frequenters might "dive" without observation. Of course, the opium den was typically belowground, as were the various speakeasy cellar clubs. Chinese gambling *hells,* German secret societies, and various mafiosi liked to go underground as well. Monks did too. Crypts and catacombs were often meeting places. Christ and his Apostles met in the subterranean Grotto of Gethsemane. Yale's Skull and Bones goes below street level to do its initiation work, as do most fraternities. Not to make this too universal, but on MTV's *Cribs* (*crib* is slang for where you live) rap artists, professional athletes, and impresarios of various sorts will often take you to their secret room, the one just for their homeys, with the plasma TV and the library of videodiscs—it's almost always downstairs in a windowless cellar.

As Sandra M. Gilbert and Susan Gubar point out in *Madwoman in the Attic,* distressed women seem to find more comfort upstairs. Think Emily Dickinson upstairs in Amherst. Or recall Bertha Rochester in *Jane Eyre* lurking in the attic or Faulkner's Emily in "A Rose for Emily" conducting her mysterious affair with Homer in the privacy of her second-floor bedroom. Conversely, recall Dracula sleeping in his dirt-filled coffin in the cellar of Carfax Abbey or Mr. Hyde coming up out of hyding to pester poor Dr. Jekyll. Madwomen in the attic, monsters in the cellar seems to be the preferred geography of gendered seclusion.

Horror films may be extreme. Having spent the last year watching old Gene Autry shows on the Cowboy Channel, I was comforted

that I had remembered correctly: when the bad guys in the western head for the rattletrap hideout, they often flip open the trapdoor and spend some quality time down in the mine shaft. Ditto the gangster film. And any reader of American literature will assure you that a man-on-the-run, from Deerslayer to Huck Finn, goes underground, into the cave.

Another characteristic of men's space that may be influenced by the dive motif is that it tends to be dirty and dark. As we will see when we look at such places as deer camps, cigar bars, strip clubs, garages, locker rooms, and even barbershops, men seem to be more comfortable in the company of other men if there's not too much of the "clean well-lighted place." While it might be tempting to consider this to be womb-like regression, I'm not convinced that it's sexual. It seems enough to say that these are liminal spaces, spaces betwixt and between, where certain rules are held in abeyance and others rigorously invoked.

Many other interesting transformations happen when men (or the individual man) go into the separation mode. Men without women may be a heroic Hemingway theme, but it gets dreary in real life. Without the woman's touch, the male tends to be a bit ham-handed with the cleanup. True, Saddam did not make his bed or tidy up the kitchen, but it gets worse when the whole gang arrives. Making a mess becomes a goal. Language quickly turns raunchy when men get in groups, social hierarchy is supercharged, alcohol is often the necessary lubricant to conversation, uniforms may get donned, initiation rituals (when extreme: *hazing*) get invoked, urination becomes celebrated, gambling often becomes a pastime, and secrecy is mandated.

Social scientists call the process *bonding,* and it seems to be at the heart of male secession and reformation into the pack. One key to these groupings is that they are usually voluntary. But why? Perhaps long ago bonding was necessary for the hunt, but why has this coagulation of masculinities into the *tribe* proven so important that it still influences the rituals of card games, stag parties, and weekend golf?

Answering that question definitively is, thankfully, not my task. Social outcasts need predictable alliances as a matter of survival, but

why do men who are not on the lam have so much trouble forging alliances in order to go out for coffee? The question of why men need what sociologists call "boundary space" and "enactments of manhood" in order to bond has become far too tangled up in the nest of gender politics for me to untangle. If you listen to some feminists, you will come away convinced that the primary reason men get together with each other in the way they do is so they can exclude the Other (women, people of color, gays . . .). Presumably in the Old Boys Network they slice the pie so that the guys come away with the biggest pieces. That many of these men-only organizations developed concurrent with the opening of the Victorian marketplace seems no happenstance to a few feminists. The modern male fears for his place and bonds to protect it, using complex and unarticulated rituals. There is doubtless some truth in this view.

Some anthropologists contend that male clustering far predates the Industrial Revolution. It is a vestige of the clan creation necessary to hunt and kill efficiently. "Can I trust you with this secret?" is a variation of "Can I trust you to cover my flank?" Medieval guilds institutionalized this behavior. And that's why modern fraternity initiations invariably involve facing danger, while sorority initiations usually call forward some socializing ritual. If you notice, women will join the auxiliaries of such fraternities, but no such male versions of sororities exist. Males need the illusion of danger; women need the predictability of safety. But, interestingly, both sexes seem to take on their gender affect through the company of men. Women become feminine against the backdrop of men, while men become masculine in the company of men. Might that partially explain why men in groups are such a perplexing cultural force to both sexes?

Sociologists weigh in with the explanation that while women's reproductive demands depend on stable community as a way to protect the young, post-puberty males are forever on the edge and anxious. They have not learned the rituals of easy conviviality, of belonging. Just the opposite. Their sexuality is aggressive and often the cause of exile. The best they can do is rough camaraderie, with the rites of passage effected by such artificial means as seemingly endless Masonic degrees or who has to do dishes at deer camp. After childhood,

the band of brothers replaces mother as the center of men's lives. In this context, is it happenstance that there was a rapid increase in fraternal organizations after the Civil War as male-only groups asserted a resurrection of lapsed brotherhood? After all, what is the controlling trope of civil war if not brother *against* brother—fratricide? And what is its resolution if not the reaffirmation of fraternity?

No matter what the explanation, there is no doubt that the *subject* of male bonding and separation is modern and intense and often the subject of much Sturm und Drang. Sex exclusion has joined racism and anti-Semitism as not just politically incorrect but almost unmentionable. Don't go there.

Yet a generation ago exclusion on the basis of sex was the norm. The English club system at the end of the high Victorian era (Athenaeum, Reform, Union, Traveller's), in which men often spent the night, or at least stayed until the feeding of the children was over, rarely arched a feminine eyebrow. The invitation-only Bohemian Club outside San Francisco, now only a vestigial parody, was the object of some deference in the 1950s and 1960s. That men of position and power took off their trousers and peed on trees and howled at the moon was excused as a Saturnalian release from a more usual life of restraint and responsibility. No more. One reason why so much attention was focused on George Bush's and John Kerry's memberships in Skull and Bones at Yale is that this kind of boys-only institution has simply evaporated. If you want to see this for yourself, drive around your town and observe the wrecks of old Moose halls and Masonic temples. The only old-line institution that still hangs the "No Gurls Allowed" sign is the Masters clubhouse (not golf course) in Augusta, Georgia. Hootie Johnson, club president, has essentially dedicated his life to being the last man standing at the locker room door.

Whatever these male-only institutions were, they are no more, at least not in their traditional form. Writing in the *North American Review* in 1897, W. S. Harwood calculated that fraternal orders boasted 5.5 million members out of a total adult male population of roughly 19 million (p. 617). Why did so many American men join fraternal orders? What were they looking for and what did they find? What

should we make of a bunch of small-town salesmen with painted faces and loincloths dancing ceremoniously around a bonfire? Why were the lodges so readily accepted by women that they joined the auxiliaries? And then—poof—they were gone.

The fraternal lodges themselves can't figure it out. A few years ago the Shriners commissioned a study to develop ways of attracting people born between 1946 and 1964. Here's what they found, according to Jeffrey Savitskie reporting for *USA Today* about these Baby Boomers:

— About 25% belong to civic or community groups. Only 7% are members of a fraternal group.
— Nearly 40% are involved in unpaid community activities, such as church groups, youth-related work and counseling.
— Only 5% view leisure time with other men as "very important."

Almost everyone you talk to about this subject has anecdotal evidence of the clustering differences between men and women. Here's mine, drawn from family life: My wife has at least three book clubs that meet with admirable regularity and seem to produce instant and intense conversations. My two older sisters have always had best friends who seemed to move easily and unceremoniously in and out of their lives. And my two daughters, both grown, have instantaneous contact with a whole sorority of women via the Internet or their cell phones. They all understand *Sex and the City*.

Meanwhile, whenever I want to see my men friends somewhere other than at work, we have to schedule some event. We have to get four for tennis or golf, field comparable teams for pickup basketball, and if we ever go out for lunch we need a compelling reason. I don't think I have ever gone to a movie with just one other guy. Although I buy stuff, I always shop alone. And we have to name a reason before we can powwow: one of us is getting divorced or moving away or has died. Or we have to name the eating group (for years it was the Melancholy Troubadours; I don't know why—we never sang—but the melancholy part was correct enough) so it will seem like we had been scheduled all along. Maybe the male *Sex and the City* is the *Magnificent Seven*, the 1960 remake of *The Seven Samurai*. The

men get together all right, but only kicking and screaming, and only because there's a town to save—a j-o-b to do.

At the university where I teach, there was a men-only consciousness-raising group that I just couldn't bring myself to attend, even in the interests of this project. I was afraid I'd have to read books by French philosophers. So to see what I escaped I e-mailed a colleague who used to attend to find out how it was going. His response:

Hi Jim,

I participated for over seven years; we met one evening every two weeks, taking turns as leader. I joined after I separated from my wife, thinking it would be useful to have a support group of fellow men. When I joined, the group had already been in existence several years. We had a book which suggested format and activities and sometimes we discussed other books, usually of the self-help variety, or movies. We also did some joint activities, such as a weekend canoeing trip or a fencing class. But the men's group gradually dissolved, due to people leaving town or dropping out. We were never successfully able to recruit new members. There were some personality clashes and also differing notions about what the group should be doing. It ended 2003.

I was disappointed that I didn't make any friends within the group, only acquaintances—perhaps because I didn't have enough in common with them. The group ranged in age from late twenties to fifties: married with kids, married without kids, divorced, or single. Since the group dissolved, I've only seen one of the members and that only once—he also is faculty.

I'm not in touch with any local men's groups now, and I don't know of a men's only book club.

I know there are a few men-only poker games in my little community. But part of being a dilettante is that I don't have to talk about books or smoke cigars, so even in the interests of research, I've stayed away.

In the summer I go back to my home turf in Vermont and things change. I see the guys I grew up with. Even then we have to be cautious not to spook each other with the fact that we are getting together *for no reason*. I don't think this skittishness is because we are afraid of being emotional; after all, we're all graduates of Dr.

Phil's therapeutic culture. It's just that we don't know how to do it. No practice. What's interesting is that once we get together we enjoy ourselves and often remark that we should do this again. Sometimes we do, but with no regularity. Each time it's an effort.

I am writing this in Vermont in my little study at camp (which you'll see in the office chapter). Maybe a vignette will help here. Our summer camp is part of a group of seasonal camps on the shore of Lake Champlain. A *camp* is the Yankee term for a summer cottage, not fancy, seasonal use only. For a few months we are part of an enclave of summer campers who spend bits of time together and then go back to their jobs elsewhere. We own our own camps, but we rent the land from the nearby town. So we are all rootless. It's been like this for the last hundred years. The women have no trouble with social tendrils. They have tennis day (Wednesday morning), when they all play doubles and men are not allowed, and then something called *ladies' lunch* afterward. They also have book clubs, gardening groups, groups to plan dinners, and lots of barely organized things like going walking or biking during the week. They often go shopping together.

But the guys are left high and dry. A few years ago a fellow academic decided the men should gather and have lunch. He called this *ploughman's lunch*, after the English pub lunch of beer and cheese. Now right from the get-go this is a fraud worth noting, as I discuss later, in the chapter on men and food. Ploughman's lunch was an advertising gimmick started by pubkeepers after World War II as a way to sell snacks off-license before the real afternoon drinking could begin. Ploughmen and shepherds did not drink beer and eat cheese in medieval times, as appealing as it is to imagine. When I tell this to my fellow campers, aka ploughmen, they say they like the idea anyway.

Not only do we have trouble meeting for lunch (although we all know each other), we have no idea what to talk about. That's why the beer at midday is important. We are confused about where to meet and what to *do*. So we move from camp to camp, with one of us responsible for giving a "little talk" about our work or our hobbies, at the end of which we politely clap. None of the young men come.

Although we are supposed to get together once a week, we cancel a lot and usually meet about once a month. The women, as you might imagine, find this amusing.

Yet in my past I was a member of all manner of single-sex groups: Cub and Boy Scouts, YMCA basketball league, summer camp, and prep school, where getting together was no problem. In college I almost pledged a fraternity. My dad had the same male-only education, only his included a college fraternity and an all-male medical school. In later life, however, he was not a member of any single-sex clubs. But both my grandfathers seem to have spent parts of their weeks in the company of fraternal organizations, one in the Grange and the other in the Masons. I have some of their paraphernalia (funny hats, swords, sashes) to prove it. Yet they spent almost their entire lives in the same little Vermont towns. What the hell did they need these clubs for? Ironically, I'm the one who needs the clubs.

When I was doing research for this project I went to a dilapidated Masonic temple in Charlotte, Vermont. I went with Ken Ross, who was interested in taking pictures there. While Ken was busy setting up, I looked at the pictures on the wall. There prominently displayed was a photo of my great-uncle Walter. He was a kook in my family, but up there on the wall he was a grand pooh-bah. I never knew this. Uncle Walter never moved an inch in his entire life. Now the average American changes houses about once every five years.

So what gives? Can the recent disappearance of men's groups really be laid at the feet of feminists who have busted up the supposed "dominant male hegemony"? I'm reminded of a famous cartoon from my youth. It's by James Thurber and it's part of a series he did called *Battle of the Sexes*. The cartoon has a giant woman glaring over the top of a house as her gray-flannel hubby approaches. That image is about as dated as the opposite view—that men are trapped in the three-piece suit with attaché case. When I show the cartoon to my students they wonder what's so funny. I really don't think women, or the perception of women, has much to do with the disappearance of male-only groups. I don't think the disappearance of the Masons has much to do with getting out of the house and away from Her.

Perhaps men my age have given up male clustering because we are a generation that has grown up from My Lai to Tailhook to wilding in Central Park to gang rape on college campuses and to the boom-boom room of Smith Barney. Perhaps we share a deep male suspicion of men in groups. But I doubt that too. What we learned about Abu Ghraib, the sprawling 280-acre gulag, complete with sniper towers and razor wire, was that servicemen and -women seemed almost equal in committing atrocities. The pictures were especially shocking because both male and female soldiers are seen mugging for the camera while behind them are haphazard piles of naked Iraqi men. Some anthropologists now claim that the once seemingly logical view of man as hunter and woman as gatherer, man as pack hunter and woman as keeper of the household, is sexist bunk.

Perhaps these male-only groups were constituted for commercial reasons, so you would know whom to do business with and whom to exclude. Maybe they've disappeared because most of the transactions we do are impersonal and dependent on judgments about the quality of goods or services, not about the membership status of the producer. You get into Sam's Club by forking over your forty bucks. Still, occasionally, there is some group, often a fundamentalist Christian group, claiming that you should do business with them because of their beliefs. One called the Christian Business League has Web links so you will know where to buy stuff when you are in doubt. And denominations like the Mormons do the same thing.

More likely, men-only groups have receded as the result of the more generalized tectonic shift caused by other developments. In *Bowling Alone: The Collapse and Revival of American Community*, Harvard professor Robert Putnam bemoans the social gaps generated by such private pastimes as solitary driving, couch-potato TV viewing, and electronic keyboarding. These machines—automobile, television, and computer—have increased the distances between ourselves and others. According to Putnam, they generate social syllepsis, a kind of individual communication with a responsive instrument at the expense of human connectedness. And such interaction draws us away from each other and generates loneliness and

anxiety. Fewer and fewer of us find time for the League of Women Voters, the United Way, the PTA, the monthly bridge club, or even a Sunday picnic with friends.

The decline of public socializing over the past two generations—club attendance has fallen by more than half, church attendance is off, home entertaining is off, even fewer board games are played—is undeniable. Maybe this is why the Shriners are shrinking. The male audience is fracturing into niches, as are other audiences. Add to this the role of the law, especially Title IX, which forbids exclusion in groups supported by government funding, and perhaps the disintegration of single-sex groupings is inevitable.

And then of course there is the fair-play argument. Assuming that single-sex groups will put the interests of their members ahead of the general weal, and assuming that both sexes are participating in such places as school, sports, entertainment, and the marketplace, then even the illusion of preferential treatment is unfair. Fathers with daughters will not countenance the disadvantage of their own kids. And young males will want equity for their mates.

Not everyone agrees. Rutgers anthropologist Lionel Tiger argues in *Men in Groups* and *The Decline of Males: The First Look at an Unexpected New World for Men and Women* that the process of men courting other men for security and advancement is not going away. What is changing is the uncertain boundaries of men's private spaces. Only a few years ago we saw the strange and awkward New Age "spiritual warriors," who, à la Robert Bly and friends, gloried in the mythopoetic fantasies of the past. Like their early-twentieth-century counterparts, the Improved Order of Red Men, these born-again masculinists sought to recover their sense of manliness through the supposed rituals of premodern males.

Bly's book, *Iron John: A Book About Men*, became a best seller. Other books by men like Warren Farrell's *The Myth of Male Power: Why Men Are the Disposable Sex*, Matthew Fitzgerald's *Sex-Ploytation: How Women Use Their Bodies to Extort Money from Men*, Herb Goldberg's *The Hazards of Being Male: Surviving the Myth of Masculine Privilege*; books by men and women like Paul Nathanson and Katherine K. Young's *Spreading Misandry: The Teaching of Contempt*

for Men in Popular Culture; and books by women like Susan Faludi's *Stiffed: The Betrayal of the American Man* and Christina Hoff Sommers's *The War Against Boys: How Misguided Feminism Is Harming Our Young Men* have all picked up on what might be called the shifting narratives of masculinity. Each of these books, as you can tell from the title, thinks the male is getting a raw deal.

Clearly, the modern male is perplexed. But I don't think it's fair to blame this on feminism. True, many of the ramifications of the women's movement and the increasingly child-centered world of the late twentieth century have scared the hell out of many men. But, while feminism and family-ism are ideal scapegoats, they are not good explanations. As Garrison Keillor writes in *The Book of Guys*, "Guys are in trouble these days. Years ago, manhood was an opportunity for achievement and now it's just a problem to overcome." The problematics of manhood, as it is called in academese, are more complex.

To understand what has happened, I look at a number of places like deer camps, cellars, garages, Masonic temples, barbershops, sporting venues, bedrooms, churches, offices, and strip clubs—places where male identity, or what used to be called manhood, is supposedly nurtured. There are many other places I could have gone: saloons, NASCAR pits, video arcades, locker rooms, prisons, monasteries, volunteer fire departments, old-style poker games, truck stops, stag parties, bass fishing, the free-weights section of the gym, a few pool halls, motorcycle gangs, sweat lodges, the Mafia—and you can doubtless think of many more. I hoped that by looking carefully at a few venues I might be able to generalize about the many. A better title might have been *Where Men Hid* because so many of the places I study are in either decline or free fall, but I felt there was more to learn about the deep history of, say, the barbershop than could be learned from some more recent development like Internet card games or video arcades. After all, how much Mars do you have to see to know it's not Venus?

In taking this trip across parts of the male planet I hope to be able to explain not just the literal and figurative haunts of the modern male but such peculiar developments as the SUV and that supreme

jerkmobile: the Hummer; the popularity of backyard barbecuing, including rigs that cost upwards of $10,000; the red-state male and his behavior at the polling booth; television shows like *Hunting with Hank* and the entire Outdoors Network, as well as Spike TV; sports like paintball and entertainments like professional wrestling, which prize a peculiar kind of contained aggression; NASCAR as surrogate family; the increasing sales of small sheds such as you see at the entrances to Home Depot and Lowe's, supposedly for tools but also for loafing; the failure of carpooling; the role of camouflage clothing; the growth of the Mormon Church and a new mutant in the Pentecostal ranks: the megachurch; the short-lived but intense attraction of cigar bars; the popularity of Civil War reenactments in the East and male-only mountain-men conventions in the West; and such old hideouts as Harley-Davidson bike week, drag racing, tractor pulls, demolition this-and-that, and the decoration of long-distance truck cabs. Whew! Let's first head for the hills.

Photographer's Note

In the early nineties, I was a photographer looking for a project. Several months earlier, I had completed a series on rodeo cowboys, and I had shut down for a while to regroup creatively and domestically. I was quite content to continue my vegetative state, but then an invitation to participate in a small group exhibition came my way and created the need to produce some new work.

About the same time, my ten-year-old son, Matt, suggested we clean up the hovel in our home that was known as the basement and set up a kind of shop for all our Scout projects. This seemed like a pretty good idea, and as we began planning, I thought it might be wise to visit the home shops of some friends to check out their setups.

We live in a tiny village of nineteenth-century houses in western New Jersey, and most residents have converted their barns or carriage houses to alternative uses. So to visit our first home shop, we just walked down the road to Charlie Palmer's place. Charlie was a middle-aged elementary-school teacher, highly regarded as a scoutmaster and a woodsman. His shop was devoted to his real passion,

restoring antique canoes. The place was amazing—a living testament to form and function, with a vintage pinup overseeing the whole works.

Matt and I took home lots of great ideas from Charlie's place that day, and from that excursion I got the notion that his space and other "guy places" might make an interesting series of pictures. I returned a couple of days later with my camera and, after a few false starts, eventually came away with what I wanted. I have been working on this project, off and on, ever since.

The series had grown to more than forty images, ranging from my father's recliner to a home slaughterhouse, when I got the call from Jim Twitchell (to whom I will be forever grateful), and *Where Men Hide* was born.

As Jim mentions in the introduction, my original title for this series was *Men's Rooms*. This phrase still accurately describes the subjects of my pictures. The places are all exclusively male in function, sometimes private yet often communal, and they are surely visited as it becomes necessary.

WHERE MEN HIDE INFO FOR TECHIES

All the pictures in *Where Men Hide* were made the old-fashioned way: on film and printed in the photographer's darkroom. The cameras used were Mamiyas, an old RB67, and a brand-new 7II, both with 50 mm wide-angle lenses. The film used was Kodak T-Max 100 rated at 50. Finally, exhibition prints were made on Ilford Warmtone Fiber Paper, selenium toned for permanence and to slightly cool the color. Actual print sizes are 19" x 23" or 24" x 30" (depending on venue).

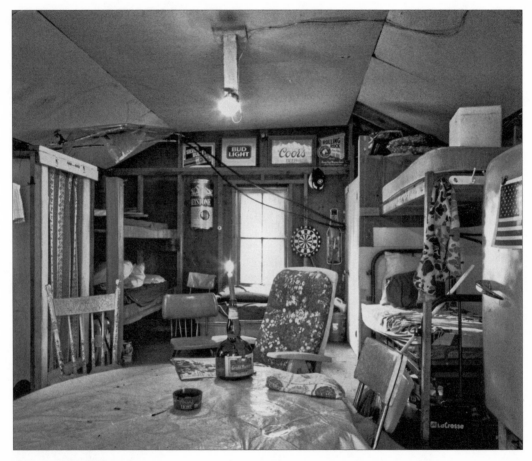

Deer camp, west view, Vermont

1. The Deer Camp

THE HUNT

What you see before you is distinctly American. It is a hunting camp, more specifically a deer camp. The word that best describes it is *ramshackle*, a word that holds within itself a curious prediction. A ramshackle construction is something so poorly made that its imminent disintegration is embraced by the builder. In other words, he builds it in order to keep on repairing it.

Look carefully at the room and you can almost hear the stuff falling apart. Those drooping polyurethane lines carrying water to the shower will fall, the beer signs will need to be hammered back in place, and the bunks will soon separate. Part of the ritual of a deer camp is the "opening up" of it every season. The men of this camp (a woman has seen this sight only a handful of times) like it that way. This is a lair, a den that needs yearly tending.

In fact, its run-down, beat-up, jerry-built insubstantiality is what gives it substance. What gives it meaning, however, is the nearby tree, a deer tree, with rope hanging from a branch. Every deer camp has one; it is totemic. And one more factoid: all the men who use

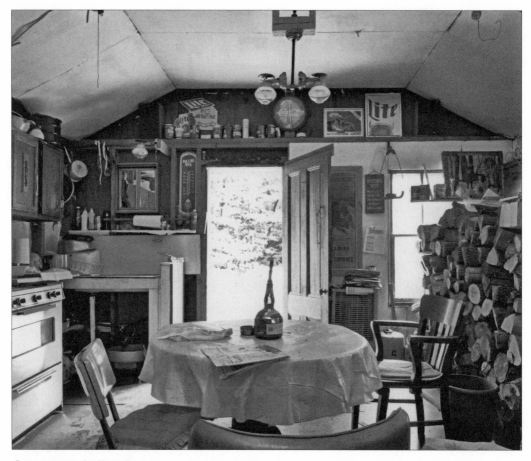

Deer camp, east view, Vermont

this camp could easily commute from home to these woods. They don't come here *to* hunt. They come here *and* hunt.

Almost every object you see here has a deep history shared by the men. Most camps have a collection of pictures, some of past events, some pornographic, either tacked up or in piles. The walls are plastered with memorabilia, the pots and pans are stashed in particular places, antlers may be hung over the door. A gun rack, a potbelly woodstove, a toilet with a number of problems, some hats on the wall, often a collection of rhapsodic poems and short stories about hunting, playing cards, and a cribbage board—all these items are part of the ritual of the yearly trip to deer camp.

Deer camp is also notable for what's not here: television, phone (including cell phone, but some hunters use walkie-talkies), radio (but not weather radio), and usually women. Most deer camps I've seen have no electricity; instead, propane fuels the lights, stove, and refrigerator.

While you might think that this space exists elsewhere in the world, such is not the case. In almost all other countries—certainly in Europe—deer hunting is organized by social rank. In this country it is done by democracy. All hunters are equal and all are dishwashers, at least for a while. What we call a *camp*, Europeans call a *lodge*. The one thing a hunting lodge is not is ramshackle.

Two circumstances explain this strange hideout. The first is that the deer hunted in North America is the whitetail, while in most other places the quarry is red deer. The whitetail is shy, solitary, and easily spooked. He likes thickets and deep woods. Only when rutting does he congregate. Otherwise, he's a loner. The red deer, however, is gregarious, moves in a herd like caribou, and prefers the open spaces. So if you want to hunt the whitetail you have to head for the hills. If you want the red deer you shoot from a stand as the animals are driven past you. The prize red deer is the *stag* with the most elaborate horn display. From his protected and often quite elegant station, the red deer hunter has a good idea before he shoots which stag will be his. Woe to the underling who shoots the wrong deer.

The other reason for this ramshackle hut is far more important. In most of the Western world, nature belongs to the rich. They own

it and the animals that pass through it. The land for the rest of us is called just what it is—the *commons*. In fact, until the nineteenth century, sumptuary laws governed the taking of red deer from any land. Stags were part of what was called the *king's deer*. Like coffee, the color purple, styles of fashionable clothing, particular fabrics, spices and sweeteners, stags were off limits to hoi polloi. Almost always the proffered reason was extravagance—these objects were sumptuous—but in truth the prohibition on hunting stags was a means of keeping class demarcations in place, of showing not just who owned what but who made the rules. Cross this line and you became a *poacher*. In North America, hunting land belongs to whoever bands together and stakes a claim. (Or at least it did.) The venison belongs to the hunter, not to the landowner.

While the goal of whitetail hunting is the *buck*, the male of the species, exactly which buck is not up to the hunter to decide. In American hunting the trophy rack is more the result of hunting savvy and woodsmanship than of the minions who have flushed the prize past the stand. The American hunter has to go into the woods. Often he has to make camp in the woods. Plus, he often has to field-dress and drag his several hundred pounds of buck out of the woods. Not so for his European counterpart. So the American hunter is by the very nature of his activity rewarded by cooperation, fellowship, local knowledge, and shooting skill.

And that is at the heart of deer camp. Whereas hunting divides classes in Europe and separates the lower classes from nature (after all, it's not theirs and if they trespass they will be prosecuted), American hunting unites classes and creates *camaraderie*. Hunting leads not to a confrontation with nature but a connection to nature, and not against men but among men. The bond among hunters has its etymology in the comradeship of war, literally the *esprit de corps*, and comes itself from the oldest kind of kinship, namely the banding together of hunters to make the kill. In so doing, the activity of deer camp is both a reiteration of ancient male bonding and a distinctly American version of man in nature. In fact, sociologists who have studied deer hunting have a specific term for this quasi-military mutation—*rough camaraderie*.

Much of the cultural meaning of American deer hunting comes from three sources, two fictional and one actual. The popular novels of James Fenimore Cooper introduced readers to the first great backwoods hero, Natty Bumppo, who epitomized the coming clash between individual and communal impulses. Bumppo, aka the Deerslayer, is a foil to Judge Temple, the personification of bourgeois-controlled society. The judge wants the rule of man's law to prevail. The old hunter, on the other hand, lives in harmony with the land and heeds the law of nature. Needless to say, we know who carries the day—at least in fiction.

The next great figure entering the mythic deer camp is Teddy Roosevelt, decked out in custom-fitted deerskin togs sewn by New York tailors, carrying a Bowie knife from Tiffany slid into a silver scabbard, and hefting whatever new model of Winchester was delivered especially to him by the company. Never underestimate the influence of Teddy in the development of American manhood, for it was his rough-and-ready narrative that connected hunting with training for war, *rough camaraderie*, and bully-good fun. Deer camp for him was "the wine of life" and every mother's son should have a swallow. T.R. never tired of explaining that he was deer hunting in upstate New York on September 14, 1901, when word came to him that McKinley had been shot. Only for reasons like this should a man leave deer camp.

This same strand of deer camp mythography was picked up at the middle of the century by the writer William Faulkner. When Faulkner was told he had won the Nobel Prize, his response carried in newspapers across the land: "I can't get away. I'm going deer hunting." Better sense and entreaties from his editor prevailed, and Faulkner did indeed attend the award ceremony. But on his return CBS News picked up the dialogue below and replayed it on the *Omnibus* show in December 1954:

"UNCLE IKE" ROBERTS: Where you been?

WILLIAM FAULKNER: Sweden.

UNCLE IKE: You got the prize I hear. That's good. (Pause) Long time to deer season. Month or two anyway.

FAULKNER: We'll get us the big one this year, you watch.

(quoted in Wegner, p. 47)

If you really want to appreciate Faulkner's focus on deer hunting, however, you need only open almost any of his Yoknapatawpha County stories. When you read his hunting stories you understand the almost hallucinatory and certainly biological importance of the hunt. Look at *Go Down, Moses* (1942) or any of the stories collected in *Big Woods* in 1955 ("The Bear," "The Old People," "A Bear Hunt," and "Race at Morning"), and you will see that the hunt, specifically the deer hunt, is the hub of a man's life, with the spokes of history, family, friendship, honor, gender, and religion all joined at the camp. The hunt is a state of grace. You cannot separate the hunt from the hunters from the hunted. And so it is on the hunt that the young man comes into his own and celebrates his manhood in the communion of his camp mates.

> There was something running in Sam Fathers' veins which ran in the veins of the buck and they stood there against the tremendous trunk, the old man and the boy of twelve, and there was nothing but the dawn and then suddenly the buck was there, smoke-colored out of nothing, magnificent with speed, and Sam Fathers said, "Now. Shoot quick and shoot slow" and the gun leveled without hurry and crashed and he walked to the buck lying still intact and still in the shape of the magnificent speed and he bled it with his own knife and Sam Fathers dipped his hands in the hot blood and marked the face forever while he stood trying not to tremble, humbly and with pride too though the boy of twelve had been unable to phrase it then, "I slew you; my bearing must not shame your quitting life. My conduct forever must become your death." (1942, p. 184)

While deer camp has a rich fictional and journalistic history, it has an equally fascinating actual history. Deer camps flourished after the Civil War as men banded together to harvest the deer crop. Venison was not a delicacy but a necessity, but the banding together probably had more to do with the bonhomie of warriors returning home than with the necessity of the tribal hunt. Usually the camps were just tents, often war surplus, surrounding a cook tent. Until

the turn of the century, the most common method of killing was by *jacking* or shining light into the animal's eyes—hardly a technique mandating a group effort. This was also called *fire-hunting*, since often the light was nothing more than embers carried in a pan. The hunter would carry the pan around a stream or lakeshore until he found the quarry with the archetypal "deer in the headlights" look. As weaponry became more sophisticated, jacking was considered unsporting, but, of course, it still continues today, especially in those places where deer hunting is not sport but survival.

The white-tailed deer is a surprisingly hardy species. While wolves, bison, and elk were hunted to extirpation in the 1800s and early 1900s, deer were able to move deeper into the woods. Even so, around the start of the twentieth century the federal government estimated that only 500,000 whitetails were left nationwide. With regulation (at first a limit of four deer per hunter!), they bounded back. There are now an estimated 28 million in the country, almost a million more than what most experts consider manageable. In many places, as their deep woods habitat has been removed, the whitetails have attained the level of neighborhood pest. You don't need to go to deer camp; just open up your back door. In many municipalities, more deer end up on the car grille on the interstate than on the deer tree next to camp. Still, deer camp lingers on.

So what characterizes modern deer camp? First, of course, the site is forever set into the amber of our remembered past. This is a place for men to hide, yes, but it is also a place for men to open up to each other and to the natural world that we have pushed asunder. There is some variation between New England, Southern, and Midwest camps in terms of size, placement, and style, but the key to camp is the nature of the buck deer's elusive habits and regal headgear.

Deer hunting is done in the autumn when the bucks are in rut and their antlers sprout. Antlers are projections of true bone that grow from pedicles, small stalk-like structures above and in front of a buck's ears. As days become shorter in late summer, male hormone levels rise, causing antlers to stop growing and harden. The velvet then dries and sheds within a few days. Now the buck is ready and looking for the doe—just as the hunter is looking for the buck.

Deer and beer, New Jersey

Chick's, New Jersey

Surprisingly, antlered bucks make up only a small percentage of a typical whitetail population. In early fall, less than 30 percent of the population consists of antlered bucks; after deer season, as little as 10 percent. Many of the bucks have been killed, and others have lost their antlers after the breeding season and will grow new ones, usually larger, the following year.

Is there something primordial about men hunting the male deer at the very time when the buck is most masculine? You decide. If it helps you understand the deep structure, realize that one of the traditions shared by deer hunters across the land is that (as in the Faulkner passage quoted above), the young man's first deer is memorialized by the rubbing of the deer's blood across his face (baptism?). Should you want more dime-store psychoanalysis, try this: if the young hunter misses an easy shot or falls asleep on lookout (as is often the case because of the late-night bedtime), tradition has it that his shirttail is cut (castration?). The more egregious the miss, the greater is the amount of shirttail taken. Often this fabric is pinned to the wall of deer camp; sometimes it's sent home to his wife or girlfriend.

The masculine nature of camp is reiterated in the names men give to their camps: Mad Dog, Neverhomeboys, Paradise, Lost Nation, Fort-Hort Resort, the Ruttin' Buck Lodge and Resort. The food is hearty and full of what's forbidden elsewhere—a cornucopia of carbs. Men tell jokes they've saved for months, or retell stories they've told for years. Here there are no food police telling you that sticky buns will ruin your waistline. No language police telling you to say "excuse me"; in fact, at deer camp escaping air more usually merits applause. No fashion police because all that nifty camo will be covered with fluorescent orange anyway. Manners are held in abeyance, jokes turn blue, there's no shaving, bourbon appears before 5:00 p.m., cigar smoke turns the air to haze, endless fun is poked, and pissing is elevated to a sacred ritual. A nocturnal stumble into the bathroom becomes a heroic mission out into the darkness.

What looks like rebarbarization is more likely the celebration of Saturnalia. It's a world turned upside down. As one wag has observed, "Deer camp is what men have for a slumber party."

Like many other male-only rituals, deer camp is currently under duress. The complexities of modern life make it impossible to synchronize what used to be common rhythms. When I was a kid in upstate Vermont, the lumbering and manufacturing industries would come to a stop at the end of October. Often deer season was written into the contracts. Mills would completely close down for the first weekend. My classmates would appear in school all dressed in red for no other reason than the beginning of the costuming ritual. They had been greasing their boots and oiling their guns for weeks. They would be going with their dads and uncles. Once the season began, pictures of bucks on the front hoods of cars were front-page news. Only women seemed to be in church. A few of my classmates would succeed in the hunt, and the manly prance would begin and last until spring. They would become the animal they had killed.

No more. Fathers can't take that kind of time off; there is a general hostility toward guns; hunting is seen as heartless; land is posted; and who knows how to field-dress, let alone actually butcher, an animal whose meat is hardly a delicacy? Bambi is not a Big Mac. More than 50 percent of the U.S. population is opposed to hunting, according to recent surveys, and that percentage is growing. Some experts predict that wildlife will soon be managed by the state largely for contract hunting and that whitetail bucks will become like partridge or mountain goats, a animal purchased to be hunted. The period of free and open hunting as it was developed in the late nineteenth century may be nearing its end. Young America becomes Old Europe.

But more important in the demise of deer camp may be that deer hunting has always been male-dominated. Only about 2 percent of women hunt deer, and they make up only 6 percent of all hunters. As deer hunting becomes less of a father-son and a male-bonding tradition, the deer camp may move farther and farther into the woods, until stoking a crackling fire in the potbelly stoves, oiling the gun, greasing the boots, hanging the sweaty socks, telling the stories, and feeling that brotherhood finally disappear into the mist.

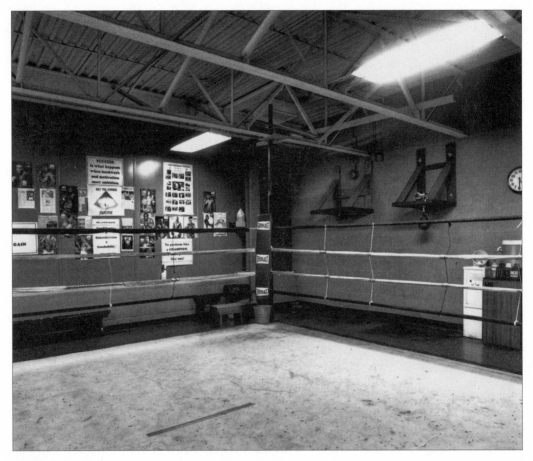

Practice ring, New Jersey

2. The Boxing Ring
SHAME AND HONOR

The image you see before you, the boxing ring, is a touchstone of male anxiety. As such it is rigorously formatted. The standard size is twenty feet by twenty feet. Although this sparring ring is at floor level, the fighting platform is usually about two feet off the ground so the crowd can see what's happening. In a competitive ring, the corner posts, used to attach the ropes, also serve as supports for the platform and are slightly inside the fighting surface. The platform extends about two feet past the ropes, making room for the seconds. The four one-inch manila ropes (sometimes three will suffice) are spaced so that the top rope is about fifty-two inches from the canvas. The ropes, sheathed in fabric so they won't burn the combatants' flesh, are strung through post hooks called *turnbuckles*. The turnbuckles in this gym have the only recognizable commercial name in boxing—Everlast—emblazoned on them.

In 1925 the Everlast company designed elastic-waist trunks to replace the leather-belted trunks then worn by boxers. These trunks, now known as *boxers*, immediately became famous, and the battle

between jockeys and boxers began. How appropriate that the other site of male anxiety should be the home of this combat.

In the 1950s I went to summer camp in Vermont. Boxing was an assigned activity. I remember the huge gloves that I was tied into and the swimming trunks I wore. That was it: we were shirtless. I must have looked like a magnified housefly. I remember feeling claustrophobia of the hands because once tied in, there was no getting out of those gloves. I remember being shoved against the turnbuckle by John Rosenthal. I have absolutely no other memories. These were the days before you wore helmets for every conceivable activity, so I may have conked out.

I get a sense of the panic I felt then by looking at this image of a boxing ring now. The "sacred inclosure," as it was often called in the nineteenth-century police gazettes, looks to me like a pen of terror. Boxing was no fun. None. And the thrill of hitting someone who also looked like a magnified bug was, for me at least, nonexistent. So why did we do it? And why now, when I am channel-surfing on TV, do I often pause at a boxing match and feel a forbidden sense of excitement? My remote-control trigger finger goes limp as I stare at men who seem to enjoy being in a boxing ring.

Do I have a screw loose? That summer camp, as well as many other single-sex institutions like preparatory schools, was based on the military model of mild deprivation being good for the soul, a model that came from Western Europe, most particularly from England. At the St. Grottelsex prep schools young men slept in cubicles and washed in cold water. In the afternoon they played sports, usually team sports, then more cold water. The battle of Waterloo was won on the playing fields of Eton, and all that. Somehow boxing was part of this homage to the Victorian principle of "sticking up for Queen and your self." President Theodore Roosevelt, who had boxed with gloves on at Harvard University, sparred with Mike Donovan, a former bare-knuckle middleweight champion, and received John L. Sullivan at the White House. The army had a name for this—*basic training*. But why was boxing basic training for life? Social Darwinians were in the saddle, that's for sure.

But there's more to it than developing self-reliance. A lot more. Boxing opens up one of the most complicated aspects of masculinity. Advance advertising notwithstanding, men are exquisitely sensitive. They are not particularly tough. I hope I am not telling stories out of school, but women are far tougher than men, just not as well muscled and nowhere near as aggressive. True, when women get their feelings hurt, they cry, which seems a little silly. When men get their feelings hurt, however, they often kill someone, which is far worse than silly. Any culture that wants to survive has to control young males' fighting, which really means it has to control how men experience and express hurt.

Here's what most of male fighting is about: sex. Civilization and its discontents being what they are, this is usually expressed more politely, as *honor*. Now honor is really about *not* feeling shame. Shame is a physiological response to public embarrassment. Men do not like to be embarrassed in front of women, certainly, but they especially do not like to be embarrassed in front of other men. By nature, we are not ashamed of much. Inappropriate discharge of bodily fluids, for instance, is one of the very few universal triggers. We literally *lose face*: the head drops, the shoulders slump, and we become immobilized. A shamed male is a nonreproductive one. He slumps, hardly erect.

Most of our other shame triggers, however, are up for grabs. They are very fluid and culture-specific. For instance, when I was growing up, public drunkenness, filing for bankruptcy, having a child out of wedlock, drug addiction, hitting a woman, spitting, using vulgar language in public, being on the public dole (what there was of it), or getting a divorce was enough to make you hang your head. Want to feel shame today? Smoke in public, grow fat, have a nose too big or a bank account too small, don't recycle, be seen littering, mistreat a pet, wear the wrong clothes, use the n-word.

So what has shame got to do with boxing? In the late eighteenth century, dueling was the male response to a breach of honor, what you did when you were on the edge of experiencing shame. Dueling became an elaborate ritual that essentially protected the oh-so-

sensitive male from public slumping. When a man felt he had been dishonored by the acts of another, he would go to the offender and demand an apology. If that was not forthcoming, he would deliver the challenge written out on his calling card (the glove across the face is a nifty Hollywood touch) and meet the offender at dawn.

Of course, with the advent of firearms, following a set ritual became even more important. The stakes got higher, much higher. The Irish Code Duello, covering the practice of dueling and points of honor, was formally drawn up and settled at Clonmel Summer Assizes in 1777. The code prescribed the conversation that should precede the duel (challenges are never to be delivered at night, as "it is desirable to avoid all hot-headed proceedings"). As well, the code set forth how to write the challenge (get a ghostwriter), the choice of instruments, the time of day and appropriate place, the role of seconds (including how they load the instruments in the "presence of others"), the onset of firing ("determined by signal, word of command, or at pleasure"), and indicated what constitutes *disablement* (a hand so shaky that it can no longer fight ends "business for that day"). You can't just duel for the fun of it, that's for sure. A primary job of the Code Duello was to flush out the riffraff, the social climber, and the psychopath.

The code was such a success at resolving hurt feelings in Ireland that it was soon adopted in England, on the Continent, and, with some slight variations, in America. The language was complex and wordy and hence appealed to those with plenty of time on their hands and plenty of anxiety—namely, the rising middle class, who desperately wanted to behave like aristocrats. The real aristocracy could, and generally did, turn on their heels and go home when slighted. Why should they read the bombastic code? But the bourgeoisie, thinking that what they were doing was pretty elegant, made mountains of maiming out of molehills of slights.

The duel announces that something terrible has happened (cheating at cards, an untoward word to a lady, mistreating a chum, saying something behind another's back about his manliness) and must be *stopped*. The key to understanding the duel is that, yes, it is the tribute bluster pays to shame, but it is also—and this is crucial—

violence with a set end. Hollywood movies and bodice-ripping novels notwithstanding, you cannot point your pistol at the sky and fire. You must participate. And when it's done; it's done. Like double jeopardy, it can't be repeated.

The duel becomes important in cultures that privilege shame (that is, how you feel you are perceived by others) as opposed to guilt (that is, how you think of yourself). For reasons no cultural anthropologist can fully explain, shame cultures (Japan, Germany, Ireland, Sicily, Iceland, the American antebellum South) generated elaborate codes of honor in which some kind of publicized "that's it; no more of it" combat occurs. Clearly, this has something to do with seeing yourself and your culture as being under siege from outside. Anthropologists sometimes explain it as a function of island mentality—but if so, why are there literal islands (Greenland, New Guinea, Baffin, Java . . .) that have relatively minor shame/honor codes?

No matter. What we are concerned with is what takes the place of the duel once firearms become too dependable. Recall that the duel was so much a part of American political life that about a hundred important American politicians dueled, the most famous of whom were Andrew Jackson, Alexander Hamilton, and Henry Clay. What a foolish sacrifice to concocted honor!

It is here that boxing comes in.

Boxing returns male retaliation rituals to the more confined level of *sport* while still invoking honor *and* maintaining a definite ending. In fact, the word *boxing* comes into vernacular use in England in the eighteenth century to make the elision between fighting to settle disputes and fighting for sport under agreed rules. That this kind of hand-to-hand fighting had a long history in Greek and Roman history made it more acceptable as a duel substitute. In fact, the boxing glove, a Victorian refinement, develops from the leather thongs (*himantes*) that the ancient boxers wrapped around their hands and wrists to leave their fingers free. By the early nineteenth century, boxing had grown popular enough that it was "deemed the national sport of England." Dueling was down for the

count, firing up sporadically again only in socially anxious places like the American South.

You can still see the pentimento of the duel in Anglo-American boxing. Boxers often used newspaper and broadsheet "cards," as they were called, to announce the challenge. This custom was picked up from the challenge card of the duel, with which the "apologize or else" message was exchanged prior to the event. As boxing became commercialized, these cards were pasted on walls and printed in newspaper advertisements. Hence the etymology of the "boxing card" or poster on which the combatants are named and described. You can see vestiges of the old cards posted on the wall in the photograph at the beginning of this chapter. Over time the *grudge match* becomes part of this heritage and often figures on the card. As well, the role of the *second* is picked up by the men in "your corner." So too "toeing the mark" and being "up to scratch" mimics the ritual of commencement as it announces how the first punches are thrown. As well, the hint of delicate male honor is never far from the challenge, and we still have the boxing vocabulary to prove it: *mollycoddle, pussyfoot, namby-pamby* were all part of the fight vernacular, all invocations of feminine *sissy*, itself from *sis*, short for sister.

But it is the rituals of conclusion that are far more important than those of commencement. Men do not fear violence. In fact, while men may not like participating in it, we are hard-wired to pay attention to it. You don't get into the breeding pool by saying the water is too cold. What men fear—truly abhor—is violence without an end. Anthropologists agree that all cultures spurn unmediated and lingering violence. The shame score must have some prospect of ending in order for the men to relax. If we can learn anything from history, from gladiatorial games to medieval tournaments to dueling to trench warfare to modern combat, it is that we seem programmed to, and have benefited from, aggression. It is a central aspect of our social and sexual selves. Rather than attempt to exorcise it, we must make sure to ritualize it in the least disruptive and most socially advantageous ways. Perhaps honor performs that service.

The anthropologist Robin Fox argues in "The Inherent Rules of Violence" that honor does exactly that. He reports on a month spent

observing the barroom behavior of the Tory Islanders off the coast of Ireland. Young men exchanged insults, holding each other back from contact, stamping their feet, threatening but not really striking. Fox observes:

> At first sight, it seems to be an unstructured scuffle. But this is the main point I want to make about Tory fights: they are never unstructured. This may seem strange, for it appears that fighting is something below the level of culture and rules; that it takes men back to something primeval, to a state of nature that is red in tooth and claw. Perhaps. But equally primeval is the principle of ritualization, and I think that this is the clue to the islanders' ability to manage their aggression. The principle of ritualization can be stated in a general form: in any community of animals there usually exist forms of combat that allow antagonists to settle their differences with violent exertion and yet with a minimum of serious damage. Sometimes the exertion itself can become ritualized—as when an exchange of shots at a distance is a duel, or the drawing of blood in a fencing match satisfies the honor of the antagonists. . . . I am reminded of ritual fights—or as the ethnologists call them, agnostic encounters—of animals. It seems that men, including Tory men, try to ritualize combat between members of the same community, much as animals do. As [Konrad] Lorenz has pointed out, many animals that are equipped to kill have powerful inhibitions against killing their own kind. Very often combats are reduced to exhausting wrestling or butting matches, or even to simple displays of threat and counter-threat. The stags who compete for harems at rutting time lock antlers and wrestle. Stallions, playing the same game, nip each other on the neck, instead of slashing each other with their hoofs. Some animals, like the fiddler crab with his great, exaggerated right claw or the marine iguana with his horny crest, have evolved special organs for this purpose. Man has not evolved special organs. Instead he has that remarkable organ, culture, to do this ritual work for him. Perhaps this is an example of culture building on nature, rather than as is usually assumed, running counter to it. (pp. 138, 145)

The playground ritual is extended to the pub ritual, to the athletic game, to the boxing ring, or even to the front lines. For as Robert Axelrod reported in *The Evolution of Cooperation*, during World War I highly articulate and formulaic conventions developed in the

trenches, with shots being "answered" not to injure but to deflect real conflict. Unconsciously, males develop a tit-for-tat program to maximize individual and group safety. Women usually don't play this game. In *St. Joan*, George Bernard Shaw blames Joan for spoiling the ritual. When Joan insists that the French generals stop knocking the English off their horses and get on with the business of killing them, she is effectively doing away with the protective routine and, for Shaw, changing the world forever.

Should you ever wonder why the Marquis of Queensberry was so important in the history of boxing, now you know. For he was the one who, in 1867, lent his name and reputation to the exact and precise rules of boxing. The marquis realized that the dilemma of commodifying boxing was knowing when it's done. The Queensberry Rules not only explained the space you see before you in the photo, but also defined the time it took to fight. The fight was to occur in *rounds* lasting for three minutes, with one minute between them. Most important, the rules stated the parameters of combat:

> 4. If either man fall through weakness or otherwise, he must get up unassisted, ten seconds be allowed to do so, the other man meanwhile to return to his corner; and when the fallen man is on his legs the round is to be resumed and continued until the three minutes have expired. If one man fails to come to the scratch in the ten seconds allowed, it shall be in the power of the referee to give his award in favor of the other man. . . .

> 7. Should the contest be stopped by any unavoidable interference, the referee [is] to name the time and place as soon as possible for finishing the contest, so that the match can be won and lost, unless the backers of the men agree to draw the stakes.
>
> (http://en.wikipedia.org/wiki/Marquess_of_Queensberry_rules)

The one stipulation the marquis did not mention was the number of rounds. Thanks to the exigencies of betting and, after a number of seventy-five-round midday battles that played havoc with the drinking and betting habits of much of the crowd, the generally recognized limit was twelve or fifteen of these rounds. The first fighter to win a world title under these rules was Jim Corbett, who

defeated John L. Sullivan in 1892 at the Pelican Athletic Club in New Orleans.

The question of why boxing went from an upper-class English sportification of the duel to the working-class American carnivalization of ethnic differences is a woolly one. Certainly one has to credit the Irish, for when you look at almost every title fight before World War II you'll see Irish surnames (Sullivan, McCoy, Morrissey, Heenan) as well as nicknames (Wild Irishman, Irish Terrier, Dublin Tricks).

The Irish were also important for a reason that transcended their history of dueling and blustery temperament. As Irish immigrants elbowed their way into urban American culture they often used boxing not just as a method of inclusion but also as an expression of ethnic honor. As with the duel, the fistfights were all about avoiding shame: blood shame, accent shame, neighborhood shame, job shame—in short, immigrant shame, the shame of being the new kid on the playground. Sociologists talk of the *bachelor subculture* of the late nineteenth and early twentieth centuries, when the number of unwed males in large cities often reached 40 percent of males between the ages of twenty-five and thirty-five. For these males, as Elliott Gorn has observed in the best cultural interpretation of boxing, *The Manly Art: Bare-Knuckle Prize Fighting in America*, the ring became the courthouse and the church for enacting and concluding the interminable squabbles of disputatious groups, be they neighborhoods, trades (especially butchers), labor unions, fire companies, pool halls, saloons, men's social and religious clubs, or political parties, to say nothing of good old-fashioned gangs of unemployed males. The ring became the pub with a soft floor.

Since fisticuffs were illegal, it took some traveling to assemble an audience safely outside the long arm of the law. The railroad and steamship moved the audience outside the jurisdictional pale. For New England, this often meant Canada; for the Southern states, it meant Louisiana, the one state with Napoleonic ties to codes of honor. Since the heartlands were soon producing a surplus of corn, oats, and barley, the prizefight liberally mixed grain sprits with manly spirits. These events were often riotous, literally. What really

generated the huge interest in prizefighting, though, was betting. The stakes for prizefights could be in the hundreds of thousands of dollars. Here was a way to enter the rituals of the boxing ring, to become a member of the pageant. You pledged your allegiance through your pocketbook: you bet your cash to protect your honor. As with so much of modern culture before electronic media, the saloonkeepers and the bookies kept the fires simmering.

Boxing has now become a minor entertainment, a vestige of its former self. Thanks to television, it lives on the upper cable channels, rarely making its way into the downtown life of most cities. Gillette's *Cavalcade of Sports*, aka *Friday Night Fights*, which ran from the early 1940s through the 1950s, was one of the "killer apps" of the new medium. The television camera showed what was otherwise hard to see: human pain. Ironically, the show destroyed the subject matter because what it really demonstrated was that when you remove the narrative, the combat itself was not all that compelling. Unless, that is, you were watching in a bar. The Golden Gloves, once a staple of ethnic pride, fell by the wayside. My summer camp has long since dismantled the boxing ring and doubtless encourages noncompetitive games under the rubric Everybody wins! True, yuppies spar and shadowbox with each other at downtown gyms under tons of protective equipment, but their real excitement is in discussing the South Beach Diet over at the StairMaster. If you want to observe the transformation of boxing-as-male-preserve, simply consider the Hilary Swank role in Clint Eastwood's *Million Dollar Baby* (2004). Compared with the male pugilists, she is indeed the champ many times over.

But the "squared circle" you see before you has not disappeared from male clustering rituals. As professional boxing has become to African Americans what it once was to the Irish, a new burlesque has picked up the ancient rituals of shaming. Oddly enough, if you pay attention to professional wrestling you will see the same stories of shame and honor enacted via gymnastics. That the playing surface is this same roped-in terrain is no happenstance. The only difference is that underneath the ring is a huge spring so that the combatants (really humour characters from the old morality plays)

can bounce up and down in safety, as if they were on a trampoline. The most important actor in professional wrestling is the TV announcer. He explains the shameful events that have made this combat so important. Whose honor are we fighting for today? Say what you want about television, this medium has had a profound effect on temporizing at least some of the bloodier rituals of adolescence. That pantomime hyperbole—professional wrestling—has replaced knuckles crushing the face, which itself replaced bits of hot lead entering the body may be a tip of the cap to Repressive Culture. That the confined twenty-foot-by-twenty-foot zone has remained stable is a tip of the cap to Testosterone Culture. Give us violence, say the ringsiders. Just make it safe.

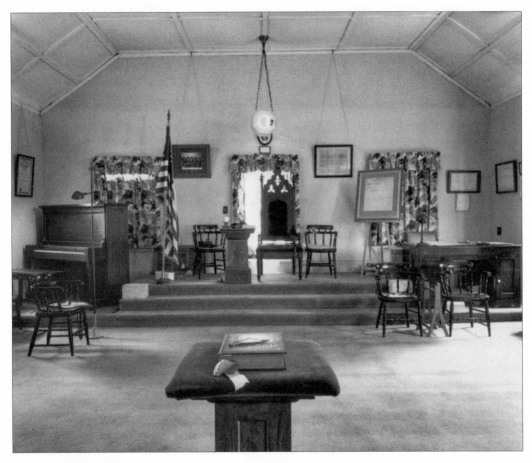

Masonic temple, Vermont (1)

3. The Fraternal Lodge
INITIATION OF BROTHERHOOD

What you are seeing here is the last gasp of a very special kind of hideout. It is a Masonic lodge in a small town in New England. It's about to fall over. The same scene could as easily be in any state or in any Canadian province. In fact, it could be in almost any European country as well, although it would look a little different.

This lodge (Friendship #24, chartered January 15, 1852) happens to be in northern Vermont. The building is barely standing. Go inside on meeting night and you'll be met by a few septuagenarians, an octogenarian or two, and a handful of sixtysomethings. The sight of all white, all men, all superannuated is a little unnerving. These gentlemen will be incredibly solicitous. They know they are dying out.

They are doing their best to dodge the inevitable collapse. Whereas it used to take months to reach the *third degree* (terms like *on the level*, *blackball*, and *square deal* come from their Masonic lore) you can now do it in a day (assuming your check for about thirty-five dollars doesn't bounce). If the lodge is lucky, new members are

Masonic temple, Vermont (2)

joining faster than old members are quitting, but in general this is not happening. The average Mason is sixty-seven years old. These guys are hiding, all right, but hiding from what? From whom? And for how much longer?

The golden age of this masculine lair was when the fathers of these members were kids. If you ever want to appreciate the prominence of the Masons, go into any old downtown area and look at the upper levels of the buildings. You'll soon see those ancient markers, insignia etched in limestone, or a plaque on a wall heralding the building's fraternal heritage. The square and compass and other icons still tell the public that these were once fraternal halls. By the twenty-first century the lodges were kaput, though. Their primary symbolic vestige remains the eye on the pyramid on the one-dollar bill. Why? Why was the post–Civil War period so important in generating fraternity? And why did such clubs suddenly lose their magnetic pull three generations later? A little background may help.

The yearnings of men to tribalize far predate the nineteenth century. Men in clusters are at the heart of most religious myth systems (the Apostles of Christ) and most European guild systems (such as the workingmen's organizations in Florence or Flanders). The Masons come from precisely this cross-pollination of religion and work. They first came together in the Middle Ages when stonemasons—a guild of master craftsmen and stonecutters—moved around Europe helping to build cathedrals. Since workers came from different countries and seldom shared a language, they evolved a system of secret signs and symbols to explain the skills they brought to the job. By the mid-eighteenth century, the brotherhood had evolved from a craft guild into a philosophical society dedicated to shaping manhood as well as buildings. The shaping of character meant the avoidance of certain characters as well—namely, Catholics and, to a much lesser extent, Jews. The signs and symbols evolved, too, becoming a kind of secret language by which Masons identified each other and passed on their traditions of "us against them."

Masons were hardly alone in generating fellowship by exclusion. The saved/condemned nature of who's in/who's out was crucial in a world in which circling the wagons was a necessary response to real

or imagined danger. So if a potential member didn't subscribe to the notion that a supreme being presides over the universe or if he was from an outré group, he didn't get in—the infamous *blackball* (today a black cube among white marbles is used; since some members may not have such acute eyesight; they make the choice by feel).

Indeed, men under stress quickly generate systems of in-group versus out-group, whereas women tend to use inclusion as protection. For instance, the Mormon Church, a highly stressed band of outsiders, adopted the principles of the Masonic temple, complete with fierce excommunication codes, passwords, handshakes, working up the ranks (the Scottish Rite has thirty-two steps, the Mormon Church far fewer), and a strong masculine chain of command. Joseph Smith was a devout Mason. Neither the Mormons nor the Masons are particularly keen about acknowledging this cross-pollination, but it shows how powerful closed fraternal cohorts can be. In fact, the Mormon Church is currently one of the fastest-growing churches in the world.

Sometimes the centripetal force of men-in-secret-groups can be too powerful. For a while in colonial America almost anyone who was anyone was a Mason. Masons built our country—literally and figuratively. George Washington, Ben Franklin, and other Masonic brothers laid the actual cornerstones of the Capitol, the White House, and the Washington Monument. Fifty-three of the fifty-six signers of the Declaration of Independence were Freemasons, along with nineteen signers of the Constitution. In any town or city across the land, chances were that the judge/minister/doctor/merchant was a Mason.

But then, in the summer of 1826, the Masons had big trouble. They became too powerful, too concentrated, too concerned about doing things in private, too obsessed with protecting their own. No one is really sure what actually happened, but in Batavia, New York, a William Morgan, a former army captain who fought for General Andrew Jackson in New Orleans, disappeared, creating a national scandal. What really happened to him is anyone's guess, but here's what most people believed: Morgan had pretended to be a Mason from another lodge, he got himself into the Batavia lodge, he was

a pugnacious drunk, and so he got himself kicked out. Morgan then resolved to publish the oh-so-secret rituals, and joined forces with another former army officer and printer to publish an unauthorized account of Masonry. (This kind of spilling the beans still goes on—just Google *Masonic secrets* and you'll get pretty much the whole bean pot.)

When Morgan was arrested for a minor offense, a contingent of Masons arrived at the jail and spirited him away. He was never seen again. Most people believed Masons kidnapped and killed him. The bottled-up anxiety about the secret order, with its not-so-secret grasp on the reins of power, burst, and the response to the scandal almost destroyed the order. For the first time in the country's history, a third political party of national scope was formed, the Anti-Masonic Party, its entire platform devoted to bashing Freemasons. Thousands of Masons, horrified by the publicity and scandal, fled the brotherhood. By the 1830s, Masonic numbers had plummeted to some forty thousand nationwide.

But the urge to merge was still upon the menfolk. Being in the company of *just us men* was an acquired taste, and the Civil War had now supercharged it. The Golden Age of Fraternity was about to begin. Here's one reason: on both sides of the Civil War, soldiers fought side by side with men from their own specific worlds—tribes, if you will. Both the North and the South conscripted and organized armies not by skill but by geography. So if you were in the Thirty-sixth Alabama Infantry Regiment you were fighting with men from Fayette, Greene, Mobile . . . counties. And if you were fighting against the First Regiment Vermont Volunteer Infantry, those militias were from Bradford, Brandon, Cavendish . . . counties. When the war was over and the Johnnies went marching back home, they were already bonded in blood.

After the war, the need for fellowship proved stronger than the stench of scandal, and the Masons reconstituted themselves. While the war invoked fratricide, the peace resolved it. Men clustered not to fight but to feel that camaraderie again. They were less cocky, less anti-Catholic, less prone to skulduggery, and more inclined toward let's-make-nice. Politics and religion became two topics *not* to

discuss. In fact, they were distinctly *verboten*, and still are. By the turn into the twentieth century this group was spending most of its time dressing up in regalia, initiating each other into the various ranks, executing the secret handshakes, and blackballing—but generally behaving themselves.

And they had better behave, because in the resurgence that followed the war American men by the millions joined competing lodges. Some of these were the Independent Order of Odd Fellows, the Benevolent and Protective Order of Elks, the Knights of Pythias, the Loyal Order of Moose, the Independent Order of Odd Fellows, and the Knights of Columbus (created by Catholics to counteract the Masons), as well as such wonderfully named groups as the Improved Order of Red Men and Modern Woodmen of America and some special-interest groups like the German Order of Harugari (founded in 1847 for German immigrants), the Independent Order of Rechabites (founded in 1842 as an abstinence society), and the Order of the Camels (founded in 1920 to oppose prohibition).

It is estimated that by the turn of the century the average middle-class male was a member of at least two men-only groups, passed about four hours each week at the lodge, and spent up to 5 percent of his disposable income on initiation fees, travel, regalia, banquets, and donations. Large cities often had more lodges than churches. The massive joint-stock insurance companies of today, like Prudential, Cincinnati Equitable, and Equitable Life, descended from the mutual protection schemes provided by the lodge. The lodges always made a production of the death of a member, not just to celebrate the individual and swell the funeral crowd but also to inform the group of a family's need for help.

These men-only groups were linked by more than a focus on death. Many lodges had similarities that may well tell us something about the nature of the American male. They are all secret, single-sex ("No Gurls Allowed"), and often lubricated by alcohol. They are filled with stuff: robes, axes, aprons, necklaces, bolo ties, rings, trowels, compasses, record books and instruction manuals, Bibles, super-deluxe fezzes, and all manner of bells and swords. The men, industrious and stern by day in the office, performed pageants and

engaged in hijinks at night in the lodge. They often created elaborate stage settings in which they played out the heroic travails, rather like the duke and the king in Mark Twain's *Huckleberry Finn*. The men usually referred to each other with elevated titles that emphasize hierarchical pecking orders, and their formal interchanges are full of fustian prose covering genuine affection and tenderness. Not for nothing is the lodge itself usually feminine, more specifically, the *mother lodge*.

The initiation ceremonies are not difficult to unravel. The members get all gussied up and become very serious. In the initiation rite, the initiate is led across some territory to manhood. The novice is often wearing a diaper-like robe. He is referred to as a cub, novice, ensign, or just baby. Invariably, he is blindfolded. In fact, in antiques stores you can often find strange goggles on a fabric strap—like the kind the Model T driver used along with the "duster"—but the lenses are dark. Called a "hoodwink" (from which the term derived), the goggles were used to blind inductees, heightening the sense of fearsomeness of the make-believe experience. In most lodges this experience is called something like the "rough and rocky road" and entails walking along several wooden planks that have deep gouges carved into them and are suspended by ropes. The hoodwinked initiate had to walk or crawl the length of this swinging bridge, with the understanding that if he fell off, he was done for. In truth, he was only a few inches off the ground.

Men seem to be drawn to these baptism ceremonies, in which the traditional activities of mothering go on under the rubric of brotherhood. Week after week, the mother lodge is filled with men giving birth to each other, inducting each other into the family, comforting each other, and promising succor. Under all those flowing robes of brotherhood is, in a sense, your loving mom. And remember that historically all this was happening at the same time that male obstetricians and gynecologists were inventing their medical specialty by pathologizing pregnancy and childbirth. It also occurred at the very time that the male was moving out of the house into the factory and the woman was domesticating the home. Do these private ceremonies show an unresolved yearning for what publicly had been lost?

Add to this the motif of *strength in union*, which is at the core of all these organizations. One of the most common icons is the faggot. A *faggot* is a bundle of sticks tied together. The meaning is that one stick can break, but a number of them, bound together in brother-hood, resist force. It may be an instructive irony that this word now refers to an individual homosexual man and has become a term of separation and derision. The etymology of *faggot* is *not* that homo-sexual men were burned at the stake for sodomy (the fire provided by burning faggots as kindling); rather, this distinctly American coinage (we have no history of burning at the stake) enters the lan-guage in the nineteenth century at the same time as the resurgence of fraternities. It may be that *faggot* and *fag* come in part from a re-action against the symbol that had come to represent self-conscious and hyper-anxious masculinity of the lodge.

Over time, the fraternal orders became progressively more con-fident. Was it because men had adapted to the competitive strain of capitalism, was it because the Civil War became less of a trauma over time, was it because social mobility, anonymity, and individualism had been subsumed into the modern nervous system? Doubtless it was all of the above. The orders soon included women in separate and slightly subservient ranks. So the Masons had the Order of the Eastern Star, the Improved Order of Red Men had Pocahontas aux-iliaries, the Odd Fellows had the Order of Rebekah, and the Knights of Pythias had the Pythian Sisters. It goes without saying that the ladies did not have to contend with all those perilous journeys and stark death encounters. They were able to get together and assume their public roles without much in the way of secret pantomime. Women didn't need the mother lodge; they *were* the mother lodge.

After World War II another burst in male bonding occurred as once again the boys came marching home, a band of brothers. In fact, before the war the Masons were still so powerful that they were second on Hitler's hit list, after Jews and before Catholics. But the males-in-hiding game had changed somewhat, and service organi-zations started to replace the fraternal ones. The Rotary, Kiwanis, Lions, Sertoma, Optimists, Jaycees, and others stole the now-domes-ticated membership. George F. Babbitt was hanging up his evening

robes and suiting up to do good at lunch. These downtown merchants were forever supporting youth programs, eyeglasses for the blind, scholarships, raffles, concerts, telethons, haunted houses, and endless pancake breakfasts. The lodges battled back, but the moxie was gone. The Masons started helping burn victims, the Knights of Pythias aligned with the Special Olympics, the Moose got into spina bifida and hydrocephalus, and even the America Knights of the Ku Klux Klan were always threatening to help somebody who wasn't in distress. But the jig was up on this PR nonsense. The lodge was done for as a manly man's pursuit.

Meanwhile the *boys will be boys* strain of fraternal life moved over to universities and colleges, where the Greek system picked up on the initiation rites and made them central to a young man's life. The initiations to manhood were now being administered by Beta Theta Pi, Sigma Alpha Epsilon, Sigma Chi, Lambda Chi Alpha, Alpha Tau Omega, and the rest of the *frats*. The "rough and rocky road" now runs around the cellar of the frat house between kegs of beer. From time to time one of these societies makes its way into the popular consciousness, as Yale's Skull and Bones did in the presidential election of 2004, since two members were candidates for the presidency. Most of the time the "tapping societies" of the male-only tradition have gone into the same world as this old Masonic temple in upstate Vermont. The only exception to the general disappearance of the *men will be boys* is possibly the Bohemian Grove celebrations, which is hardly a mainstream event; rather, it's a Saturnalian once-a-year blowout of the rich and powerful.

As a tradition is disappearing, parody often appears, providing a kind of swan song to what's ebbing out of the culture. Remember the screwball raunch of *National Lampoon's Animal House* (1978) in which the Delta Fraternity under the able leadership of John Belushi as Bluto Blutarsky lays waste to every sacred cow of the Greek system? A generation earlier, the *Jackie Gleason Show* made almost constant sport of men-only lodges. It's worth a second look.

Bus driver Ralph Kramden (Jackie Gleason) and sewer worker Ed Norton (Art Carney) were members of the Raccoon Lodge in Brooklyn, New York. The fraternity was called the International Order of

Friendly Sons of the Raccoons, the International Order of Loyal Rac-
coons, or at times, the Royal Order of Raccoons. Clearly, the writers
knew a lot about the culture of these orders, as did the early TV
audience. The motto was "E Pluribus Raccoon," the uniform was
a double-breasted military jacket with oversized epaulets on each
shoulder, a white shirt, a dark tie, and a hat with a raccoon tail.
Morris Fink, a sewer worker with Ed Norton, was the Grand High
Exalted Mystic Ruler. He wore three tails on his coonskin hat. The
handshake involved touching elbows (first right, then left), followed
by a "Woooooo" cry as the member wiggled the raccoon tail on his
lodge hat.

Much of the humor centers on the levels of rank, most specifical-
ly who will be elevated to Raccoon of the Year. No wonder, because
this meant:

- Opening the first clam at the annual clambake
- Steering the boat on the annual ride up the Hudson River to Raccoon
 Point
- Getting a free burial with spouse at Raccoon National Cemetery in Bis-
 marck, North Dakota
- Having an opportunity to run for Grand High Exalted Mystic Ruler
- Throwing the first bag of water out of the hotel window at the Raccoon
 convention

Much is made of proper lodge behavior, the correct way to drink a
toast, what to wear, how to vote, the vaunted nicknames, the special
trips, the speeches, and all the folderol, but invariably things degen-
erate into Ralph and Norton flipping up the tails of their coonskin
caps and going, "Woooo-woooo-woooo!"

Another place to acknowledge the passing of this version of the
male lair is in Preston Jones's *The Last Meeting of the Knights of the
White Magnolia*. We watch the death throes of an outdated order
now reduced to card playing and whiskey drinking. The arrival of
a new recruit provides the need to resurrect their ancient "mystic"
initiation rites, leading them to realize the loss of still another era
that once was. As L. D. Alexander, one of the Good Ol' Boys, says:

People got to where they didn't want to join up any more. Can you imagine that? They didn't want to be Knights of the White Magnolia. . . . They turned around and stabbed their granddaddies square in the back. . . . Little by little the lodges just sorter dried up. Nobody wanted to join. No new people. Jesus, but we was big once, Lonnie Roy. Hell, there was governors and senators that was Brother Knights. We had con-ventions and barbecues and parades. Took over a whole hotel there in Tulsa. Gawd, and it musta been somethin' to see. Bands playin' and baton girls a-marchin' along. The Grand Imperial Wizard of the brotherhood rode in a big open carriage pulled by six white horses, and up above the whole shebang was this great old big blimp towin' this here banner sayin' TULSA WELCOMES THE KNIGHTS OF THE WHITE MAGNOLIA. Gawdamighty, now wasn't that somethin'?

LONNIE ROY: Jeeezus, you mean to say that with all that great stuff, that people quit joinin' up?

L. D. ALEXANDER: That's right, Lonnie boy.

And L. D. was right, "people quit joinin' up." In many ways, as Harvard sociologist Robert Putnam has chronicled in *Bowling Alone*, the passing of this version of "joinin' up" is yet another loss of community. True. But it is also a backhanded tribute to the automobile, the television, and the computer, which provided new places for men to hide. Neither the service clubs (which were mandated by the Supreme Court in 1987 to open their doors to women—an event that postponed their precipitous fall) nor most of the fraternal lodges (which kept their doors shut and found no one a'knocking) could stop a tectonic shift in male clustering. Young men were going elsewhere.

Baby boomers like different music, they don't like dancing to Glenn Miller, and they don't sit still to eat. They don't want elaborate initiation rituals and parades. They don't like to play dress-up and act-out. Fraternal lodges were places for cultivating a sense of belonging when men got together to drink beer, smoke cigarettes, and get away from the wife and kids. They were places for community when community meant *getting out of the house*. Now young men want to get back into the house and spend time with the wife and

kids, who have also been out of the house all day. They want dress-down Friday and down time in the home entertainment center—the modern den.

As one wag commented, the animal-kingdom versions—elk, moose, and eagles among them—are faring better than their human counterparts. The lodge is now the endangered species. Such a paradox: the very things that made them historically strong—their elitism, their predilection for secrecy, their corny theosophy, their reverence for tradition and ritual, and especially their hideout status—are now destroying them. Men may still want a room of their own but, if so, they are finding it in the car, in the chat room, strip club, cellar, and maybe, strangely enough, back where the Masons first joined together—at church and on the job.

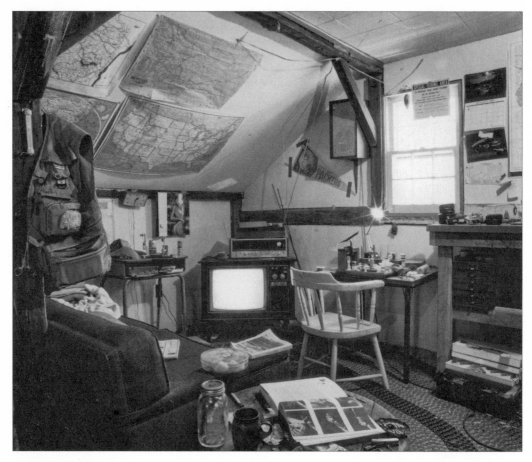

Pete's place, New Jersey

4. The Snuggery

FATHERS, SONS, AND TRAINS

In the Victorian country house there were a number of gender-specific rooms. Milady had her *apartment,* to which she and her chums "withdrew" after dinner. She also had a *boudoir* or a private room adjoining the bedroom, which men never entered without permission. And she had a *morning room* or *breakfast room* that was open to guests and family of both sexes. As well, she had claim to the *drawing room,* as it was the launch platform for the promenade into the dining room.

By contrast, the gentleman had a few more rooms: the *library,* the *billiard room,* a *gentleman's room* (for business transactions), a *study,* a *smoking room,* a *gun room,* and a *snuggery* (where he could do as he pleased with his hobbies). While women hesitated before entering most of these rooms, they positively stayed away from the billiard room (too much smoke) and the snuggery (none of her business). The snuggery was what the male had for a boudoir.

When you think about it, the private space of women has to do with socially constructed modesty. In these rooms, she's not yet

Jakie's jigsaw puzzle, North Carolina

properly dressed. However, most of the male preserves are founded on claims of chivalry. On the surface, his rooms free him from the "remember-there-are-ladies-present" responsibilities. On a slightly deeper level, it's clear that he is in there to hide. Her rooms are for her getting prepared for him. His rooms are for him getting away from it all, including possibly her.

Of course, along with contemplation, these rooms also allowed him to store and inventory all his personal stuff. Recall that, as John Stuart Mill clarioned in his *The Subjection of Women* (1869), the married Victorian woman had almost no property in her own name. Should she ever leave her husband, she went empty-handed. Even their children were legally his. In *Wuthering Heights*, Heathcliff gets all the stuff of both the Earnshaws and the Lintons by cleverly marrying strategic women in the inheritance chain. Those he can't marry, he marries off to his son. Read John Galsworthy's *Forsyte Saga* and see what happens to Fleur after she flees her smarmy husband, Soames. She's lucky she still has her coat.

This what's-yours-is-mine structure, with the male hogging the good space, was literally built into the architectural premises of the Victorian house. The rooms themselves were designed to limit contact between the sexes and to assert male dominion. Even the servants had gendered spaces. The maids slept three stories up in the attic, and the butlers were one flight down in the basement. To make sure the servants did not dally, separate staircases were built, with the butler's room monitoring the male servants and the housekeeper's room supervising the females. These staircases were called the "men's stairs" or "bachelors' stairs," and women used the "young ladies' stairs." Only in the so-called "servants' hall" could both male and female servants spend time together.

But what of the male-only space in the post-Victorian home? Where are the gun room, billiard room, gentleman's room, smoking room, study, and snuggery in Suburbantown USA? These scattered preserves of the Victorian country house have essentially evolved into two rooms just for men: the den and the workshop. The den—the library until the late nineteenth century—has all but disappeared, having been taken over by the family entertainment

Top of Tre's barn, New Jersey

center. The workshop, however, is still a place for a guy and his tools. But even that, as we will see later on, is at risk.

What you see in this photograph is unique. It's a vestige of the snuggery, the place for the man and his hobby. Usually this dedicated hobby room is in the basement or out with the car, but the snuggery space shown here has been removed from the house and is in a detached barn. The lucky occupier of this space was told by his wife that "all activities practiced in the barn are those banished from the home."

Knowing this, we have an interesting case of what might be called ethnological ontogeny recapitulating phylogeny. For the space here holds all the various Victorian male spaces in one room. There are some books from the library, a desk and chair from the gentleman's room, a few trophies and pieces of sports equipment from the gun room, a banner (for God, for country, and for Yale) from the study, and some team pictures and a cigar box from the billiard room.

But it's that model train in the middle that sets this room up as a modern snuggery. And why should a child's toy be so important to a full-grown man? Is this a case of arrested development or something more intimately connected to the need for separation? Let me explain from my own circumstances.

At Christmas 1952, when I was nine years old, I got an electric train like the one in this snuggery. The train came to me not under the Christmas tree, as the ads had shown. The only things under the tree were the empty boxes. The train was down in the cellar, in a part of my dad's workshop. My dad had stayed up most of Christmas Eve to assemble it. The main switching yard for the rolling stock was on a table next to the washing machine (the beginning of my mother's space), then the main line ran out along the side of his shop, through a bin that held lumber scraps, then up an elevated trestle past the drawers holding his Mechano pieces (a toy from his youth consisting of metal brackets and braces that were bolted together like Legos), then leveled out on his workbench and ran about ten feet past his neatly stored tools before circling back.

The locomotive was jet black, and if you put a pellet into the smokestack, it "belched" a little smoke. It had a whistle that occasionally

worked. Down at the switching yard near Mom's laundry was the transformer. That's where I spent most of my time, jamming the cars together to see if the knuckle coupler worked at high speed.

In the rail yard, where the cars were coupled and uncoupled a thousand times on that Christmas morning, was a particular rig that I distinctly remember. It was a cattle-loading platform. Here's how it worked: You drove the train so that the cattle car was up next to this platform. The plastic cows waited patiently. You flicked a switch somewhere, and the slightly tilted metal floor vibrated under the cows' plastic feet, causing them to gradually inch aboard their car. Then you could drive them around, through the lumber scraps, up the trestle, across the edge of the workbench, past the screwdrivers, and then back again. I forget how they got unloaded.

But I remember how soon I was bored by the whole operation. Not just the dumb cows, but the whole world of railroading. By New Year's Day I had pretty much had it.

And I'm sure you know why. My dad really loved the train. It was from the Lionel Corporation. Although it was mine in name, and definitely not my sisters', in reality it was his. He was forever tinkering with the layout. He and I didn't have any of the same plans. He liked to lay track. I wanted more locomotives. And what I really wanted to do was open up gaps in the trestle so that the train could plummet to the cement floor. I never did that. Instead I sent the train down the slope past the Mechano drawers at full throttle so it would derail in the woodpile.

Now that I'm a little older than my dad was when he bought me the train, I'm aware of what disappointment he must have felt. Only now do I appreciate the importance of his installing it in his protected space instead of, say, in my room, where it would have never been assembled, just tossed on the floor.

To the generation that had come back from World War II, the model train carried profound meaning. While only the rich could afford "electrical novelties," as they were called in the 1930s, by the 1950s the prices had fallen, and the wartime factories could not be retooled fast enough to produce these objects for mass consumption. The coupling of electricity and toy then was far more

transformative than the current coupling of computer chip and toy. Which do you think was more exciting to see barreling down on you: a giant locomotive puffing smoke or some cartoon character with a snarl?

During the war, Lionel had used its train-making equipment to build various objects like the compensating binnacle, pelorus, and alidade (all of which were used by the navy to chart positions and duly advertised in boys' magazines to show that Lionel was true blue). So clearly men in their midlife, like my dad and the inhabitant of this pictured snuggery, found in these trains the out-of-reach magic of their own childhood.

Ad for Lionel trains, *National Geographic*, November 1950

But that wasn't the only allure. The real selling point, or the "Unique Selling Proposition," as they said in the advertising lingo of the 1950s, was the very thing that didn't happen between my dad and myself. In buying this model train, my dad was going to find not just his lost boyhood but his present son. We would hide together. I have no idea if my dad ever saw this ad in the *National Geographic,* but we subscribed, and so perhaps he did.

There I am, in the upper right, looking glumly out the window while my dad was reading the paper. Below is the wonderfully flattering headline (for me, at least): "One of the Best Ways Men get to know Each Other."

> How well do you know your boy?
> Does he really know you? He's growing fast.
> Is he growing away from you? Shed those years,
> Come down out of the clouds and get

down on the floor with your boy and Lionel Trains
this Christmas. It will make him happier and
you a lot younger. Lionel Trains bring a man
and boy closer than anything in the world.

If that prose didn't get a dad to put down the paper and hightail it to the dealer, nothing could. A few years later, under the same headline, this slightly revised text:

Start a new comradeship this Christmas, with your boy and LIONEL TRAINS. Share with him the matchless thrills of railroading . . . and the deep satisfaction of building a bigger and better railroad. See Magne-Traction at work . . . the exclusive feature that makes Lionel locos go faster, pull more cars, climb steep grades.

As with the previous ad, the mid-page picture has dad and son joined at the transformer. In many of the ads we see the boy wearing exactly the same garb as the dad—even a coat and tie! Alas, however, in my particular case, the mid-page picture—the "paternal bargain," as it was called in Lionel marketing ("We'll build it together!")—was never achieved.

But it was for thousands of others, perhaps even for the owner of the train in the barn snuggery. And that's not because Lionel had the best trains—American Flyer and the trains from German companies like Marklin did—but because Lionel had the best marketing. And that marketing came from a genius, Joshua Lionel Cohen (changed to Cowen in 1910, but the middle name Lionel was British-sounding and is still the company name).

Whereas most other train makers sold their product for what it was, namely, a model railroad, Cohen sold it for what it could do, namely, bring Junior into the family, and especially closer to Dad. After repeated ads, Cohen "owned" the territory under the Christmas tree. In fact, when he died at eighty-five in the mid-1960s, the *New York Times* obituary noted that his trains had become "the third wing of Christmas, along with the evergreen tree and Santa Claus." It may be sacrilegious to suggest that the under-the-tree train sets became a secularized celebration of the holiday, either replacing or

complementing the crèche scenes depicting the birth of Jesus, but it is nonetheless true. Restoration Hardware, no slouch in marketing allusions, offers a battery-operated train for twenty-nine dollars whose only function is as Christmas decoration.

Cohen got his trains under the tree by promising to induct the rambunctious and pouty boy into the brotherhood of men. In a never-ending barrage of full-color November advertising, Lionel promised that, bought for Christmas, its trains would teach boys the importance of electricity (the catalog for 1924 says railroading "will give you a knowledge of the principles of electricity . . . help you solve problems in traction and transportation . . . knowledge that will be of inestimable value to you when you grow to manhood"), how to plan ahead (by saving money to buy more trains and by not crashing them into things or running them off the rails), increase manual dexterity (presumably by using tools to change the layout, not by goosing the transformer), and generally keep the dreaded Juvenile Delinquency at bay. Like Boy Scouting, team sports, the World Book Encyclopedia, Teddy Roosevelt, savings bonds, Jack Dempsey, and a paper route, a Lionel train was on the track leading into the Region of Responsibility.

These Lionel ads rarely used photographs to make this point. Instead they relied on the best illustrators of the time (Raymond Thayer, Fernando E. Ciavatti, Jon O. Brubaker, Bertram Goodman, to name a few), and the images they created are just an inch shy of dream life. The trains are almost always cast in silhouette or else are hard-charging straight at you. They are never seen as model trains. They are the stuff of comics, Saturday matinees, or dime novels, in the service not just of thrills but also of maturation. If Mom and Sis are pictured, they are over in the corner, amazed that Junior can control such power. Junior is often wearing an engineer's hat. Dad is close at hand.

Needless to say, those days are over. The Lionel Corporation has been dying a particularly ghastly death. In the 1960s it fell into the hands of Joshua Cowen's grand-nephew Roy Cohn, the particularly sleazy crony of Senator Joseph McCarthy. (I wonder how he reacted to the body copy of the ad mentioned above: "Start a new comradeship

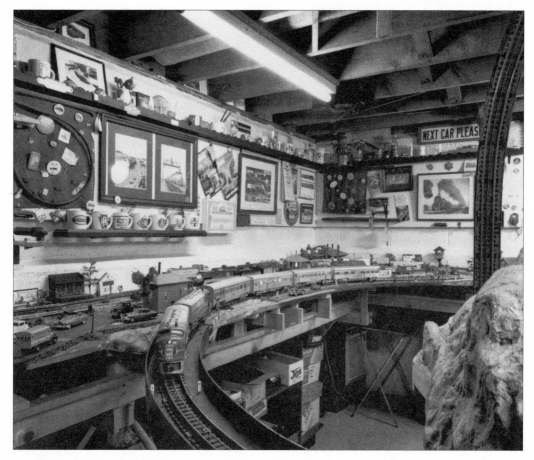

Dick's train room, New Jersey

this Christmas, with your boy.") The company was sold to General Mills (the maker of Hamburger Helper and Lucky Charms, for goodness' sake!), which then sold it to a real estate conglomerate that now uses it to service the middle-aged train enthusiast. Alas, what was once the world's largest toy company went totally off the tracks in 2004 when it couldn't pay a $40 million court judgment for stealing a rival train's blueprints (Pereira and Smith).

There are still trainiacs, for sure—approximately 300,000 hardcore train hobbyists in the United States, who spend about $500 million on their passion. Grown men still use their sons as a cover for their own hobby, but the jig is up. Kids today prefer video gaming to driving trains into piles of lumber scraps. Every once in a while there is a train like the Hogwarts Express (the magical train from the Harry Potter books) or the Polar Express (a train that goes to the North Pole) that crosses Junior's path, but for the most part it's hard to get excited about an industry that has Amtrak, losing millions a year, as its leading exponent.

That said, however, in a culture that has been chugging around the track trying to break down gender differences and single-sex hobbies, we might pause to give Barbie and Lionel their due. Maybe building houses on concrete slabs so that the basement disappears is not without its downside. Maybe, like the habitats of the snail darter and the spotted owl, the snuggery needs a bit of protection.

A few years ago Mihaly Csikszentmihalyi, a sociologist then at the University of Chicago, outfitted two hundred working men and women with electronic pagers, beeped them randomly during the day, and asked them to write down where they were and how happy and creative they felt. He was interested in what he called the "flow" of experience and how sometimes adult humans achieve a concentration of time and energy that elevates consciousness and delivers a sense of transcendent peace. It's what Abraham Maslow called a "peak experience" but without all the quasi-religious folderol. Flow is happening all the time. Csikszentmihalyi wrote about this joy in the best-selling (at least for academic books) *Finding Flow: The Psychology of Engagement with Everyday Life*. He found that women were

the happiest in the bathroom, where they could forget the kiddies and finally concentrate on just themselves. They were the most un-easy in the basement. You need not be told the part of the house where men reported they found the most contentment. Stand at the top of the cellar stairs and you can almost hear the happy hums and choo-choos.

Bachelor's bed, Maine

5. A Room of His Own
TWO OF MAN'S BEST FRIENDS

Poor Oedipus. In the midst of other woe, our ancient hero stumbles across the Sphinx, a winged lion with the head of a woman. This she-beast sits at a crucial crossroad and asks passersby a riddle. If they can't answer, she eats them. All around her are piles of skulls and bones. Here is the riddle: Who in the morning walks on four legs, at midday on two, and in the evening on three? Although Oedipus was profoundly confused about *who* he was, he certainly knew *what* he was, and he says, "It is man!" (Crawling baby—adult—old man leaning on a cane.) Poof! The Sphinx had to throw herself down from the cliff, and a stumbling block is cleared from the roadway of life. Things get worse for Oedipus, but that's not our concern.

What seems to be at the heart of the riddle is that human life—specifically life for men—is something of a conundrum. A man's life seems to start and stop in the same place, rather like the ancient symbol of the *ouroboros*, or the snake with its tail in its mouth. One might imagine that a man's life begins at point A and then ends far away at point Z, but it instead seems to circle back to point A.

A woman's life, on the other hand, seems to be more directional as she moves into her children, into the world, in a way the man does not. That may be a sexist observation, but the male life, as the Sphinx recognizes, is a lonely one. Consider these famous lines from Shakespeare's Seven Ages of Man analogy:

> And one man in his time plays many parts,
> His acts being seven ages. At first the infant,
> Mewling and puking in the nurse's arms;
>
> . . .
>
> Last scene of all,
> That ends this strange eventful history,
> Is second childishness and mere oblivion;
> Sans teeth, sans eyes, sans taste, sans every thing.
>
> *(As You Like It,* II. vii)

Or this from William Wordsworth a few centuries later:

> Shades of the prison-house begin to close
> Upon the growing Boy,
> But he beholds the light, and whence it flows,
> He sees it in his joy;
> The Youth, who daily farther from the east
> Must travel, still is Nature's priest,
> And by the vision splendid
> Is on his way attended;
> At length the Man perceives it die away,
> And fade into the light of common day.
>
> *(Ode: Intimations of Immortality,* 67–76)

Like a character (a male, incidentally) in one of those M. C. Escher prints who we observe going up the very stairs he is also going down, the masculine life seems more circular than does the feminine one. Not by happenstance is existentialism a worldview promulgated primarily by men.

This is not to say that the male has an easier or a harder time of it. Far from it. Observe the opprobrium reserved for the woman who lives like a male, i.e., the nonreproducing female. The term

spinster came into common use during the early nineteenth century when the thankless task of spinning cloth had been pushed off to unmarried women as a way for them to earn their keep in the home. She was not doing her biological job, so she got this domestic one. Contemporary use of the word conjures up a mental image of a childless, frumpy, middle-aged woman who is somewhat depressed and is secretly longing to be expansive—that is, to bear children. She is usually alone, or living with an extended family. She is considered a societal outcast living in the shadow of others. She makes those around her uncomfortable. A synonym: old maid.

To see how we view the spinster, look at movies from *Now Voyager* (1943 Bette Davis), to *The African Queen* (1951 Katharine Hepburn), to *Fatal Attraction* (1987 Glenn Close). In each case the single woman is viewed as incomplete. The stereotype admits little variation. The female needs to reproduce to find space: no man = no children = no social place. The term *bachelor* doesn't have the same negative connotations. *Bachelor* alludes to a healthier sexuality, more normal than the implication for the unmarried female. Only in a few film portrayals has the male stereotype been interpreted negatively (the fussbudget Felix Unger in the 1968 film *The Odd Couple*, for example). More typically, movies such as *The Bachelor and the Bobby-Soxer* (1947) and *Bachelor in Paradise* (1969) reflect our unmarried male stereotype. Think bachelor pad.

And that is exactly what we are looking at here: *a bachelor pad.* Not quite what most of us have in mind but probably closer to the truth than what we saw in the *Pillow Talk* movies. What you see on the next page is a single old man's room. It looks strangely like a young man's room. The occupier happens to be a lifelong bachelor. Like a child, he is being cared for, as the neatly folded laundry on the bed indicates. He sleeps in his pajamas, and if the empty bedside table is any indication, he doesn't do much reading. Instead, rather like an adolescent, he wakes and sleeps in tune with his television set. Doubtless, this Cyclops is a good friend. On the wall and table are smallish pictures of his family, and if you look carefully you'll see that he also has hung his war medals next to the lamp.

Unky's room, New Jersey

It's not a very happy room. In fact, when I look at what's there I remember adolescent angst. I can almost hear the Beach Boys' "In My Room." In this song the usually carefree Southern California boys are admitting the private melancholy of "dreaming and scheming . . . crying and sighing" that can only happen when you're alone, in your room. The exuberance of "All Summer Long," "California Girls," "Fun Fun Fun," "Good Vibrations," and "Little Deuce Coupe" is no more. Surf's definitely not up.

The particular image that carries this melancholy is hung over the television set. That's Lassie. The version on the wall happens to be paint-by-the-numbers and it would be nice to think it was painted in the old man's youth. Still, what is a dog beloved by children doing in the room of an old man? If he were younger and heterosexual, there would be pinups of young women. But now he is old and his choice is more varied. An ancillary question might be, would this dog be in the room of a spinster? Wouldn't she more likely foreground a lost love or a family member as the picture over the television set? What I am asking is this: is there any possibility that, when all is said and done, the dog *really* is man's best friend?

The dog is the only animal that man has successfully befriended. At first glance the explanation seems obvious. In early times women tended the home fires, literally. They were homebound not by lack of a danger gene but by the simple fact that birthing, nursing, and baby-tending enforced socialization. The male, on the other hand, was able to move around, literally and sexually. He was rewarded by confronting danger, either in the hunt or in breeding. Hunting is not innate to the male; it is learned.

On the hunt, however, he had to bond with the very people he had to compete with sexually—namely, his peers. This must have been difficult, but it was necessary because hunting was far more successfully done in a tribe than alone. Lionel Tiger, the Charles Darwin Professor of Anthropology at Rutgers University and author of *Men in Groups* and *The Decline of Males*, coined the term *male bonding* to describe this enforced tribalization. And it's also here that the dog enters the bonded circle of masculine friendship.

This relationship seems to have begun millions of years ago as wild dogs (descended possibly from the gray wolf) started to cross paths with humans. Man and wolf learned that they could not only hunt together but also keep warm together—exchanging fire and fur. Over thousands of generations, wild dogs changed in their appearance much as man did.

By the time man learned to keep flocks of sheep for his food, he also discovered a new way in which his dog could help him. Here a crucial step in co-evolution was taken as man learned he could breed the dog to give up his instinct for killing in order to be cared for. Once the dog learned this difficult lesson, he became very skilled at protecting his charges. From watching sheep, it was an easy step to watch family, home, and property. Little by little, in these ways, dog became "man's best friend."

Ah, but there's another version. Man is dog's best friend. Raymond Coppinger, professor of biology at Hampshire College and coauthor with Lorna Coppinger of *Dogs: A Startling New Understanding of Canine Origin, Behavior, and Evolution,* asks what if the dog chose man to be his best friend and used him to feed and care for *his* family, home, and property? The problem with the standard wolf-into-pet-dog story is that it can't be reproduced in controlled circumstances. So perhaps wolves chose domestication by hanging around man and slowly training him to protect the dog in exchange for doing some light housekeeping. It's natural selection, all right—but the dogs did it, not the people.

Let's split the difference and say that when two species live together for a long time, each usually influences the genetically conferred qualities of the other. People may have selected preferred abilities in the dog, but dogs too may have fostered their favorite qualities in people—not, of course, deliberately but simply by giving people who used and tended them a better chance of surviving than people who did not.

This symbiosis has become so ingrained in our culture that trained dogs are now adopted members in the Family of Man. Or is it that unruly people have come to behave like trained dogs? Gives

you paws for thought, doesn't it? Anyway, just as Lassie is hung over the television, dogs are all over our lives. Think Rin Tin Tin, Old Yeller, Benji, Buddy ("Air Bud"), Spuds McKenzie, Asta (in *The Thin Man* movies), Hooch (of *Turner and Hooch*), Pongo and Purdy (*101 Dalmatians*), Jerry Lee ("K-9" dog), Enzo (*My Dog Skip*), Beethoven (movie star St. Bernard), Eddie from *Frasier*, the Taco Bell Chihuahua, to name just a few. It's no wonder that *Dogs Playing Poker* is one of the country's all-time best-selling decor items (usually to men) and that some of our most beloved characters are totally make-believe dogs: Snoopy, Scooby Doo, Astro (on *The Jetsons*), even the Pets.com Sock Puppet.

And it's not just entertainment that has gone to the dogs. Consider politics. Harry S. Truman once remarked that in Washington, if you want a friend, get a dog. Franklin D. Roosevelt used his Scottish terrier, Fala, as a weapon. Republicans had accused him of sending a navy destroyer, at taxpayers' expense, to pick up the dog from a remote island. "They have not been content with attacks on me," FDR said. "They now include my little dog, Fala. Well, of course, I don't resent attacks, but Fala does." As vice-presidential candidate in 1952, Richard Nixon persuaded voters to overlook accusations that he was helping himself to campaign funds by talking about his new spaniel, Checkers. And who can forget the aptly named Buddy, Bill Clinton's chocolate Labrador, who was 100 percent loyal even when his owner wasn't. We have learned that whenever a modern president is in trouble he goes into the doghouse and out comes the dog. Every time Dubyah makes a boo-boo, out comes Spot the spaniel. And if it's a biggie, then look for Barney, the Scottish terrier.

But no dog holds a bone to Lassie. Although it's been forty years since the TV series was canceled and sixty years since the movie *Lassie Come Home* premiered, more than 25 percent of dog owners surveyed by Iams (the pet food with the revealing name) said Lassie was still their favorite dog star. As is often the case, celebrity overload finally set in, and Lassie is in decline. Ask a baby boomer about Lassie and she or he will most likely give you a rendition of a famous routine by a now-forgotten American comedian, Andy Andrews:

Did you ever notice how Timmy would talk to Lassie? "Lassie, Lassie, go get Mom and Dad and tell them that I'm down by the beaver pond and I'm stuck under a pine tree. It's a loblolly pine tree, not the long-leaf variety. They are on the north forty, Lassie. Not the south forty, the north forty, on the red tractor." And Lassie would take off. "Woof!" That would be all Lassie would say but Ruth would say, "Oh, my God, Paul. Timmy is down by the beaver pond stuck under a loblolly pine tree."

(quoted in Purgavie, p. 10)

As is fitting in the case of a legend with nowhere left to go, this subversive parody made its way into the Australian movie *Babe* (1995), where Lassie, ironically named Rex, is a deaf sluggard and plays the heavy to a pig.

Such harsh subversion works only because the underlying fable is so well known—in fact, too well known. What is less well known is that the Lassie story starts abruptly in the December 17, 1938, issue of the *Saturday Evening Post*. A struggling screenwriter named Esmond Knight produced a potboiler called *Lassie Come Home*, about a young Yorkshire boy, Joe Carraclough, who can't understand the ways of his taciturn father. More specifically, he can't understand why his dad has sold the kid's collie to the dotty dog-loving Duke of Rudling. In truth, it's because the dad has been laid off from his job and is too embarrassed to tell his son. Father and son can't communicate. They are hiding from each other.

Once sold, however, Lassie keeps returning home, and father and son must deal with the fact that "a deal's a deal," no matter the extenuating circumstances. The mother is almost entirely out of the loop, wondering why her menfolk are so distant from candor. Why can't they communicate?

When the duke takes Lassie up to Scotland, she escapes the control of the evil kennel master (somebody has to play the dirty-dog role) and makes what will become a genre in itself—*the incredible journey home*. Lassie's pretty well beaten up by her return journey, and father and son take her in. The duke comes by looking for his dog, sees what a mess she's in, understands that after such a journey the dog really belongs with the Carracloughs, and pretends to

mistake Lassie for some other dog. "I never owned this dog," he lies. "'Pon my soul, she's never belonged to me. Never!" Father and son exchange meaningful glances. The father never has to lie, the son learns to respect the code, and the mother is a little baffled that men have to engage in such charades. All's well that ends well as the duke offers the dad the kennel-keeper job—but not before his wages are negotiated upward by the savvy mom, who knows that it's swell to have a nice moral code, but first you need to eat.

When MGM made this short story into a movie in 1943, the male bonding took a backseat to the pluck and determination *not* of the Yorkshire men but of the dog. The story is told from Lassie's point of view as she goes from one heartrending moment to another. Shot at, beaten, adopted, befriended, cursed, abandoned for most of four Technicolor reels, Lassie finally makes her way back home, allowing young Joe to befriend not his dad but the duke's granddaughter, played by Elizabeth Taylor. In the last scene, the young'ns are bicycling through the duke's estate followed by Lassie and her young'ns. Presumably Lassie's gotten hitched and is going to make some pups a good mum. (No matter that Lassie in the movies is always played by a well-disguised male—female dogs tend to shed while in heat.)

Allegedly, Louis B. Mayer wept during the screening of the movie and commanded the studio to fire up a massive publicity campaign. A star, he famously said, is born. And he was not referring to Ms. Taylor. Seven movies later, the property that the studio had bought for $10,000 had earned $285 million, and there were suggestions that Lassie's barking head should replace that of the roaring lion in the MGM logo. She was called by one critic "Greer Garson in furs," but the studio, rather like the evil dog handler in the short story, mistreated her by overexposure. When, in 1951 Lassie's owner-trainer Rudd Weatherwax tried to collect $17,500 that the studio owed his dog, MGM settled the debt by surrendering the rights to Lassie's name.

Had he been still in charge, Louis B. Mayer would really have wept. For Lassie's new kennel masters made another fortune when, starting in 1954, CBS's *Lassie* began its nineteen-year run, third-longest of any dramatic series in TV history. Presumably, it was during this time that the occupier of this lonely bedroom made friends with

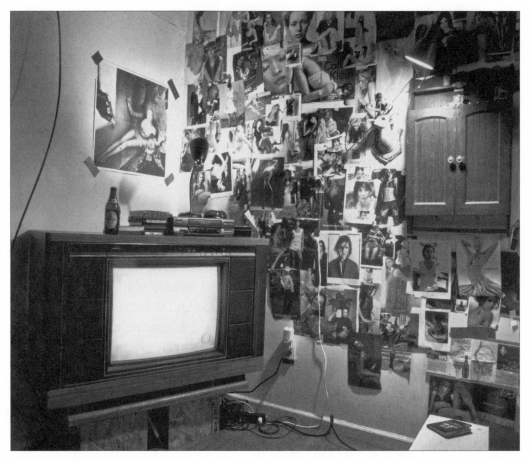

Matt, Eric, Joe, and Beau's girl wall, Rhode Island

America's most famous dog, painted him (or her, depending on the collie), and hung the painting on the wall.

To the best of my knowledge, in all of Lassie's future incarnations as movie sequel, as radio and television show, and a master franchisee of all dogdom, the father-son motif has never been resurrected. Usually, the triad is Lassie, Timmy, and Mommy, and the preferred medium of telling is, appropriately enough, through the machine below the painting, the never-blinking eye, the TV. More than half a century later—375 years in dog time—Lassie remains the most enduring, most winsome, most recognized, most intelligent, most beloved, most profitable animal in the universe. Whenever there was someone to rescue from burning barns, swirling rapids, murky swamps, dangerous ledges, hazardous caves, or crumbling mine shafts, a Lassie has been there. Whenever there was an ailing farm to be saved, a marauding wolf to be fought, an injured child to protect, or a cunning desperado to be vanquished, a Lassie has cocked her head knowingly and dashed to it. Not by happenstance did Lassie often end her TV show by shaking hands with the person she had just rescued.

Although both Groucho Marx and S.J. Perlman have been credited with the quip "Outside of a dog, a book is a man's best friend. Inside a dog, it's too dark to read," the fact remains that had the Sphinx asked, "Who's man's best friend?" there would not have been such a pile of skulls and bones. The answer is easy. If dogs and men continue to spend time doing what they both do, and if evolution continues to bring them closer, it may be that the picture of Lassie and the television will merge. A survey by the American Kennel Club (AKC) and the Iams Company showed that almost half of the dog population currently watches the tube in order to be with their human compatriots. In fact, 87 percent of those surveyed said their dogs curled up next to them or at their feet when watching television (PR Newswire, January 14, 2004). Perhaps they are training us for a new season of reruns.

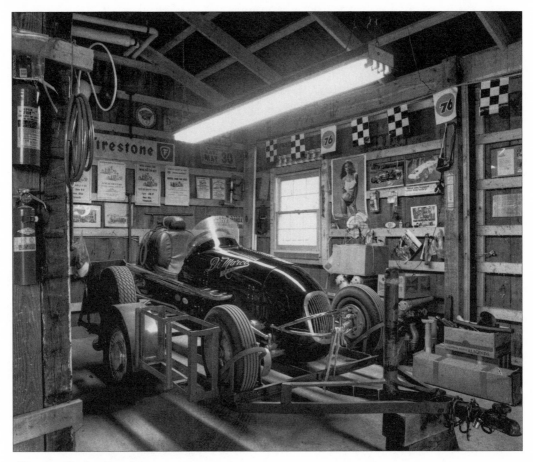

Al's car barn, New Jersey

6. The Garage

CAR AND CALENDAR

Anyone who says men are not as sentimental as women needs to observe a middle-aged male looking at this image. Check around his eyes for telltale puffiness. Maybe he feels the way a woman feels when she looks down into a perambulator and sees a cooing baby clutching a rattle. What they both see is something small and beautiful, and what they both feel is a yearning to tinker. You could put this car in the guy's living room and he wouldn't miss a beat. If that is hopelessly demeaning to men, so be it. My best friend has a 1952 MG grille mounted on the wall of his den just like a lion's head and it makes perfect sense to me. Tim Allen's wife on *Home Improvement* may not understand why he skedaddles out to the garage to be with his hot-rod car, but I can.

Even if they don't know what direction a screw turns and can't remember which is the nut and which is the bolt (and I often can't), most men know that this object, heroically lit and on the trailer ready to spit dirt, is the magical stuff of boyhood dreams. Technically, it's a Midget race car. In many ways it is the archetypal sports car in that

Start-finish, New Jersey

before anything else it looks *sporty*. It's a metonym of speed and escape. In a racy way, however, compared to modern speedsters, it's little more than a souped-up go-kart.

The Midget comes out of the Great Depression, yet another object of American garage lore, rather like the airplane. As the Wright brothers tinkered with their bicycle parts to make an engine that would take off from the ground, so the Justice brothers—Ed, Zeke, and Gus fiddling in their garage in Paola, Kansas—shaped a car that seemed to have no purpose but to look and go real fast. The Wright boys and the Justice boys both did their dreaming in a new version of old space: the *shed* attached to the barn, intended for farm use, was becoming the *shop* for mechanical tinkering, which would then become the *garage*, for solitary escape.

The Justice boys knew they were onto something. They moved to Southern California, where they built a slightly more streamlined Midget and started racing it on the beach. If Detroit was the place where cars were mass-produced and if New York was the place where they were advertised, then California was the place where they were imagined. Here cars were set to music. The "Little Deuce Coupe" of the Beach Boys was in our yearnings long before we ever saw it on the road.

California was also where the internal combustion engine entered the American dream via film. The Midget was the car refined by famed car builder Frank Kurtis to become the rocket driven by Clark Gable in *To Please a Lady* with Barbara Stanwyck. As well, it was handled by Mickey Rooney in *The Big Wheel*. Strange, but I can't look at this photographed garage and not expect to see Andy Rooney poking his head in to ask if she'll be ready to fly at the Carvel Race. If he gets his grades up, his father, the judge, has told him that he'll be able to work in the pit—and won't that just impress Judy Garland.

Of course it's not Andy Rooney but Andy Hardy I'm seeing, and for those who grew up on the fourteen or so films made by Louis B. Mayer between 1937 and 1946, this garage is somewhere in that quiet, tree-lined, white-church world of Judge Hardy and his family. The town of Carvel was the next town over from Bedford Falls, where George Bailey (played by Jimmy Stewart) lived in our

imaginations. No one who saw the look on Andy's face when he got his '32 Ford will forget the love and attention he lavished on it.

I suppose the generations after me saw the look in the eyes of David Nelson when he got *his* car, or Spin and Marty of the Mickey Mouse Club when they got theirs, or, well, hasn't every generation had a fictional character in film or television who gets there first? Or has it? Perhaps the reality of this boy dream is short-lived, since the progressive complexity of the automobile has made it almost too complex for anyone other than precocious Clicks and Clacks to tinker with. In a modern garage we would see only racks of those artificial heart machines with keyboards attached—the tools we use today to work on the modern engine.

But the dream of escape still survives. As the California hot rod returned to Detroit to reappear as the muscle car (and now, I suppose, as the PT Cruiser and the Prowler from Chrysler), the Midget made its way back as the jaunty two-seater. Along the way, cars like the Midget got mixed in with the English roadster and the driver in the flying silk scarf, but if you will look at what's now coming out of Japan you'll see that the open cockpit runabout is having yet another resurgence.

Perhaps the Midget is never far from the masculine imagination because it captures the essence of male separation and dreams of glory. There's room for only one person in that cockpit. The Midget grew up to become the Offenhauser-powered race car of the Indianapolis 500, at least until the 1960s when race car engines—reinvented by Colin Chapman—began moving to the rear, and the front ends started looking like something dredged up from of the land of the coelacanths. Modern race cars have long since left the garage imagination and entered the computer programs and wind tunnels of rocket scientists. Such beasts certainly don't inspire nostalgia. You couldn't tinker with them even if you tried. They don't run on nitro; they are powered by tiny Intel chips.

The Midget has returned to its roots as a dirt track, state-fair, embankment-climbing hellion. Alas, this little wedge on wheels has grown a roll cage and sprung aerodynamic wings—twenty-four-square-foot inverted airfoils mounted on top of their cockpits for more

Mazda Miata ad, 1990

down-force to keep it from flipping. It even has a new name: *supermodified*. You can watch it on TV, where these race cars have become rather like professional wrestlers—a highly entertaining but fraudulent travesty created to entertain by tipovers and flips.

The garage in this picture is a gallery of lost causes and captured memories. One of the *New York Times*'s most popular archive photos is a 1932 photo of an Indy Midget swinging through the curve with dirt flying and the goggled driver almost in our laps. While women may gather porcelain figurines for the coffee table, men will display die-cast models on the desktop. Really successful men collect these cars and even race them on weekends, a hobby few women appreciate because they rarely looked into a dream garage like this and felt those feelings.

Should you wonder about the potency of such feelings, have a look at this advertisement for the Mazda Miata.

The ad image is an almost perfect rendition of the Midget photo. There, stage center, lit from behind like a haloed angel, is this thing in your garage. The maudlin text below the icon makes it clear that all this was/can still be yours:

97

It was one of those summer evenings you wished would never end, and the whole neighborhood turned out to see your new car.

You answered a million questions, and everyone sat in the driver's seat. They went home long after sunset.

In an interesting kind of temporal dislocation, the "you" is living in the past tense. This is the "you" of your childhood, the you who peeked into this garage. The last line in the copy pulls the plug. "But it was still t-shirt warm by the time the kids were in bed. So you came out for one last look." The you as observer has become the you as owner. It's yours now. This missing part of your past, this thing that always belonged to someone else in real life, is finally yours. Little wonder the car is positioned and lit like a holy relic. It's coming at you. All you have to do is grasp it.

What separates this ad from the usual automotive pitch of "car as hero" is its claim on memory. The more usual claim for sports cars is sexual. Get this car, get that girl. So the sports car is usually photographed out in the rugged countryside, the sport himself is young and virile, and the chick by his side just can't stop looking at him. In advertising lingo this is called the aspirational sell: use the product and everyone will see what a real man you are.

What is important about this Miata ad is that there is no one at the wheel and no dreamy chick flapping her lashes at the driver. His seat is vacant. You've always wanted to sit there. Now you can. Larry Kapold, executive creative director of Foote, Cone, and Belding in Los Angeles, which created the ad, says he was able to tease this ad from various focus groups. Here's how:

> Early on, whenever we'd show a picture of the car to anyone, we'd get one of two reactions. Either, it's beautiful or you know what it reminds me of. . . . We wanted to tap that feeling of a car evoking warm memories without hitting people over the head with something like a 1950's sock-hop.
>
> (Goodrich, p. 6)

Should you ever wonder why the Mazda Miata ushered forth a herd of runabouts reminiscent of the Midget (and the Anglo'd versions: the Healey 3000, the Triumph TR, and the MGTD) like the

Audi TT, the revived Nissan Z car, and the Lotus Elan, now you know. "The past is a foreign country," novelist L. P. Hartley said, "they do things differently there." Women must surely think this as they contemplate the dream life of boys being sold back to them as adults.

And while we are on that subject we might look at the other dream vision held in the amber of this garage, the calendar girl. She is now part of a genre of antique ephemera called *petrolina*, which also includes those Phillips 76 flags, the Firestone banner, and all manner of old battery signs, clocks advertising truck mufflers, license plates, hubcaps, and such precious detritus from long-gone garages and auto parts stores.

The pinup calendar was aptly named, for it was pinned to the wall. No disrespect was ever intended to the subject matter. She was never pornographic and never naked. To the proprietor she was simply part of the interior decoration of a male-only shop, but to young boys passing through she was a vision of what, if you were incredibly lucky, you could/would/might perhaps find in your future. In fact, this goddess of Tooltown was impossible to really contemplate, for staring at her betrayed your innocence. You could never properly focus. So you glanced at her and marveled, never really knowing if she was providing the calendar date for Champion spark plugs, or if she was really interested in you. She certainly seemed interested, looking you right in the eye, a little bashful.

The pinup started with the trade cards of the late nineteenth century. She was on one side of a playing card and an ad was on the other. She and her sisters then formed the so-called stiffeners that separated cigarettes in a package, and then they jumped loose to grace the postal card and finally the calendar. Each development was really an advance in printing, for as chromolithography became cheaper and printing more realistic, thanks to the photograph, the pinup became larger and larger.

Once on the calendar, the pinup appeared in three important male-only public venues: the pool hall, the barbershop, and here in the garage. You almost never hear the word *pinup* anymore. It has a charming, almost dusty connotation, like *hi-fi* or *sock hop*, that

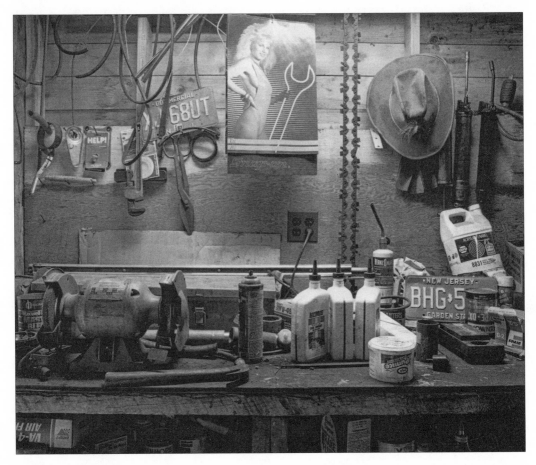

Waldy's bench, New Jersey

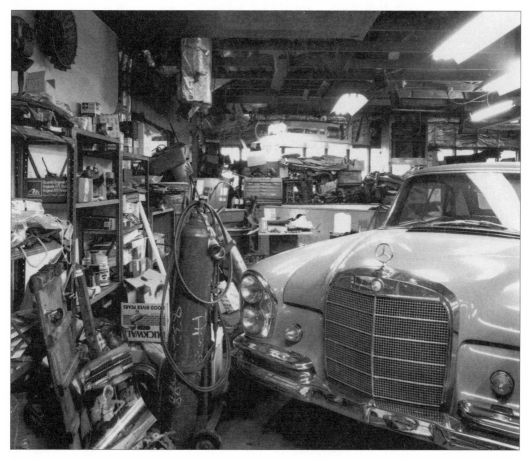

Fred's Benz, New Jersey

conjures up a more innocent time. Her heyday ran roughly from the '20s to the mid-'40s, reaching its zenith with Betty Grable winking over her shoulder or Jane Russell sulking defiantly from a bower of straw. Our older brothers went to war for her. Then *Playboy* took over and she went under the bed and inside the locker: Marilyn Monroe on that red rug.

These deities of the garage were elbowed aside not only by the airbrushed, navel-stapled "let's get dirty" playmates of glossy magazines like *Playboy* and *Hustler* but also by the non-airbrushed sorority of "let's clean it up" feminists. Snap-on Tools, which used to distribute more than a million calendars, expanded the coverage of the denim hot pants and increased the size of the blue bikini top, but to no avail. As the *Wall Street Journal* reported (Rose), they stopped not because of female complaints but because male employees were sending them back. The calendars were in bad taste.

The iconography of this magical garage has not disappeared. Rather, like so much nostalgia, it has been commodified. Go into any chain restaurant like Bennigan's, Duffy's Tavern, or NASCAR's Café and you will find yourself sitting in a booth surrounded by this stuff. And why should these items be appearing in family restaurants? Because restaurateurs have found that although women are always eager to go out and spend time sitting surrounded by tablecloths and napkins, to get men to go out and pay five bucks for a hamburger, they have to make the guys feel comfy. And nothing seems to make men feel better than sitting in a garage.

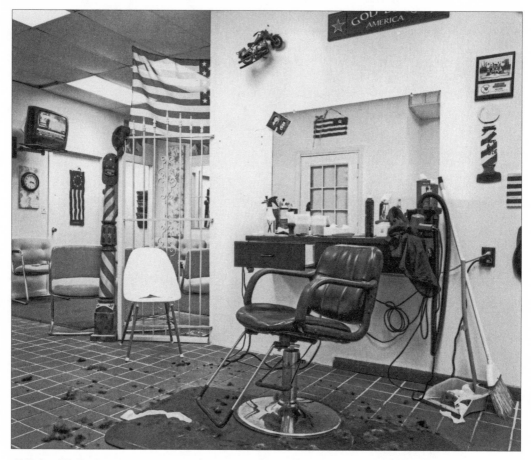

Rich's Cuts USA, New Jersey

7. The American Barbershop

"NEXT GENTLEMAN"

A barber joke from my parents' generation goes like this: A farmer goes into town to get a haircut. He patiently waits his turn. The barber says, "Next gentleman." The farmer jumps up and says, "Not so fast. I thought I was next."

To appreciate this joke one needs to understand the egalitarian nature of the barbershop. The barbershop is a place where all men—well, almost all men—are treated as equals. True, you may defer if you want a particular barber, but the standard behavior is, or used to be, this: you drop by, you wait your turn, you chat a bit, you get your hair cut, and you pay. You never complain.

As with many male hiding places, the barbershop too features rituals of initiation that set up this process. A boy's first haircut is one of the central separation events from Mom. And it is an event that seems cross-cultural. Spanish-speaking cultures even have an idiom for it: "En la barbería no se llora." No crying allowed in the barbershop.

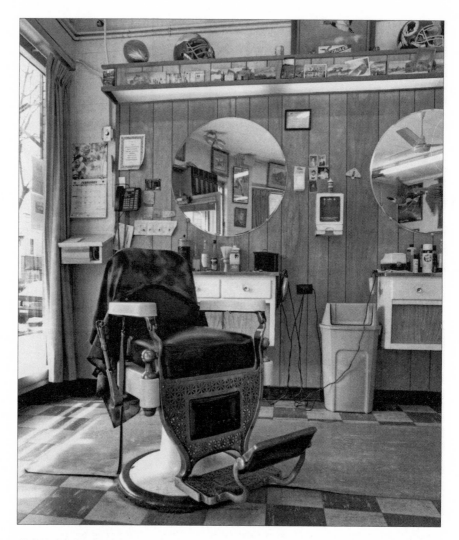

Barber's chair, New Jersey

Whereas the time at the barbershop is now about a fifteen-minute wait for a fifteen-minute haircut, two generations ago one spent more than an hour at the shop. Shave and a haircut: two bits. That's because the shave used to be a crucial part of the trip. Now, with the specter of AIDS, the shave has disappeared. And, more important, this entire space is rapidly disappearing, but not because of male neglect (as per the cigar bar) or because of female attention (as per the fraternal order). The barbershop has disappeared primarily because of the disposable razor. In 1880 about 45,000 barbers cared for a total population of about 50 million men. Today about the same number of barbers are available for about six times that number of customers. The decline has been especially precipitous since World War II. There were about 287,000 barbershops in 1950; today there are about 55,000 (Staten, p. 42).

This image was taken about halfway through the historical decline of the barbershop. In it you see both the vestiges of past uses and reasons for the current desuetude. What we call the *barbershop*, by which we mean a place for males to get a haircut, was at one time a bustling lair in which cigars, whiskey, slightly blue reading material, and various tonics were consumed. If you could read the barber's note posted just to the left of the central mirror you would appreciate the shift to modern temperament. It says in all caps, "NO PRACTITIONER AND PATRON SHALL SMOKE WHILE SERVICES ARE BEING PERFORMED." Not only is the language ludicrously legalized, it is a travesty of what barbershops used to be. If you couldn't smoke that cigar at home (or drink that drink), you took it to the barbershop.

The barbershop and the saloon were joined at the bottle. During prohibition the barbershop sometimes took on the role of speakeasy. The alcohol-based hairdressing that was sold in those colored bottles (seen on a shelf in front of the barber chair) often became potable, dispensed out of casks of regulated grain alcohol stored in the back room. In fact, Bay Rum, now an aftershave, with a stopper just as in the days of bathtub gin, is a reminder of the connection between tonic for the hair and tonic for the body. Prohibition was the age of patent medicines, which were essentially ways

of delivering alcohol and opiates in the name of vague pain relief. Barbers' concoctions, such as Sea Foam, Brilliantine, and Tiger Rub, allowed men to circumvent the Eighteenth Amendment. In fact, the alcoholic content of barbershop hair tonic was substantially higher than that of patent medicines. So while women bought most of Lydia E. Pinkham's Vegetable Compound, their husbands were laying in supplies of what was called Florida Water. Should you ever wonder why so many gangsters got killed while getting a shave, it's because they were at their place of business. What a propitious arrangement: back room bottling plant, front room all-male barbershop.

Oddly enough, the paradox of clean-up and get-dirty may explain the unique status of this male-only space in history. On one hand, the barbershop has been a place for men to go to tidy up. The barber was, in a sense, a *groom*—a man who prepared other men to go out in public, as did the manservant of the royal household. When wigs were in fashion, the barbershop sold and fitted them. When beards were fashionable, here's where they were trimmed. And when, most importantly, clean-shaven became not just a fashion but an external sign of grace—cleanliness being next to godliness, and all that—the barbershop became the way station for putting on the public face. Other manly preparations occurred here too: not just a shave and a haircut but a manicure, a shoeshine, and even *facial freshening* (the barber removed blackheads and popped pustules).

But then there is that other side, the Sweeney Todd side. Barbers in Western Europe had a long and combative history with priests and surgeons, as they were all allowed to cut open the human body. The priests gave up this trade in 1163 when the Council of Tours declared it sacrilegious for ministers of God to breach the human body. The surgeons separated from barbers in 1745 when both the French and the English split the two groups into those who did general practice and those who performed science. Barbers cut on the human body, or, more usually, applied leeches to drain the bad blood. This was because blood was thought to be one of the four humors, along with phlegm, choler, and melancholy, that could lead to sickness. Bad blood made the patient *sanguine*, either overly tired

or overly nervous. The barber was the mechanic who changed the oil by getting the bad blood out.

The barber pole with its red and white stripes bears testament to this bloodletting. When the barber towels were hung out to dry in front of the shop, the red ones were those that had been used and the white ones were those that had already been washed. In America, where there was no medical history behind the tonsorial arts, the iconography was adjusted during World War I by adding blue to make it patriotic. As a further, typically American adaptation, an electric motor was added to make the stripes appear as if they were eternally swirling.

So in America the barber experience was about not salvation or health but the shave. After the Civil War one of the most startling changes in American male primping occurred with the cleaning up of the face. As with so many other signifiers of capitalistic success, like the collared shirt, chest chains, and the starched dickey, the fact that your face was regularly shaved meant you were not "one of them," not someone who did manual labor—hoi polloi. That distinction was at the heart of a new social order based on the distance between one's hands and one's job.

One sees the startling appearance of the clean face in politics at the fin de siècle. The main reason for this change was the mass production of soap. No longer made on the farm by boiling lard or other animal fat together with lye or potash, soap was manufactured in huge vats of aerated oils and chemicals. Think Ivory, so pure it floats. But that's only half the shave. The other development was made possible by the mass production of weaponry of the Civil War—the ability to grind hollow blades with concave sides. This technology, which created the penknife (to be worn at the end of the watch fob), also created the mass-produced straightedge razor (to be etched and personalized). All you need do is leaf through a Sears catalog from the 1890s and you'll see page after page of these razors, made distinctive by their elaborate decoration. A gentleman might own a few razors, as it was thought that the metal needed to rest between stroppings and, oddly enough, lost its ability to hold

Kochs' Hydraulic Barbers' Chair, No. 800

Porcelain-Enameled Iron

Raising Lowering Revolving Reclining

Patented May 15, 1891; Aug. 26, 1892 (two patents); May 23, 1893
Aug. 12, 1915; Dec. 26, 1916. Design Patented

MANY of the leading hotels throughout the United States and up-to-date metropolitan barber shops in the large cities of the country are equipped with this model. This chair embodies every late improvement known in barbers' chair construction. It is massive and roomy and yet of highly artistic and graceful design. Made entirely of iron, porcelain-enameled. One-piece fluted base, equipped with Kochs' patented telescoping housing, which completely envelopes the hydraulic mechanism and protects it from dust and hair clippings. Fluted seat-rail, to match base. Back-frame and arms are porcelain-enameled. Ideal manicure sockets, strop ring and haircloth bar attached to arms. Porcelain-enameled lever handle. The floor-rim, step and footrest are cast in solid German silver; all other metal trimmings heavily nickel-plated. Kochs' Patent adjustable Spring-cushion Headrest with paper roll and cutter. Upholstered in the best possible manner; seat and back cushions made with double-stitched edges and covered with finest quality leather of any color.

Koch's Hydraulic Barbers' Chair, No. 800, early twentieth century

an edge if stored pointing east and west. So straightedge hand razors were often kept in presentation boxes and displayed as items of male jewelry. Owning a razor meant that you were not part of the *mobile vulgus*, the rabble on the move, or, in the popular Victorian slang—the mob. You had a desk, an office, a clean face.

Now look at the politicians. After Lincoln, facial hair suddenly disappeared. Lincoln grew the beard for his 1860 bid supposedly on the advice of an eleven-year-old fan who complained about the pocked irregularities of his face. Only five presidents in U.S. history have had beards when they moved to the White House—not one in the past century. A mustachioed Thomas Dewey twice tried and failed to win the presidency. Worse, his lip hair occasioned the famous comparison from Alice Roosevelt Longworth to the "little man on a wedding cake" (even though Alice's dad, Theodore Roosevelt, was mustachioed himself—for a short while). Nixon, you may remember, was criticized for having five o'clock shadow. And, in passing, it is noteworthy that after Vice President Al Gore lost the 2001 election he announced his capitulation not in court but in the media by sporting a salt-and-pepper beard. He had no idea what he was doing, but students of facial hair and American politics knew. He was a loser.

Shaving with a straightedge was no easy task, which explains not just the role of the barber but also the importance of this chair. The barber chair was first developed as a one-piece recliner, in 1878 by the Archer Company in St. Louis. Moving the chair, not the client,

made the barber's job easier. Then Theodore Koch of Chicago incorporated all the up-and-down, sideways, and tilting into one chair in 1885, and a few years later Ernest Koken made it all hydraulic with the patented joystick side lever. The barber chair was not bolted to the floor; rather it was held upright by oil-soaked sand in the base. After World War I came the porcelain enameled iron chair, and then, oddly enough, after World War II came a strange non-barber recliner mutation—the La-Z-Boy chair. The modern male throne for viewing the television (and a nifty hiding place in itself, as we will see a little later) is a direct descendant of Koken's shaving chair.

The male with enough disposable income to be sitting in this barber's chair, say, in the early years of the twentieth century, would visit his barber three times a week to be shaved. Although the barber would use his own straight razors, the soap was often supplied by the customer in his own shaving cup. That's because "barber's itch" was thought to be caused by contamination of the soap. Before the rise of vegetable oil in soaps (hence the name Palmolive, for instance), animal fats were standard. With time the fats "turned"; they grew putrid. Individual soap mugs were stored at the barbershop, in what was a mutual sign of respect. The consumer was saying, "I'm a member here," and the barber was displaying the cups near his chair, saying, "These people trust me." The barber sold both fresh soap and (at a 400 percent markup) the mugs, which the customer often embellished with his name and his fraternal organization. When you see these shaving mugs at antiques stores you'll notice they can be turned outward to show both name and affiliation, almost like a calling card.

At the turn of the century a French scientist named Remlinger transformed the entire barbershop world by finding that barber's itch could be linked not just to the soap but to everything that touched the customer's skin: razor, scissors, and towels. That discovery ushered in what were called *sanitary shops*, in which everything was sterilized. Towels were held in a steam jenny, razors were boiled, strops were disinfected each day, and shaving soap was carefully controlled in heated dispensers that became known as "latherizers." Although these objects have long left the barbershop, you can still

see combs floating in blue carbolic fluid in a see-through glass reservoir—a reminder of earlier anxiety.

The male-only world of the barbershop crumbled after World War I, not because of germs but because of King Gillette. This young man's genius was not that he invented the safety razor and its disposable blades, but that he knew how to market his invention. He invented the term *five o'clock shadow* to sell his blades, just as his colleague Gerard Lambert popularized *halitosis* to sell Listerine. Sell the disease first, then sell the cure. And what was his cure? Gillette realized you could give the razor away as long as you controlled the patented blades, and that is precisely what he did. In 1903 he produced 51 razors and 168 blades. Next year the numbers were 90,000 razors and 2.4 million blades (Barlow, p. 103). When the doughboys went overseas they carried in their ditty bags the Gillette safety razor. A gift from King Gillette. No blades, however. Before the war more than half the barbering business was shaving. After the war, only about 10 percent of the business was shaving.

The barbershop was not just a men's club with open membership; it was a study in democratic conviviality. You can see this in the names. As Vince Staten says in *Do Bald Men Get Half-Price Haircuts? In Search of America's Great Barbershops*, whereas hardware stores carried the owner's last name, the barbershop carried just his first. It's Smith's Hardware, Floyd's Barbershop. Such conviviality is what historians call an *attributed back-formation.*

In fact, the place is so relaxed that the constituents break into supposed song. The *barbershop quartet* is a kind of male-only close harmony, popular in vaudeville, in which the melody is sung by the second tenor. But it went without a name until 1910, when the term *barbershop* was used to describe all-male harmonizing, and the song "Play That Barbershop Chord" was published. The *quartet* was added a decade later and then finally popularized by the creation of the Society for the Preservation and Encouragement of Barbershop Quartet Singing in America in the late 1930s. When Norman Rockwell painted his *Shuffleston Barbershop* cover for the *Saturday Evening Post* (April 29, 1950), he showed the vacated barbershop in the foreground and then in the back room the barbers

making music. This tradition is totally brainspun, sensible only to the myth, not to the reality, of the barbershop.

But why? Why should men who enjoy the pleasures of quartet singing in close harmony have needed the creation of a totally fictive organization like the SPEBSQSA? Why do they have to get dressed up in those outfits? Why the link to the barbershop? Women who enjoy doing something probably would not have to invent a seemingly historical organization—they'd just do it. Book clubs, garden clubs, lunch clubs, bridge clubs, exercise clubs, kaffeeklatsches, investment clubs, all exist for women without such fancy provenance. But for men to get together, as we have seen, they need the sense of tradition, of an established group, of fitting in to something larger. They need to be lions, moose, elk, masons, veterans, shriners meeting down at the lodge. Or they needed to be getting a haircut.

In 1958, a barber wonderfully named Sherman Trusty wrote a treatise titled *The Art and Science of Barbering*, with an eye to helping young men navigate the treacherous waters of dealing with other men when there is no Moose Lodge in place. Here, presumably in

order of success, are pointers on how a barber can strike up a conversation with his customer. To bring the customer out, Trusty suggests you ask,

Are you a native of this state? (If not, ask which state.)

How long have you lived in . . .

Are you working these days?

Do you think business is improving?

Did you read about the big fish that was caught yesterday?

What make of car do you have?

Do you enjoy the movies?

Do you know Senator . . . is in town?

Did you know that Mr . . . was married the other day?

Have you heard about Mr . . . dying?

Who do you think is going to be elected governor? (But do not add your opinion.)

Have you ever heard Dr . . . speak?

Who do you think is going to win the national heavyweight championship?

Do you like the East?

When do you think it is going to rain?

Do you enjoy this kind of weather?

How is your family?

(pp. 324–25)

Leaving aside the necessity of creating such a list, let alone publishing it, it's worth noting that "How is your family?" or, in fact, any family questions at all, are way down at the bottom of the ice-breaking interrogatories. Maybe that's why the barbershop itself is organized with such predictable regularity. It is organized by ritualized male concerns, as we see here with the football memorabilia and the wildlife pictures. True, it also has those small pictures of the barber's kids—not so much an afterthought as a reminder.

If we could see more of the shop in the second photograph there would probably be two more chairs, a table of worn magazines (some of which you wouldn't find at home, not because of their racy nature but because they were about either sports or adventure—what used

to be *Argosy* and *Field & Stream* are now *Maxim* and *Rolling Stone*), a few seated men—only some of whom are waiting to have their hair cut, and a radio (yesterday) or a television set (today) turned on but no one watching. Here is the male equivalent of those yellow signs with comforting hands that inform battered women of a safe zone.

One of the best places to pick up on the jouissance of the barbershop is from a recent movie of the same name: *Barbershop*. Although this film and its mediocre sequel fictionalize a Chicago barbershop of recent vintage, and although reviews invariably point out the African American nature of the banter and playfulness, the sense of camaraderie inside a protected space is the nonracial theme. True, the barbershop has a special status in the history and culture of African Americans as a place to organize, speak freely, and find respect that was missing in the larger society. Or as the older barber, Eddie, played by Cedric the Entertainer, tells the young owner, played by Ice Cube, "This is a place where a black man means something. Cornerstone of the neighborhood. Our own country club."

Inside this community of mostly men, adolescents move to adulthood and aged men reconnect with their youth. In the flux of men at different stages of life is a spinning conversation between men who otherwise would not or could not meet. And it is to be expected that much of what is said has little to do with reality but lots to do with the personalities of the shop. The most controversial part of *Barbershop* is a string of disparaging remarks the iconoclastic Eddie—who never has a customer in his chair—makes about people like Martin Luther King Jr., Rosa Parks, and Jesse Jackson. And it is these remarks about Dr. King's extramarital affairs and Ms. Parks's social importance that a historically tone-deaf Jesse Jackson excoriated as reasons to boycott the film. These remarks were libeling the brotherhood, claimed Reverend Jackson.

But as Brent Staples editorializes in the *New York Times*, such commentary is precisely the privileged function of the shop:

> South Side Chicago shops were de facto social clubs and debating societies where black men from all social classes spent their Saturday mornings, talking about politics, religion and their favorite subject—hypocrisy in high

places—as they waited a turn in the chair. The hypocrites were both black and white, and no one was spared. As with most barbershops today, there were no appointments; you showed up, sat down and waited your turn. Many of us came as much for the spectacle as for the haircut. The barbers were showmen who moved easily from subject to subject, pulling the conversation back from the clubhouse vulgarity that was all too likely when men gathered without women. (October 13, 2003, A12)

As Staples concluded, Jesse Jackson knows this, as do the habitués of the shop. In fact, that's just the point, as others in the shop vigorously refute Eddie's put-downs (what he says about Rosa Parks's historical importance is just a howler, obviously untrue). But Eddie's main point, that the shop is a place where you can say anything because you are with your guy friends, your homeys, is the force behind the movie and the barbershop.

Is the barbershop dead? A subject of nostalgia? A setting for a movie? The inventory of countless antiques stores? Will a new mutation of the tonsorial parlor return? The barbershop Rubicon seemed to have been crossed in the 1960s with the appearance of the mop-topped Beatles. It was not long hair that caused the problem but the fact that it had to be shaped, and that shaping was best done by someone who knew how to cut long hair and then blow it dry. This job was better done by Darlene in a place called Curl Up and Dye, Hair Port, Shear Perfection, A Cut Above, or Hair Affair, than by Floyd in a place called Moe's. Today no state even requires a barber license, 60 percent of barbers are females, you call ahead for an appointment, and if you're not careful you'll get a shampoo. Little wonder the hairstyle that develops from these forces is the mullet.

Establishments like Gentleman's Quarters in Dallas or the Men's Grooming Center of Boston claim that they can make a hybrid of the male-only shop of yesterday with the unisex salon of today. The American Male Salon has even franchised the idea with fourteen outlets nationwide, offering free beer, football on television, and facials, haircuts, and manicures—just for men. Rather like the cigar bar, these self-conscious places with their cherrywood floors and forest green walls are for men who want the reminiscence of child-

hood with the reality of a pedicure. These places are spas cavorting as bars, salons as saloons. Although strangely true to the history of the barbershop, it won't work. The barbershop is not about poodle grooming, it's about male camaraderie. And it's hard to get something going with someone who's sitting there waiting for his Asian back-walking massage or his coif colorizing, called *camouflaging* by the American Male Salon.

The American barbershop offered a refuge from the gaze of women. It was a retreat, not a launching pad, and the haircut was not a theatrical event. What happens in the true barbershop is not about creating what Maureen O'Sullivan says of her husband, Lloyd Nolan, in Woody Allen's *Hannah and Her Sisters*: "This haircut that passes for a man." In fact, the old barbershop was really not about the haircut at all. Like deer camp, the strip club, or the playing field, it was about men feeling at ease with other men.

Tidewater Tides dugout, Virginia

8. The Baseball Dugout

CHEW, SPIT, AND FIGHT

If you ever wonder why there is so much brawling in modern baseball, here's one reason for it—the dugout. Oddly enough, this simple and essentially unnoticed space for men has had a profound effect on American culture. What happens here reverberates throughout all athletics, and hence through all male behavior.

That cave you see before you is a baseball dugout. It's essentially a shed with a bench. In no other game are the active players isolated in such a confined area, almost like animals in a holding pen. What makes it a *dugout* is that the den is usually down three steps from the playing surface. Players don't have to be so confined and the dugout doesn't have to be such a dank and foreboding space. In fact, the rules stipulate only that the off-field players are to stay in a space that "shall be roofed and enclosed at the back and ends" and not less than twenty-five feet from the baselines.

The team that is "at bat" loiters here awaiting the call at the plate. Like monks in the refectory, they sit patiently until it's their turn to climb the steps and move to the on-deck circle. Down the first-base

line (or the third-base line, for the visiting team) is the aptly named *bullpen*. When the team's turn at bat is over, the players surge out of the dugout and run to their defensive positions in the field. Meanwhile, the other team's players assume their restive positions in their own dugout. This is a male-only world visited only by a tidying-up batboy or now, with audiences shifting, a comely batgirl. As well, the team mascot hovers around this space, most often perched on the roof, razzing the opposition, inciting the crowd, and selling what is the profit center of modern baseball: logoed spiritwear.

The dugout also empties in times of stress. Often the men pile out for a fracas. The cause? A cohort has been threatened, and the team, as the television announcer intones with mock melancholy, *clears the benches* and *charges the mound* to *settle the score*. Vengeance is ours, saith the players, as they ritualistically surge into public view like so many supernumeraries on the Elizabethan stage. Usually the vigilante violence is pantomime, but occasionally, as in some of the set-tos involving the New York Yankees, the pretend is replaced with the real. Anyone who witnessed the ten-minute brawl between the Yankees and the Orioles in the late summer of 1994 will not soon forget it.

Ironically, the dugout came into baseball as a way to control violence, not incubate it. Dugouts as we now know them did not exist until the early 1900s. Before that, ballplayers sat on benches near the stands, as they still do in Little League and country baseball. The first modern dugout appeared when Philadelphia's Shibe Park was built, about 1909. The below-grade dugout afforded some protection from foul balls, yes, but more important, it connected to a tunnel that led under the stands to the clubhouse. Before that, in order to get to their clubhouse, visiting players had to walk through the crowd, where they were more likely to become involved in confrontations. The price of making peace with the fans is that now the boys of summer are more likely to make war with their opponents

Baseball is not football, basketball, hockey, or even soccer. In these sports, players of both teams are always on the playing surface at the same time. There is no cave to duck into. The contest is designed in such a way as to produce hundreds of collisions between

opposing players. Players jostle each other as a matter of course. Many collisions are tactically appropriate and even legal. Admittedly, it's not always easy, in the heat of battle, to distinguish the clean hits from the cheap shots. Consequently, some collisions—combined with hair-trigger competitiveness and arm's-length proximity to the enemy—lead to spontaneous attacks and retaliation. Intentional violence in these sports is inexcusable, but understandable. After all, they are *contact sports*.

Baseball is different. Supposedly, no contact between the players is to be made other than the tag-out. The proximity necessary for flesh-to-bone violence is usually achieved only by base runners, and it can be as sharp and stinging as a cleat to the face. Then it's over in a burst of blood and dust. But at bat things are different. Here the player's face is also at risk. And here is where the slow-burn fuse connection to the dugout is lit. When a pitcher intentionally throws a fastball uncomfortably close to the opposing batter's head (usually because the batter prevailed in the previous encounter by doing what he's paid to do), the ritual of retribution begins. Usually the pitcher is blameless. After all, would you voluntarily pick a fight when you knew you were outnumbered nine to one? At this moment, however, the dugout becomes central.

In modern baseball, fisticuffs are often written into the script both as crowd-pleaser and pressure releaser. Big league baseball is approaching the condition of hockey without the padding, and this is having an effect elsewhere in sports. The men who have been bonding from end of February to end of October, the teammates who have been eating and traveling and playing together, the brothers who all have the same manager/father laying down the law, the gang that has been developing the code of "us against them" takes to the street as an act of seemingly spontaneous violence. The "little chin music" orchestrated by pitcher to hitter becomes a symphony of righteous outrage.

Is this little shed really all that important? Not by happenstance did the term *dugout* come into baseball parlance after World War I. The covered stalls along the foxholes were called *dugouts*, and from time to time men went over the top to engage the enemy. As we now

know, this did not happen often. These dugouts harbored about the same number of fighting men as a baseball team—slightly larger than a squad size, about twelve or so. What makes this collection of men without women especially potent is that they have a designated leader, a sergeant. In the baseball dugout the *manager* is the man who organizes the men from within the squad.

While the history of baseball is written as the performances of individual players, the real story is of how individual managers brought their squads out of the dugout into the battle. Modern baseball, as Leonard Koppett of the *New York Times*'s sports pages explained in *The Man in the Dugout: Baseball's Top Managers and How They Got That Way*, is the result not of owners or players but of managers. These are the men who mold the various individual players into the team. From John McGraw, who established the principle that the manager is the unquestioned boss; to Branch Rickey, who enforced the concept of team play while all the time wearing a spiffy business suit; to Connie Mack, whose concentration on bending talented players to his will enabled him to build two dynasties decades apart, the successful manager is the man who turns the space of the dugout into the crucible of the hunt.

The dugout is command central for the manager. Here he not only motivates his men, he also relays his field commands to his subalterns at first and third base. With his hands and eyes, he talks with his men, especially with his catcher, and everyone, especially his pitcher, knows what it means when he picks up that phone to the bullpen. So he often stands on the upper step, a veritable itch-and-scratch machine, touching first his hat, then his chest, ear, hat, nose, throat, and hat. One of these signals may be an indicator that the other signals are to be neglected, so confusion is always possible for those who are not paying proper attention to his motions. The live signal can be at any spot in the series chosen by the manager. Let's say the third touch is the live signal. He touches ear, hat, cheek, throat, et cetera. Cheek, as the third touch, becomes the live signal: curveball. Woe to the daydreamer. The complexity of signaling is one reason few players dare approach until he has switched off the signaling, thereby transferring control back to his other coaches.

If the prototypical football coach is Don Shula, then the prototypical baseball manager is Tommy Lasorda. Some years ago, Lasorda was fitted with a portable microphone, and a series of tapes were made that are still circulating through the baseball world. Lasorda was a man who could have appeared with Reverend Robert Schuller to encourage penitents to accept the reflective and nonviolent life. But in the tapes you hear him exhorting his men to do all manner of things that would be considered rather un-Christian. When you hear him excoriating Doug Rau, or Jay Johnstone, or Dave Kingman, you realize that he had the ability to maintain dual personalities: he might be rated PG and tender in public, but he could also be X-rated and fierce in the dugout.

In one famous exchange, he is chewing out his pitcher Doug Rau. Rau says, "You can't take me out, Coach, because I'm especially good with left-handers," and Lasorda barks something like (in polite language), "I am the manager and I can take you out any time I want, so give me the blankety-blank ball. And if you think you're so hot with left-handers how come those three lefties got on base, huh, huh, huh?" (quoted in Vecsey). The original version has a bit more color. A lot more color. Lasorda's dual personality is at the heart of his coaching: he's a street angel but a dugout devil.

When the players are in the dugout they are strangely quiescent, almost asking to be molded. Ted Williams once said that this respite is crucial to generating the focus necessary to whack away at something the size of a gnat flying past you at the speed of a punch. Sometimes the men holler and chatter, but in modern commercial baseball this activity has been off-loaded to the mascot, who hangs around and over the dugout and trades insults with the opposition, safe in the furball of his costume. The players usually pay him no heed. Often the men seem to be almost dozing next to each other, coming alive only when they move to the on-deck circle or when they feel the television camera coming in for a furtive peek at what male space looks like. When this happens they usually swirl a wad of tobacco the size of an orange around in their mouth and let it fly.

The activity of chewing and spitting is central to what happens in the dugout. Boys spitting is an ancient ritual of barely contained

aggression. Often it has to do with separation from women. You spit in the bar and in the barbershop. You don't spit at home. Legend has it that since the old-time players couldn't smoke on the field, they needed to find another way to get their tobacco fix. So the dugout became a kind of spittoon. Part of the attraction is clearly that it's gross. The players know this. The spitting during the 1982 World Series by Milwaukee manager Harvey Kuehn was national news. It was incessant and almost obscene.

Some years ago *Sports Illustrated* inventoried a major league dugout to find out what this spitting entailed. Here are the results:

300 pieces of gum (100 sugarless)
18 bags of sunflower seeds
24 bags of pumpkin seeds
Several canisters of tobacco

As *SI* opines, if you are ever invited into the dugout café after the game, wear boots, as the floor will be covered with a soup of tobacco spit, seed shells, and gum wrappers (O'Brien, p. 19).

One of the best descriptions of the passive/hostile characteristics of the men-only world in the dugout can be seen in a Norman Rockwell illustration done for the *Saturday Evening Post* of September, 4, 1948. While we may not usually associate Rockwell with insight into male violence, he was an eerily perceptive illustrator of churning emotion. The illustrations he produced during the war made him conversant with male violence. So, while his usual take on baseball after the war was celebratory (his famous *The Rookie* features a young rube entering the Boston Red Sox locker room for the first time, and *Bottom of the Sixth* shows umpires in conference as the sky begins to open), in *The Dugout* he pictures the hapless Chicago Cubs just at the edge of hostility. They are lit and burning.

Below the screaming crowd of Bostonians, who are clearly celebrating the demise of a Cubbie at the plate, the players in the dugout are pictured at the end of their rope. They are in positions of shame, faces tipped, shoulders slumped. They are big, big men. Back-from-the-war men. Their caps are pulled down and their hands are covering parts of their faces. Out in front of the dugout, between them

and the game, stands the hapless batboy. He looks as if he has lost all muscle tone, just slumped down as the CHICAGO and the sewn line under it across his caved-in chest have formed a drooping arc that looks like an unhappy face.

The dugout image brings to life the suffering Chicago Cubs, who were at the time solidly in last place, with a 61–93 won-lost record. Specifically, the painting shows the dejected Cubs sitting in the visiting team's dugout at Boston Braves Field during a Sunday doubleheader that was played on May 23, 1948. But it is a more generalized vision of strong men

The Dugout (*Saturday Evening Post* cover, September 4, 1948)

under pressure. The Cubs appear to be hiding from the view of the fans while allowing their batboy to be subjected to the humiliation of catcalls from the stands. They are bloodied, not unbowed, however. The image also communicates a sense that these men might have been pushed too far, might come out of their den, might come charging back. They clearly are powerful men, and although the anemic batboy is scapegoating their defeat, they themselves, almost coiled in shame here, may well explode in anger.

Like other places where only men congregate, the dugout is organized by unarticulated rules. Who sits where, whose equipment goes where, and even what conversational topics are permissible are prescribed. As old-timer Waite Hoyt said, "In the daytime you sat in the dugout and talked about women. At night you went out with women and talked about baseball" (quoted in Hall, p. 220). But some topics are taboo. For instance, you never talk with a pitcher en route to a no-hitter. You move around, but you don't leave the

dugout unless it's your turn at bat. At the middle of the seventh inning you move around more, maybe even pace down the tunnel. You never stand or play in front of the dugout. But the key to dugout etiquette is the same thing that makes it such a powerful force for men: this is a world of men without women, a world in which the masculine principle of bonding is never to be violated. You may chatter together, you joke together, you spit together, and from time to time you charge the pitcher together. Woe to the player, even the multimillionaire player, who decides to sit it out and play the pacifist. The dugout makes that unthinkable.

Jim's Harley hotel, New Jersey

9. Getting Outta Here

MY WHEELS, MY SELF

When I was growing up in the 1950s my father would often "go out for a drive." Almost every weekend he'd say, "I'm going out for a drive." He had a series of Plymouths, one of which was a V-8 Fury—the car driven by cops. But most of his Plymouths were green and dreary and embarrassments to me. Sometimes he'd ask if I wanted to go along. I had two older sisters. I don't remember him asking them. When we got into the car we always went to the same place—out to watch Interstate 89 being built through the rock hills of northern Vermont. He loved to watch the big clanking Caterpillar D8s and the LeTourneau Earthmovers, which could flatten a hillside in an afternoon. Sometimes he would chat up the workers, but usually we just drove around and watched the big rigs. He enjoyed "going out for a drive" so much that we drove up to Messina, New York, to watch the earthmovers gouge out the St. Lawrence Seaway. There we saw something new to us—the American Hoist drag-line excavators. My dad didn't have much to say to me. But when we'd see some guy leaning over a shovel, then he'd look over and say that

Let's get outta here (Ditch the Joneses from Lincoln and Over the River from Toyota, 1990s)

unless my grades in school improved, I'd end up as a ditchdigger. I could plan on it, he said.

I have since realized what he was up to with these "out for a drive" drives. He wanted out of the house. The car was privacy. All that was in the house was women: my mom and my two sisters and my grandmother across the street. I'm sure he took me along out of guilt and possibly because he thought I too wanted out of the house. A little bonding and advice were thrown in, but really that was an afterthought. The car was escape.

Why have we been so slow to realize the connection between the middle-aged male, hiding, and vehicles? Strangely, advertising, which is the most reliable Geiger counter of human yearnings, rarely foregrounds what makes the automobile attractive to *Vir domesticus*. Commercial speech, which addresses every human yearning with such thoroughness, has almost completely neglected the "out for a drive" drive. Yes, *escape* is the claim of sports cars for young men, but what about *hiding* for the middle-aged? Doubtless this oversight is a result of the demographics of the automobile business. Young men buy the product in part for the same reasons they buy beer and aftershave: to impress women. Look at most car ads: buy the car, get the woman. I used to wonder what would happen if older males were advertised to like this: Buy the car, get away from women.

Then came the SUV in the 1970s. The Sport Utility Vehicle allows men to have it both ways—escaping in full view while still being a family man. Everyone, even the manufacturers, seemed befuddled

by the SUV's sudden popularity. But they shouldn't have been. These sleek iron-and-plastic behemoths are modern man's version of the horse at the end of the John Wayne western. Who cares if Old Paint is overpriced by about 30 percent and almost never used as intended (98 percent never leave the blacktop)? The 4x4 has become the hottest thing on hooves. Slide the cell phone, pager, and Palm Pilot into your saddlebags, and off you go into the sunset or to check out construction equipment. Or buy a Hummer and *become* construction equipment.

If you are ever confused about SUVs, just look at the early ads. Almost without fail, a single male is implied or shown as driver. Like Huck Finn, who had similar problems with the Widow Douglas, the driver is lighting out for the territories, going for a little peace and quiet at the edge of the civilized world. The SUV is so powerful an agent of male liberation that in one ad on television, a business type morphs into a lumberjack just by looking at his magical Pathfinder, Safari, Explorer, Expedition, Durango, Navigator, Grand Cherokee, or whatever it is that will spend much of its time in the Kmart parking lot.

In another of my favorite television ads, one for the Isuzu Rodeo, our modern ranger is shown going ever deeper into the frontier, apparently following a disembodied command from above: "Go farther." He crosses plains, mountains, and prairies, at last ending up aboard a raft beside his beloved, well-bumpered buddy, idly drifting downstream. Like Huck and Jim, he is finally at peace. In the last scene, alas, a waterfall comes into view as the Godlike voice from afar says comically, "Too far." We need not ask, "From what?"

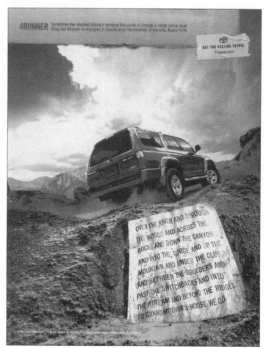

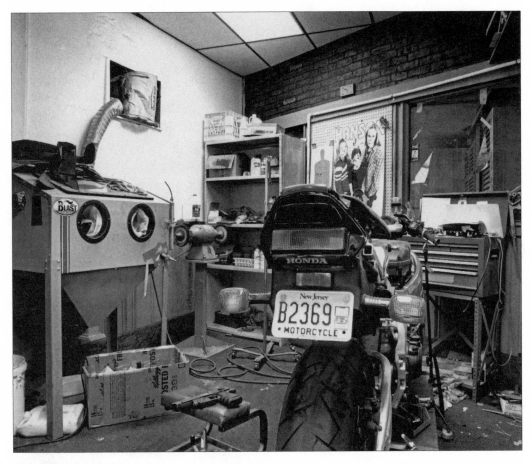

Hogs and rice, Pennsylvania

The other automotive genre that reveals men's cave-on-wheels is the transformation of the pickup truck. Here the underlying vehicle is a workmobile, not a stealthmobile. Yet again notice how the pickup has become sissified at the same time it announces its toughness. Again trust the advertising to tell you what's what. The names are suspiciously somber, announcing not bravado but most often affiliation with a far-off locale—places where the male wishes he could be. Here in order are the best sellers: Ford F-Series, Chevrolet Silverado, Dodge Ram, GMC Sierra, Toyota Tacoma, Dodge Dakota, Toyota Tundra, and Chevrolet Colorado. Inside there's all manner of comfy seats that remember who you are, dual climate controls, latte holders, and air bags from every angle. Best-selling vehicle in America? Not a sedan. It's a pickup. The Ford F-150. Invariably, when the pickup truck is advertised, we see it against a backdrop of construction equipment, as if to say that when you drive this pint-sized LeTourneau Earthmover off the site, or at least out to get beer, you'll always be one of the boys.

Knowing that the middle-aged male uses his car not just for transport and display but for sanctuary as well, one can understand the overwhelming failure of carpooling. Sharing the ride is such a sensible idea: how nonpolluting, how economical (an average yearly expense of about $4,500 for a twenty-mile daily round-trip), and how beneficial to slow the rapid decay of roadways and infrastructure. But how *public*. Once you appreciate how much the modern male prizes that time in hiding, or at least that time without women, you realize that such sensible solutions won't work. Ironically, building more roads may make things worse. Drive through Atlanta, D.C., Boston, Houston, Denver, and the major California cities and notice the number of single males driving at rush hour. They're everywhere. I've looked at their faces. They should be tense and irritable. They're not. They often look quite peaceful as they creep bumper to bumper down the highway.

Could this desire to ride alone also explain the recent surge of motorcycles among the graying set? J. D. Power and Associates found that the average age of a new motorcycle buyer increased from forty-one in 1998 to forty-four in 2003, with the number of

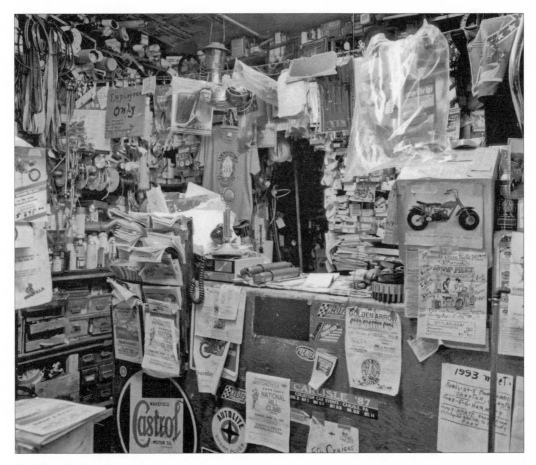

Cycle shop, New Jersey

riders forty-plus years old accounting for nearly two-thirds of the total new motorcycle sales. Admittedly, there's a testosterone surge here that's not present in sports cars, SUVs, and pickups, but could it be that the male likes riding alone under all that state-mandated protection, like bulky helmets, and likes the fact that if he has to congregate he can do it in a specially configured, cloaked community—the motorcycle *gang*? Riders look so tough under all that leather and helmetry, but viewed in the flesh, as it were, they look kind of like your dad on a bad-hair day.

The most famous male community—and one that has been studied to within an inch of its acoustic exhaust pipes (often at some risk to the ethnographer)—is that of Harley-Davidson owners. Here is a bit of pig iron, chrome, and leather that is 20 percent more expensive than its German and Japanese counterparts and probably 30 percent less well made. But it has the almost total reverential devotion of thousands of people, mostly men. And their money. Clustered like pilgrims around an icon of worshipful concentration is a community of aggressive outsiders linked with a brand so deep in pretend lore that in the Harley Owners Group both machine and owner share the same name: "Hog."

Again, look at their ads. They promise escape, pure and simple. Harley has had a steady run of 20 percent profits for a number of years, now controls 53 percent of the market, and "owns" the concept of rugged American on the lam. In a way, Harley-Davidson has been blessed that its major competitors—Honda, Yamaha, and BMW—can't crack this shell. These foreigners are all coming *into*, not heading *out of*, American culture to the frontier.

What makes Harley so interesting a story is that thirty years ago it had been almost bled of meaning. The company was driven into the ground by AMF, the maker of bowling equipment. But thanks to the Hell's Angels, some misunderstood movie sequences with Marlon Brando (in which he's riding an English Triumph), great product names (Knucklehead, Panhead, Shovelhead, Hard-Tail, Super Glide, Hydro Glide, Electra Glide, Dyna Glide, Chopper), a symphonic exhaust system that produced a recognized sound (*potato-potato-potato*), and elaborate chrome presentation allowing for customization,

When was the first time you heard the calling? and "No. You can't wear a cape to school" (Harley-Davidson ads, 2004)

this object has become a talisman of crossing over to the other side, of crossing the line, entering the state of Maleville in Testosterone Nation.

As has often been pointed out, any brand that encourages its acolytes to literally transfer the logo onto their body as a tattoo, any brand that has believers using the owner's manual as a Bible for marriage ceremonies, any brand that has pilgrimage celebrations like Bike Weeks, any brand that has a special version of the Ford F-150 pickup fitted out with cargo bed specially designed to coddle the bike, well, whatever that brand is, it's getting almost religious. Like the SUV saga, the story here is about the power and freedom to get away. Beneath the noisy product, under a cloud of smoke and the roar of exhaust, the process is quiet separation, giving the world the slip.

Knowing the importance of vehicles in escape fantasy, we might look again at the dream machine, TV. While it is true that television has become the primary hiding place of the modern male, less acknowledged is what is playing in that hiding place. In other words, what stories draw the male into the Barcalounger and tip him back into somnolent mind-travel fantasy? Clearly, watching sports paves the way into the cave. And the mutations of sporting competition, like motocross and endless professional wrestling and NASCAR, have become almost cartoons of violence and escape.

At the same time, this movement toward the edge with Xtreme sports has influenced other genres, like reality TV. So a variant of reality programming for men, with sport as the underlying motif, has

produced such shows as *Jackass* and *Fear Factor,* as well as the endless variations on Evel Knievel. It's in this strange mélange of competitive thrill seeking that Discovery Channel's *American Chopper* can be located. It is clearly Xtreme motorcycling, as the machines are tributes to the chopper, but the daring is in the design, not in the badass performance. These bikes are created more to express emotion than to kick dirt. They compete with each other on the catwalk, not on the tarmac. Like the chopped Harley of Peter Fonda in *Easy Rider* (1969), complete with raked front end, high ape-hanger handlebars, small front tire and rear one made fat, lathered chrome and glitz, the behemoths were made not for travel but for statement. After all, how comfy can you be with no windscreen, no front fender, and a wheelbase so long it mandates wobble? Look at the size of the gas tank: you're not going to fly the coop for long, maybe just up and down Main Street a few times.

The competition of these bikes is not with the tough world outside but with each other on the showroom floor. Which chopper can make the most outrageous statement of "going for a ride"? So on "Full Throttle Mondays," the Discovery Channel also features *Motorcycle Mania,* a show about a California chopper-builder named Jesse James, great-great-grandson of the famous outlaw, and *Monster Garage,* with the late Indian Larry. The beauty pageant climaxes in the *Great Biker Build-Off,* or at least that's the putative goal of the contest. These shows are what gearheads have for *Trading Spaces* or *Queer Eye for the Straight Guy:* engine block and fuel tank decoration. *Overhauling* is just the guys' term for redecorating. It's what

they have for découpage and flocked wallpaper, with an added dollop of "who's most outrageous."

But *American Chopper* is much more. It is a compression of the Osbournes, Xtreme motorsports, and Do-It-Yourself metal shop, with a sprinkling of Dr. Phil. It has proven irresistible to men who make up Discovery's largest audience—of Discovery's 1.5 million viewers, 70 percent are males, with an average age of about forty. Like most reality shows, *American Chopper* is a tribute to clever editing. We see a world made up almost entirely of males who are at work building wondrous things of pure imagination—in this case, themed motorcycles. Often the bike is being built to celebrate some group or event, like the 9/11 firefighters, American POWs, the Marine Corps; *Spider-Man* or *I, Robot* movies; or built for some celebrity, like David Letterman or Jay Leno, or for a manufacturer, like a welding company or a maker of lawn mowers. From time to time there are pastoral interludes, as in Renaissance drama, when we see our sculptors of steel and plastic out playing golf, riding horses, driving a tank, shooting upland birds, going on a date—all of which is clearly meant to be funny because these men are working men, men who tell time in terms of how close they are to the deadline, and yet who are, not to put too fine a point on it, passionate artists. Well, not all of them, and certainly not all the time.

The show is about men being watched by other men safely protected by the cathode ray tube and thousands of miles of coaxial cable. And what is clearly at the center of the fervid gaze, as feminists say about male pornography, is the interaction of the major family members with each other and with the chopper as hunks of iron transform into baubles of perfected aggression. There's Papa Bear, Paul Teutul, a lumbering man with a huge walrus mustache, enormous tattooed biceps (think pythons), and size twelve scuffed work shoes (as in "If he keeps doing like he has been doing, he is going to get a good look at the wrong end of my size twelves"), and his two cubs, Paul Junior, a creative artist as well as a continual force of independence, and Mikey, the bumbling but lovable layabout, the jack-of-all-trades and master of none. And then there's Vinnie DeMartino, Paul Junior's childhood buddy, the hardworking,

laconic foil who, like us, is caught inside this family, although he has a family outside of his own.

Few women appear. What these guys do is build customized motorcycles that sell in the neighborhood of about $200,000. They work in absolutely generic space: a cement floor, a run-down industrial park, Paul Senior's little office off to the side, tools everywhere—and at the center, like a holy relic, the slowly appearing chopper. The scene is rather like what one imagines medieval goldsmiths did, clustering around an object, each hand adding something magical and then pulling back. We see the chopper appearing before us in stop-action photography. So we see the first frame, then rear wheel, engine mounted, front fender, rear bumper, sissy bar, gas tank, transmission, exhaust pans, seat pan, oil tank, front tire, handlebars . . . all materializing as pieces are fitted together. Then finally the bath of chrome and sparkle paint.

What's compelling is that as we see this polished sculpture appearing before us we also hear the banal and vulgar interactions of the artists. It's like Raphael and Leonardo are dipping tobacco and cussing while applying paint to plaster. Here is just a bit of what was heard during the 2003 season:

PAUL SENIOR: Come over here and stand in front of me so I can hit you in the back of the head.

PAUL SENIOR: Mikey, get your fat ass upstairs and find my drill bits.

MIKEY: I want you to apologize for calling me fat.

PAUL SENIOR: I apologize for calling you fat. Now get your fat ass up there and find my fuckin' bits!

[The boys are going to inlay a photo of Dad on a bike's seat]

PAUL SENIOR: That seat's gonna look ridiculous with just a picture of me on it.

MIKEY: Well, who the hell sent him a picture of just you?

PAUL JUNIOR: It's gonna look ridiculous.

MIKEY: I don't care. Every time I sit on it, I'll just . . . I'll fart.

[A welder hits the frame of the Comanche bike with a hammer in order to bend it.]

Dick's caps, Maine

VINNY: I cannot emphasize how much you cannot do that!

MIKEY: Dad, I'm here to kick your ass!

PAUL SENIOR: Oh yeah, why me?

MIKEY: 'Cuz I'm STRESSED.

[Debating a detail on the Fireman's Bike . . .]

MIKEY: You guys want me to hold it on there while you fight about it?

PAUL SENIOR: [laughing] You know why you're here? You really know? To make me laugh. That's the only reason you're here.

MIKEY: OK. So, let's get this fuckin' bike together!

[Paul Senior enters the shop looking grumpy . . .]

PAUL JUNIOR: Uh-oh, grizzly's out!

MIKEY: You know, everybody gives me a problem about the grinder being faceup and they think my middle name is "safety." But it's not. . . . It's "danger." No, I'm kidding. . . . It's "Joseph."

And in one particularly touching scene after a day of mistakes and miscalculations Paul Senior and Paul Junior are sitting at opposite ends of a black leather sectional couch, talking man to man in the hushed tones of anger. Then suddenly their eyes tear up. They sniff. They stand and hug. "I love you," Paul Senior says. "I love you, too," Paul Junior says.

It's not just about the bike. The show is really about (gasp!) relationships. The men clearly care deeply about the tasks. We watch them throw out hours of work if the result is not exactly what they want. The job always must be done, they are always behind, and they are revisiting the same subjects and personalities, but they never compromise. *American Chopper* is like viewing a medieval morality play in which stock characters act out various set pieces. So Paul Senior is the old king, forever berating the boys for not keeping the shop clean and exhorting them to stay on task while he wanders off, presumably to lift weights or take a nap; Paul Junior is the prince, often almost blissful in concentration; Mikey is the jester; and Vinnie is the journeyman. What holds them all together is a kind of rough joy, if you will, of submerging themselves into the creative

Big Foot, New York City

Hummers on display, New York City

task. Critics who have considered the Teutuls a dysfunctional family have simply not paid attention.

The fact that things on wheels should provide the modern male such imaginative pleasure is surely a function of the mechanics of production as well as the myth of escape. And that things on wheels should be not just the center of engine life—as with flywheels, driving wheels, and spinning wheels—but the means of movement shows how sensitive we are to extending the dreams of separation. "Going for a ride" is for men what "being in the kitchen" is for women, a place of control and quiet. Doubtless before the Industrial Revolution the male imagined escape on horseback (think not just the western movie but the eighteenth-century novel). Now he plays out the sequence from the driver's seat of an internal combustion engine. But it is in these mutations of transport—SUV, Hummer, and motorcycle—that we see the deep connection between the dream life of the modern male and "getting outta here." What often looks to be impractical and downright silly (do you need four-wheel drive in Scarsdale? how safe is driving a gargantuan motorized bicycle?) becomes understandable, even sensible, when you realize the unarticulated yearnings that lie behind it.

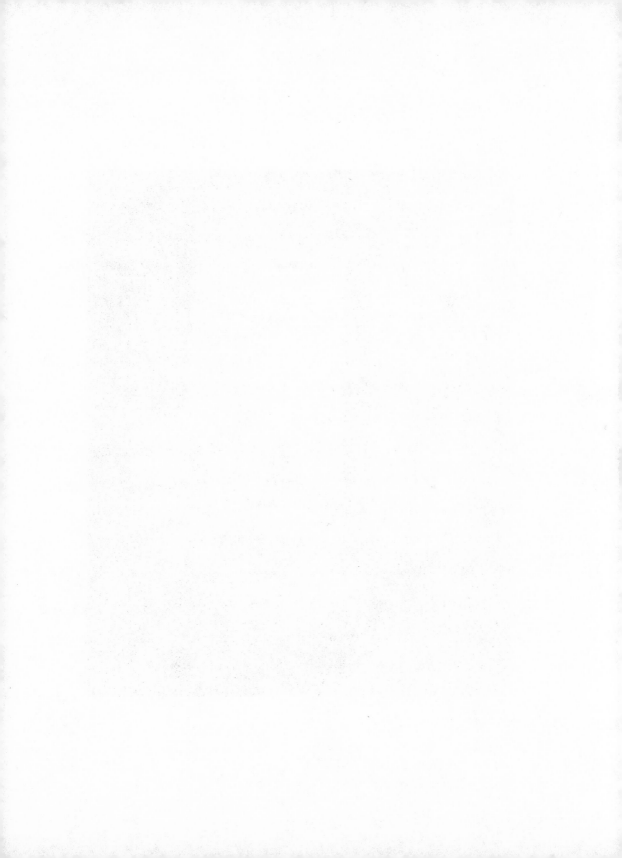

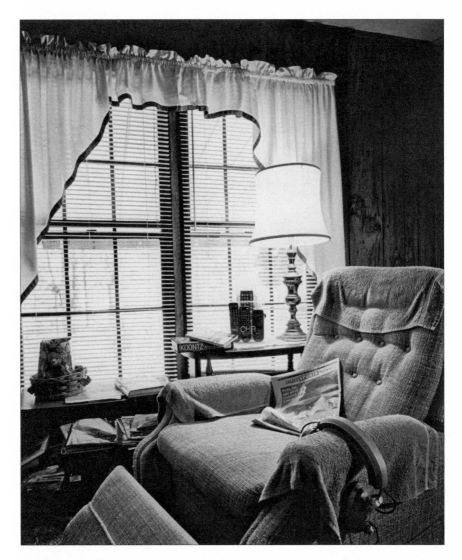

My father's recliner, New Jersey

10. The Recliner Chair

HIDING IN PLAIN SIGHT

Sometimes the best hiding place is the most obvious. As Edgar Allan Poe's famous detective C. Auguste Dupin notes in *The Purloined Letter*, often the best place not to be noticed is the place right at the end of the pursuer's nose. So for the male who wants some time alone, as for the purloined letter, occasionally it's best not to head for the cellar or the club; just sit there quietly right in the middle of the maelstrom—hiding in the eye of the storm.

The savvy sleuth Dupin finds the mysterious letter sought by the police literally hanging on the wall, hidden by being totally un-hidden, the only sizable sheet of paper on a rack designed to hold business cards. It is battered and dirty and torn, but sports a black seal with the Minister's initials. And so perhaps it's appropriate to consider this battered and bruised chair as an appropriate hiding space for the male, his protective colorization. Like the teenager so enmeshed in a video game that he's invisible, so too is father fitted into his *papa chair*, burrowed into his newspaper.

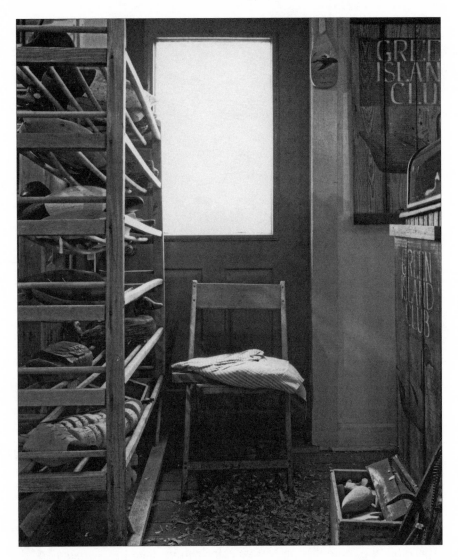

Carver's chair, North Carolina

This chair hardly seems a stable enough object to carry such social weight, but consider the social purpose of chairs. As opposed to other furniture, like the bed or tables, the chair is peculiar in that there is really no need for it. You could just as well sit on the floor. In fact, this is what happens in many cultures. So, before all else, the thing to realize about chairs is that they are as much about getting social structure up and running as they are about sitting down and relaxing.

Most chairs are about power. Chairs are about ordering, about rank, about who's where and who's nowhere. Don't believe it? Consider the chair at the head of the table, the electric chair, the departmental chair, the hot seat, the umpire's chair, the captain's chair, the pattern of chairs in parliaments, the different chairs in a Masonic lodge, the lifeguard's chair, the professorial chair, the chairmanship of a committee, and, well, Dad's chair in the living room. Still don't believe it? Go down to any auto dealership that sells conversion vans or high-priced SUVs and look at the cross-pollination between the automobile seat and the regal throne.

The first time most of us learn about the special relationship between a man and his chair is in our own living room with our own dad. When he comes into the room, you get out of his chair. Remember Goldilocks and the Three Bears? Who can forget that when this little trespasser makes the fatal mistake, *not* of eating porridge that is not hers, and *not* of sleeping in the wrong bed, but of sitting in the papa chair. We all remember how the Great Huge Bear bellowed, "Somebody's been sitting in my chair." We know what she must have felt like.

Plus, we know ourselves the indignity of having to sit on a phone book to be of proper table height or being exiled to the do-nothing chair. And what about musical chairs, in which we come to associate a place to sit with staying alive in the game. And how nifty is it to have someone younger than you relegated to the high chair, from which no amount of yelling and food throwing gets you set free? In school you squabble over who sits where. "That's *my* chair," we squeal all the way from K through college. Then you graduate and get a nifty captain's chair with your school crest and you can make other people sit in it.

The chair that explains all other chairs, including the one you see before you, is the *throne*. What's a throne but a chair bigger than other chairs, more powerful, more *up* there? In a sense, the throne of God, the throne of the king, and the throne of the father are all what anthropologists call *homologues*. It's all about whose butt goes on the throne. The language may be vulgar, but the point is not. The seat of state is where the king puts his butt. It's all about territoriality. The seat of the church, the cathedral, is where the bishop puts his butt. The Vatican is where the pope sits on the Throne of Saint Peter. When Pope Clement V moved the papacy and his residence to Avignon during the Great Schism, he made sure to take the throne along. When aboard Air Force One, George W. Bush, no slouch when it comes to uttering the inappropriate, likes to wear his nifty jacket with the presidential seal and sit in the big leather chair he calls "the throne." And if we are to trust the Book of Revelation (20:11), God himself sits on a Great White Throne. When kids are taught to pray they often are told they are addressing God on his throne. The throne is a synecdoche of command. He who sit on it rules. The throne is not a love seat. It's a bludgeon.

What are Shakespeare's history plays and tragedies all about if not who sits where? This runs deep in Anglo-American culture. Remember the beginning of Disney's *The Lion King*, in which young Simba is introduced to the world he will inherit. It stretches before him, green, lovely, and abundant, like a beloved country, and the animals line up in hierarchical ordering and supplication to the King of the Beasts, who is sitting you-know-where. It's a scene straight out of Shakespeare, including the evil Scar, who is pure scheming Claudius trying to get onto that throne. And what of Patrick Stewart's self-conscious invocation of Shakespeare's kings every time he plops himself down into the captain's chair on *Star Trek*? Trekkies will tell you how they inhale each time he takes the throne of power.

Perhaps the best picturing of the centripetal power of this chair is the French painter Ingres's *Jupiter and Thetis* (1811). We see the god of the ancients, Zeus (aka Jupiter) from below, seated on his throne high atop Mount Olympus. The Lord of the Heavens is resting his arm upon a cloud, looking very lordly and totally in power.

All he needs is the remote-control clicker. Kneeling beside him and reaching up to touch his chin is Thetis, mother of Achilles. She is begging Zeus to allow the Trojans to win a round with the Greeks. Zeus doesn't look all that concerned about her plight. On the other side of Zeus sits his bird, the eagle, who also looks a little bored. But it's the look on Zeus's face that is so compelling. He's so in control, so dominant, so above it all, so outta here. He's in the catbird seat. And he knows it.

You don't have to be a god to sit in the catbird seat. This seat first appears in the 1940s in a short story by James Thurber called "The Catbird Seat" (you can find the story in *The Thurber Carnival*). In the story, a meek accountant is driven to contemplate murdering a fellow employee who won't stop babbling trite catchphrases, including—you guessed it—"in the catbird seat." And this brings us back to this catbird seat, the papa chair. About the same time Thurber was popularizing the term (which, incidentally, he picked up from sportscaster Red Barber, who got it from a poker-playing pal), two chair companies—La-Z-Boy and Barcalounger—were making chairs specifically to fit our modern living-room version of Mount Olympus. It is from these thrones that our modern-day captain of the U.S.S. *Enterprise* puts on those headphones and slips away into the most popular of his hiding places, the television set. True, on first sight the newspaper is part of the escape route (recall the typical *New Yorker* cartoon from the 1950s of the husband hidden behind the paper, again a contribution of the great James Thurber), but on closer inspection, look at all those remote controls and the audio headset. The guy sitting on this throne is getting *outta here* into the Land Beyond.

"Get outta my chair," Archie Bunker would yell to the son-in-law he called Meathead, and then Archie would take up his throne. Archie's chair, an overstuffed recliner complete with pull lever, now resides in the Smithsonian Institution. How appropriate that Archie's chair was viewed by most males from a chair very much like Archie's chair. This new household throne was something that depended on television; in fact, it is one of the first accessories—along with the TV dinner—for what has become the central appliance of modern life.

Call it what you will—idiot box, electronic wallpaper, plug-in drug, painkiller, chewing gum for the eyes, summer stock in an iron lung, Hollywood films for the blind, dream killer, dream machine, vast wasteland, white noise for the brain, a toaster with pictures—this electronic cubbyhole has put all earlier hiding places to shame.

By the time of NBC's hit sitcom *Frasier* in the early 1990s, the recliner had become a member of the family, kissing cousin of the telly. Recall the trials and tribulations of Martin Crane's (Frasier's dad) chair. The well-worn yellow-green recliner was stage center from the time Martin moved in. Frasier tries to throw it out, clean it up, and push it aside, all to no avail. His dad loves this chair. It's the chair he sat in when Neil Armstrong and Buzz Aldrin landed on the moon. It's the chair he sat in when the USA beat the USSR in hockey during the 1980 Olympic Games. It's the chair he sat in when Frasier rang to tell him that he had a grandson. And most of all, it's the chair Martin falls asleep in. To Frasier it's just a chair, but to Martin it's part of his life. Usually Martin never lets anyone else sit in his chair, but when Sam Malone comes to visit and Martin finds out he was a baseball star, he lets Sam sit in his chair. When Martin's chair is destroyed by fire, Frasier manages to get him a chair that looks identical. Since this particular recliner isn't made anymore, Frasier has to get it specially made, and it is now the most expensive piece of furniture in the apartment.

The focus on the recliner is not happenstance. The recliner is arguably the most significant piece of modern furniture for the male. This chair allowed one to assume the proper supine position for TV viewing, and TV is the escape hatch of modern times. More than 25 percent of American homes now have either a Barcalounger or a recliner from its competitor La-Z-Boy. Beer consumption has increased dramatically since the 1950s, thanks to this chair. Beer seems to be the preferred substance for lowering the viewer into the lazyboy mode. Many TV sets come equipped with "sleep control," which turns off the set after consciousness has been lowered too far. As Newton said, "A body at rest tends to remain at rest." And many chairs have a massage function to pave the way into the ultimate hideout of sleep.

No piece of furniture in modern times is more gender-specific than this one that has cradled, rocked, pivoted, and massaged the American man into the World Beyond. While women have not been moved by *motion furniture,* as the industry calls it, the La-Z-Boy Chair Company flirted with the idea of a La-Z-Girl chair a few years ago, but test markets proved it untenable. Feminism has passed this object by. Men, however, have attached themselves like barnacles to mechanized chairs almost from the day they got launched.

La-Z-Boy even makes regal accessories, like an inscribed tumbler, a key whistle, a cooler, and a remote-control holster. And check out some of the Barcalounger product names: Marquis, Highlander, Hamlet, Westminster, Monarch, Dunhill, Kingsley, Bostonian, Rapture, Churchill, Longhorn, Bentley, Titan, and Apollo. In retrospect, it was the remote-control clicker, introduced in the 1950s but made standard equipment by the 1970s, that really made the recliner into what has been voted "the most emotional piece of furniture in the household." Now you never have to move. On such a throne, bearing the remote-control scepter in one hand and a soothing beverage in the other, the average Joe is transformed into the Master of the Household. Or at least the Master of His Own Chair.

So far, we have been able to avoid the last common use of *throne,* but no matter how comfy he is, sooner or later our Zeus will have to leave the recliner. How fittingly ironic that the other private perch in the modern household is called a throne. In fact, when you look the word up in the Merriam-Webster online thesaurus the one and only synonym you find for *throne* is: "TOILET, || can, crapper, || donicker, head, john, johnny, || loo, || pot, || potty." That the great white throne of God, the ivory throne of Saint Peter, the golden throne of Zeus, and the bejeweled thrones of royalty should be as well the porcelain commode of modern life may testify yet again to the old saw that a man's home is his castle and his throne is wherever he puts his butt.

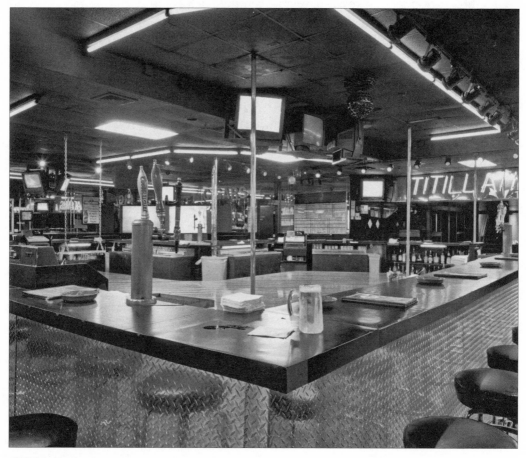

Titillations, New Jersey

11. Strip Clubs

HIDING BEHIND THE OGLE

In the mid-1990s, Lorrie Beno sold auto parts for a Canadian company humbly named Magna International. Magna makes everything from seats and mirrors to running boards and door handles for the Big Three automakers in Detroit. Lorrie's job was to schmooze with the purchasing agents of the car companies and then make the sale.

The competition was intense, as there were many suppliers of essentially the same products. Magna was the fifth-largest supplier in this county and so had to be aggressive. Even today, selling bent metal and plastic is very much a male business. In fact, selling car parts is just about the most *just-us-boys* business there is—right up there with military hardware and trading grain futures. These guys buy and sell exhaust pipes and mufflers, not Tiffany and Rembrandts. They love the *Howard Stern Show* and *Married with Children*. This industry virtually spawned the pinup calendar market. No Gurls Allowed.

Since auto parts are crafted to company specifications, there is not much room for negotiation, or even imagination. It's a relationship

business, and the relationships are between competitive men who, let's face it, are frequently bored. Women can sometimes succeed at selling in such businesses, if only because these men are tired of dealing with each other and want a change of pace.

Back at Magna, however, Lorrie had a problem. The auto parts business in Detroit was often (and still is) conducted over lunch at one of the many strip clubs surrounding the executive offices of the Big Three automakers. Detroit has dozens of these clubs, and many of them have affiliations with particular companies. For instance, GM deals are frequently cut at Trumpps; Ford's HQ is just a few miles from the Wild Mustang Bar and Grille; and Chrysler's white-collar types can be found at Jon-Jon's over in Warren. For a major part of the day these strip clubs are dedicated to the car business. They have direct lines to offices, and a stock ticker runs the endless market news. When the *New York Times* sent a reporter to observe the goings-on in 1997, what she saw was men involved in intense bargaining. They rarely even looked at the girls (Meredith, p. A1). Lorrie was uncomfortable in such a setting. She complained to her bosses at Magna, who did nothing.

Lorrie had an interesting point, however. Why do men go to strip clubs with other men? Part of the allure is that both manufacturer's reps and purchasing agents like to get out of their office cubicles and away from the phone. Part of the attraction is that a little alcohol makes relationships a bit smoother. But most important is that strip clubs provide a venue where men can feel good about their maleness and business relationships can develop quickly. After all, it's a little dark, women are there to make you feel macho, and the experience has the allure of rough camaraderie, or in this case, of hammering out deals. So what looks like men ogling women is really men focusing on work. In other words, these men are using the gyrating women to, in a sense, move closer to other men!

Lorrie didn't sell well in this environment, and since her bosses did nothing to change the venue, she took her clients elsewhere. When Lorrie submitted entertainment expenses of $70 to take clients out to an ice-skating show she was denied reimbursement. Meanwhile other Magna salesmen were submitting entertainment

expenses of more than $300 a lunch at strip clubs and they were being reimbursed. Lorrie was told that clients didn't schmooze well at places like the ice show. She protested. She was fired.

Lorrie sued Magna International for $23.25 million in punitive damages. She said she had been sexually discriminated against by having to endure doing business in a smoky booth while other women were bumping and grinding in the background. She also said that she was routinely grabbed and verbally harassed when her fellow salesmen came back from their liquid lunches. Part of Lorrie's claim was that the atmosphere of these clubs made men hostile toward women.

In the publicity that surrounded the lawsuit, spokesmen for all three automakers did pretty good imitations of Claude Raines in *Casablanca*. They were shocked, just shocked, that their car parts were being contracted for in booths, over lunch, in front of topless women. But of course they knew better. Men who used to do some of this schmoozing at the male-only downtown business clubs had been told by the courts to include women. Now, with the strip clubs, they had found a place to do business where women were not overtly discriminated against; nobody's keeping women out of strip bars—it's just that not many women want to go into such clubs.

Lorrie got her job back, but no punitive damages. Her case, however, cast light upon yet another dim place Where Men Hide. While it may look as if men go to strip clubs to consume confected images of women, often just the opposite happens. They go to steer clear of women—real women—and to be with men. They go there precisely because Lorrie won't. They go to bond with each other. The strip club is more homosocial than heterosexual. As Dave M. Kirchoff, who helps design the assembly lines for car doors at the Saturn division of General Motors Corporation, told the *Times* (while nursing a beer at Jon-Jon's): "You get a bunch of guys in a room who don't know each other, you get drunk and look at naked women and the next day you're great friends" (Meredith, p. A1).

As women have fought their way into enclaves like private clubs and golf courses, where business is supposedly discussed, men have gone into places like bars and restaurants, where topless dancers

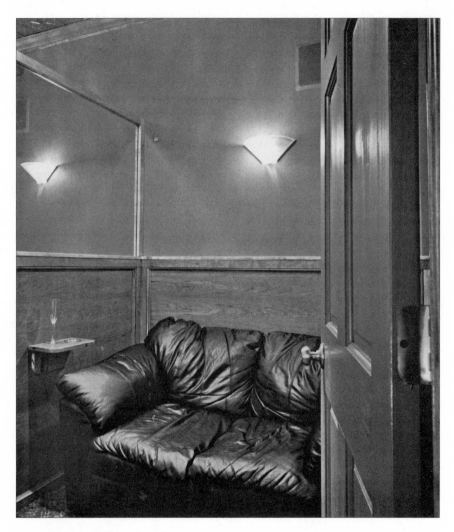

Private dance room, Titillations, New Jersey

gyrate across stages, swing around poles, and cozy up to customers, to actually *do business*. In the strip club the men found the perfect hiding place. It would never occur to any woman that getting drunk over lunch and watching guys take off their clothes was a good way to reach an agreement.

Hence part of the attraction of the strip club is its unattractiveness to women. But note this: many salesmen frequent these clubs not because they are consciously trying to exclude female salespersons but because this setting makes business easier by speeding up the male bonding. And doing business in this setting is not limited to the auto parts industry. Every major American city has its share of topless clubs that cater to business crowds. A 1995 survey by *Sales and Marketing Management* magazine—admittedly limited to a small sampling of 228 people nationwide—found that 49 percent of the salesmen polled had entertained clients in topless bars, but only 5 percent of the sixty-six saleswomen had (Meredith, p. A1).

With the possibility that men go into places filled with smoke and mirrors and topless women because these are places where women wearing tops are not likely to venture, is there any reason to believe that *sex work*, as it is often called by feminists, is not always about sex but is sometimes about male privacy and generating male community? In this sense, perhaps half-naked women are a facade to hide behind. And hide from whom? From fully dressed real women.

Now, admittedly much of the sex work industry is about men being in touch with women, literally. There is not much ambiguity about street prostitutes, call girls, and massage parlor workers. The goal is to touch. Lap dancing, peep shows, table stripping, and some escort services may be a bit more complex, mixing titillation with safe distance. The goal is to look up close but not touch. But what about such institutions as bachelor parties, key clubs (like the Playboy clubs), strip clubs, pornography in general, and Internet porn in specific? Aren't those entertainments really more about generating distance than lessening it? Looking from afar.

As opposed to a *showman*, whose usual job is to show things to men other than himself (think P. T. Barnum), a *showgirl* shows herself (think stripper). She is a kind of two-dimensional woman who

receives the voyeur's gaze but not his advances. When she allows him to get close, it is not to touch but to pay. He stuffs her panties with money, not with himself. Whole industries are dedicated to this transaction. Paris's Follies Bergère, the French Quarter in New Orleans, and the Las Vegas Strip essentially rent the image of the woman to be safely consumed by men, often in the company of other men. Not by happenstance are these convention centers places where men go to congregate and *do business.*

The showgirl doesn't invoke the more complex interactions of reality (aka sex and humanity). "Look but don't touch" is not so much the showgirl's prohibition as it is a relief to the male viewer. So while the strip club may look like a brothel, its meaning is almost entirely to the contrary. Many men may go to the strip club because they can predict safe distance from women, because they know they can be macho without having to be sexual, because they know that now, at last, they can relate to . . . whew! . . . other men.

Observe the *striptease.* The word itself tells you that touching is not the goal. The act is public, not private. You watch with other men. And it ends most often, especially in convention centers, with panties and pasties, not with full frontal nudity. Nudity implies the acts of nakedness; something happens next. Not so with the striptease. A tease protects the viewer. It's only an act; *nothing* happens next. The paradox is palpable. First, as any stripper will tell you, it takes a lot of clothes to get properly almost naked. And second, stripping is really not about nudity and not about sex. It's about power and relationships. The woman may have some power, but the men have the relationships.

A quickie history of the striptease will help show how the strip club has become a modern male hiding place. In the 1920s, the old burlesque circuits closed down, leaving individual theater owners to get by as best they could. The striptease, a minor theme in burlesque, was foregrounded as an attempt to offer something that vaudeville, film, and radio could not. Since there was nowhere else to see a woman disrobing, going to a strip show became a rite of passage.

There are a dozen or more popular legends as to how the strip qua strip was born—telling how a dancer's shoulder strap accidentally

broke, or some similar nonsense. But in fact, it had been around since Little Egypt introduced the "'hootchie-kooch" at the 1893 Chicago World's Fair. To be sure, stripping had been part of stag parties (the word itself is informative) since the eighteenth century. But promoters like the Minsky brothers took the *strip* out of the back rooms and out of burlesques and put it onstage as the tease.

Strippers had to walk a fine line between titillation and propriety—going too far could land them in jail for corrupting public morals, but not going far enough would not allow the men the camaraderie of being teased. Some performers gave stripping an artistic twist and graduated to general stardom, most famously fan dancer Sally Rand and former vaudevillian Rose Louise Hovick—better known as the comically intellectual Gypsy Rose Lee. The audience went along for the ride. H. L. Mencken, the wit of Baltimore, coined the term *ecdysiast* to describe Ms. Lee. *Ecdysiast* comes from the Greek *ekdysis*, meaning stripping, and the highfalutin etymology gave the act a kind of wink-wink privilege. Ms. Lee was often credited with turning the vulgar into the virtuosic, but Mencken actually did part of that job.

Thanks to electronic media, seeing what Ms. Lee had to show is now no farther away than the TV or the Internet. If what the *ecdysiast* has to offer is what the audience wants to see, then the strip club should have disappeared long ago. But seeing the show is not the goal; male bonding is. Observe the cigar bar.

Just as the strip club split from burlesque, the cigar bar devolved from the strip club. In the cigar bar the eye candy has been removed and only the smoke remains. It's the pool hall without the pool table, the deer camp without the deer, the strip club without the strippers. Once again women are not expressly excluded from attending, but the men know full well that only a few women enjoy the smell of cigar smoke. That's the point. While there is no need to discuss the barely sublimated importance of puffing away on a huge stogie, the fetishized behavior of preparing the smoke and lighting it up with much fanfare, the centrality of the competitive expense, and the display of all the accessories, the cigar bar is all about males in hiding. True, sometimes a cigar is just a cigar, but sometimes it's a symbol of difference, of separation.

Thumb through a copy of *Cigar Aficionado* (now renamed *Aficio-nado* with the *cigar* lowercased) and you'll see what I mean. Most of the articles are about cars, golf, game cards, business, and the like. The covers most often feature successful men and their favorite smokes, not sexy women and their half-draped bodies. A typical spread in the magazine used to show the interior of a cigar bar (this was an urban phenomenon) shot in *Architectural Digest* style: lots of overstuffed leather chairs, low, warm lighting, and just good quiet talk between us guys—a locker room done in Naugahyde.

Another place to see the dynamics of the strip club is in HBO's *The Sopranos*. Tony and his family of thugs run a strip club called the Bada Bing. It's the hangout for men doing business: Tony, Paulie, Silvio, Christopher, and the rest of the crew. The name comes from a line adlibbed by James Caan in *The Godfather*, and it has a wonderful sense of the forbidden (Bada) and the frivolous (Bing). It may be forbidden, but it is certainly not frivolous. Anything but. This is where the boys hatch their plans and lick their wounds. The club is co-owned and run by Silvio Dante, Tony's consigliere, played just at the edge of male-buddy parody by the musician Steven van Zandt.

From time to time Tony beats up on someone inside the club, and sometimes he just sits pensively at the bar, but usually he's in the back doing business. No one really pays attention to the dancing girls other than us folks at home in front of the TV set. The dancers are pneumatic and centerfoldy and far classier than any dancers you would really find in Jersey. But they are background scenery to these men. When one of them moves into the foreground, trouble follows. When bully-boy Ralph Cifaretto (Joe Pantaleone) beats up and kills a dancer behind the Bada Bing, all hell breaks loose. He has had the stupidity to mix business with pleasure. In a profoundly disturbing episode—because the death of the dancer is clearly less important than the welfare of the hoods—Tony looks Ralph straight in the eye and slowly, coolly relates a warning from the code of honor. "You disrespect this place," says Tony. "You don't disrespect the Bing." Then Tony pummels Ralph against the Dumpster.

Tony has made his point. Men don't let women get between them when there's business to do. That's what the Bada Bing *means*.

These women are there not so much as skirts to hide behind but more as panties to hide in front of. They are scenery, façade. Look but don't touch.

The futuristic cult novel and movie *Fight Club* picks up on this theme of violence resulting from the absence of real, sentient women. In many provocative ways it is an interesting play on the Hemingwayesque theme of Men Without Women. Set in a world of men forever fidgeting, *Fight Club* depicts a new generation that has grown dull, depressed, and lonely. The young men can't sleep. They have trouble eating. In a sense, they have spent too much time at the Bada Bing. The only time the lads feel truly alive is when they are beating each other up, bare-knuckled. *That* has become their business. They feel uninspired by the safe, nonviolent, voyeuristic consumer society in which they have no business to do. The process of male bonding, while often dangerous to the welfare of others, may be an attempt by the male to generate meaning and purpose in a life in which he has relatively little to hunt. The modern problem addressed by *Fight Club* is, What's left to hunt? Good deals on exhaust pipes? They are men in a state of perpetual frustration. English sociologists have a word to express this behavior: *aggro*.

I certainly don't mean to give too much cultural weight to the strip club or the other places where men go to hide (boxing ring, deer camp, paintball, locker room, bass boat, video games), but perhaps men do need places to build up steam and places to blow off steam, lest the real stuff result (physical aggression, combat, war). They also need to understand the difference. While there is no reason why men can't absorb and discharge this aggro without making life intolerable for women, there is some reason to believe that pantomime hostility is adaptive. Men have a different way of bonding, and ritualized aggression seems to play an important role in tribalization. Certainly from Lorrie's point of view, the men she does business with ought to be able to do deals in a place that is less humiliating to her. It may be small comfort that they are not trying to make her feel uncomfortable as much as they are trying to feel comfortable with each other.

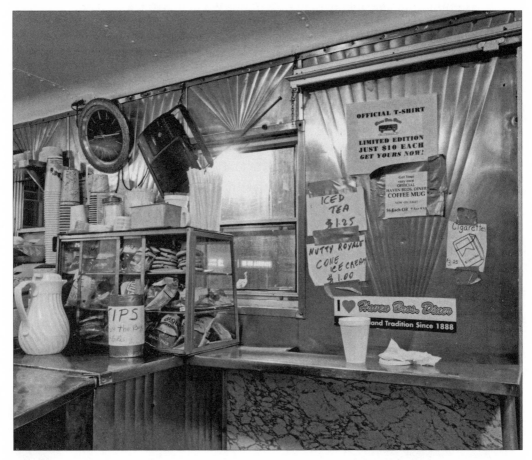

Haven Bros. Mobile Diner, Rhode Island

12. "Aah lurve this place"

THE MALE WAY OF EATING

In 1939 the Swiss sociologist Norbert Elias published *The History of Manners*, the first volume of his monumental work, *The Civilizing Process*. It was a transformative work in the history not just of culture but of gender. It showed how so-called polite behavior was up for grabs. Of all the places Elias went to track down the roots of behavior—bedroom, bathroom, public rooms, churches—none was more historically important and socially contentious than the eating (much later *dining*) room.

In medieval times how and where you ate was a prime site of the never-ending food fight over how to behave. Dedicated eating space took generations to develop and really didn't separate itself from the kitchen until the seventeenth century. By the Industrial Revolution, however, the division of labor had made food preparation and food consumption different activities, involving different clothing and manners and different rooms. Not only did the groaning board move away from the hearth, but activities like blowing one's nose on one's shirt, spitting across the table or into one's fingers, chewing

with an open mouth while using fingers to move the food around, belching, grabbing food off the plates of others, and farting were all—over time and often with much resistance—discouraged.

Then came the development of table utensils: first a spoon—originally one for the whole table and only later, in the mid-sixteenth century, a spoon for each diner, and a century later an individual soup plate, rather than a common vessel into which one dipped one's own spoon—then the knife and fork, and so on until flatware exploded in the nineteenth and early twentieth centuries into such minute distinctions as salad fork, dinner fork, seafood fork, cake fork, cold-meat fork, baby fork, berry fork, cheese fork, fish fork, game fork, oyster fork, pickle fork, pie fork, relish fork, sardine fork . . . The social use of tableware became important not to move food but to settle rank. Do you know your forks? Did you sit above or below the salt?

How do you behave at the table? Do you blow your nose into your hand or onto a newfangled bit of cloth called a *handkerchief*? As with much decorum, this behavior emerged in Italy and France during the Renaissance as a practice of the wealthy upper classes and spread like a virus among the parvenu. The word *etiquette* comes from an Old French word meaning *ticket*. The ticket promised by etiquette is a bit of prescribed routine that grants you passage to a better *class* of people, as the Victorians called social groups. Knowing how to behave around food became crucial if you wanted to get your ticket punched.

One more example, because in it you may see how the modern male often uses etiquette to separate himself: spitting at the table was perfectly acceptable until the rise of eating etiquette. After all, the word *spitting* came from the activity of sparks sputtering from burning wood and the fat of meat boiling on a spit. Wood spat, meat spat, diners spat. Spitting was commonplace in the courts of medieval feudal lords. Gradually it became something one did into one's handkerchief, rather than on the sleeve or on the floor, where other people walk. By the middle of the nineteenth century a special vessel, the *spittoon*, had become a familiar implement in the nicer houses, and by the early twentieth century the container

had slowly evolved from a prestige object to a private utensil. Now, ironically, it's a vase for flowers. Men, however, still use spitting as a bit of rebellion. As we found out in the dugout chapter, professional baseball players won't stop spitting, and that's part of their charm, at least as far as men are concerned. To some degree, it keeps women at a distance.

When you watch animals eat, you realize how socially constructed eating really is. Almost every natural private behavior is now considered impolite in public. The dog growling at the bowl to keep others at bay, the baboons squabbling over portions, and especially the animal—usually male—who grabs the goodies to eat in private are all considered impolite to *cultured* humans. Go to the zoo and observe how human visitors to this insane environment pass judgment on the natural way of eating, and you'll soon appreciate the profound nonsense of manners. You'll also understand why women from Emily Post to Judith Martin (Miss Manners) have been the arbiters of manners, why men are so rarely enrolled at charm school, and why so few of them know the names of the different forks, let alone how to use them. The subversion of manners, however, provides men with the avenues of escape.

Let's look at three kinds of eating venues beloved by some men. They are popular enough to be named: the bar, the greasy spoon, and the barbecue. And here is the question: what is it about these places that makes them attractive to men? Is it the food? The surroundings? Or is it the fact that women don't gravitate to them? What is the relation between social graces and social control? In other words, do men use the subversion of food etiquette to find solace and safety? Do men hide behind food?

SNACK TIME

The photo on the following page shows a box of donuts and three empty beer containers, two glass bottles, one aluminum can. Chances are, the food represented by these containers was eaten by men. If you ever want to see men eating in a relaxed mode, just observe the behavior of workers gathered around the stainless-steel box on the

Breakfast, Salvage Yard, New Jersey

back of the pickup truck that delivers coffee and donuts to garages and work sites. Called in the trade the Office Coffee Service, it is a huge industry, built on the institution of the *coffee break*. This mid-morning break used to occur in the late afternoon. It was switched to morning in the 1930s when coffee failed to replace tea as an afternoon drink. In late afternoon we now have the cocktail hour and Miller Time.

To take in the full meaning of this picture you need to appreciate that it is American puritanism and intense anxiety about alcohol that has made it unthinkable that the Office Coffee Service would ever include morning beer. Not so with Europeans. In fact, one of the more interesting meals in terms of male hiding is the English ploughman's lunch. It consists of a cut of cheddar or some other cheese, a home-baked bread roll, pickled onions, and a pint of beer. It sounds so pastoral, just us shepherds and plowmen out in the field enjoying a break while tending the flock. Peasants really did have such a meal, called "a bait," in which they stopped work often for a beer, a fresh onion, and a little conversation. So, though you might think the ploughman's lunch comes directly from the medieval "bait," it's not so. It was developed post–World War II by distillers and caterers who wanted to encourage a pub lunch as a way to sell more beer and light food free of meal taxes. What is noteworthy about the ploughman's lunch is that now the consumer often eats it alone while reading the paper.

In 1984 the British film *The Ploughman's Lunch* satirized how commercial culture was concocting traditions and selling them back to us as parts of our past that were worthy of celebration. Drinking beer has become associated with working folk, and hence getting drunk on beer has become a rite of passage into real manhood. Wine coolers don't count. Researchers trying to understand "modern masculinity" could save themselves a lot of bother by going down to the local sports bar—our version of the English pub—and just observing. Entry to modern manhood is earned not by sprouting a beard, shooting a deer, or filling a wallet, but by mixing with other men, watching endless sports shows, and getting drunk on beer. The rite of passage ends with peeing in the parking lot. The sports

bar, usually with the word *Hops* or *Brew* in its name, a couple of dish antennae, and a menu of buffalo wings, has become the sweat lodge of modern maturation.

Remember *Cheers*, the NBC hit show that ran from 1982 to 1993? From an ethnographic point of view, this locale was yet another confection of idealized male reality. Thanks to our omnipresent mythmaker, television, you sat in your living room and it was as if you were there on a barstool. Finally, a place where "everybody knows your name." Here was the romanticized picture of men's space, a picture imaged from Hogarth to LeRoy Neiman and etched in print from Fielding to P. G. Wodehouse. The set of *Cheers* was what we had for the Pickwick Club meeting down at Dingley Dell, our Drones Club. Of course, like the ploughman's lunch, it was made modern and thoroughly pasteurized by commercial interests.

The totally phony name Cheers washes away the chauvinist history of the public house from the Bulls, White Horses, Red Lions, Dukes of Wellington, Kings Heads, Foxes (with or without Grapes), Stags, and Cocks that are so much a part of English and American colonial life. Where are their female counterparts, the Vixens and the Hens, the Duchesses and the White Mares? There are none. Women come into this space, yes, but they don't colonize it. And what of the status of women employed in bars? Consider the barmaid, currently celebrated in beer ads and even as the St. Pauli Girl on the beer bottle. She's a floozie.

On *Cheers*, the St. Pauli girl was Diane. There was no replacing her when she left the show; when Rebecca entered, it was as a modern executive woman. Rebecca ran the joint and set her hook not for Sam but for the head of the holding company. She never seemed comfortable in this space.

All the central characters in *Cheers* were defined to some degree in terms of lovable flaws: Sam, the Lothario bar owner and a bit of a dim bulb; Carla, the abusive terror of a barmaid; Woody, the sweet, naive, dumbbell bartender who replaced Coach, the avuncular dumbbell; Frasier, the intense, off-the-wall psychiatrist, and Lilith, his robotic, overbearing wife. The still points between these vibrating characters, however, were the men in hiding, most par-

ticularly Norm, the beer-guzzling, affable cynic who could barely lift himself from the barstool, and Cliff, the blowhard mailman. Every other character changes, but not these two. They remain forever static, hiding from women (whether mother, wife, or girlfriend) and holding down the bar as they have for the last four hundred years.

THE TRUCK STOPS HERE

Although the next image hardly conjures up exclusive masculinity, it does open up a kind of eating that men enjoy: small booth, greasy food, and (what used to be) tobacco smoke. The scene is a counter-point of linen tablecloth and silver flatware. Manners are minimal. The booth, here in a pizzeria, is probably seen in its purest form at the truck stop—or in what has now become the truckers' section of the truck plaza.

Years ago the truck stop was also known as a *greasy spoon*. This poetic metonymy did justice not only to the flavor (grease) but also to the viscous nature of man's food (ladle needed, not a fork). From omelet to baked beans or mashed potatoes to pot roast, meat loaf, beef stew, spaghetti and meatballs, chicken-fried steak to biscuits the size of hubcaps, and gravy everywhere, this was cooking from the Land of Crisco. It was hard to categorize restaurants while driving along the highway, but the sure sign that a place offered tasty (greasy) food was a parking lot full of trucks. Now that the interstate highway system has turned the *truck stop* into the *truck plaza* or *travel center*, the tastiness is not predicted by the number of eighteen-wheel tractor-trailer rigs in the lot. Once inside, however, note the segregation of the truckers (or *drivers*, as they are known there) and the rest of us. The greater the separation, the more hidden the men, and the more likely that the spoon really is greasy.

I used to stop at the Jarrell Truck Plaza on the Doswell exit of Interstate 95, just north of Richmond, Virginia, about midway from Maine to Florida on the well-traveled route. In many ways the Jarrell Plaza is a typical male hideaway. The plaza has the usual lines of diesel pumps that can transfer a hundred gallons in a few minutes and a so-called truckers' travel store with CDs and tapes, as

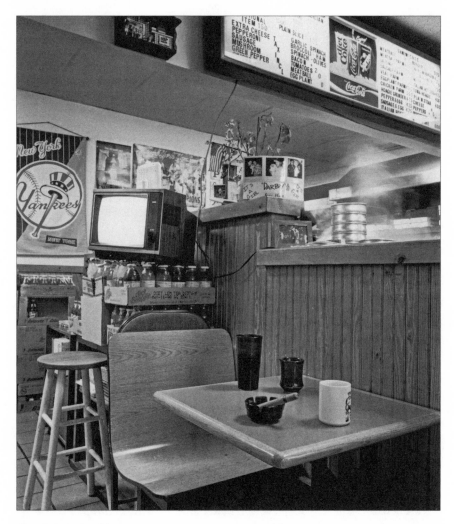

Pizza, Yankees, cigars, New Jersey

well as baseball caps ("AOL Sucks") and T-shirts ("Sure, Lincoln Was a Great Man. But He Was No Truck Driver") that are bought by the tourists. For the pumpers of diesel, or course, there are special showers, laundry, TV lounge, ATM machine, drive-thru truck wash, and everywhere the remains of a culture that used to communicate by land-line phones. The stems of pay phones and jacks are all over the place, while the drivers now walk around with the omnipresent cell phones stuck against their ears.

What makes a truck plaza like Jarrell's modern is not that the public is let in but that they are kept out. The dining room is divided into two areas: one, rather stark, for the truck drivers, is in the back near the kitchen. The other, up front, with large murals of past, present, and future Virginia, is for the people who buy the hats and T-shirts. The tourists are charged a premium of about 10 percent more than the truck drivers. But in truth those in the rear would probably happily pay the premium to be left alone.

The menu is filled with *easy food, comfort food,* or if you want something more descriptive, *already digested food.* A sure sign that it's for men is that the term *home cooking* is prominently featured on the menu. For years Jarrell's was known for having not professional cooks but rather women who just loved to cook. Supposedly they never followed a recipe. On a good day the kitchen can easily send out more than two thousand meals of pulled-pork barbecue, batter-dipped flounder, fried oysters, crab cakes, mashed potatoes, corn muffins, hush puppies, stewed tomatoes, beans, hotcakes with maple syrup, creamed chipped beef on toast or biscuits, eggs with bacon, pork brains, corned-beef hash, home fries, grits, bread pudding, shortcake, cobbler, and all kinds of pies. At the checkout you can finish off with a touch of Tums or Pepto-Bismol.

Should you consult a pamphlet titled *The Vivarin Guide to America's Best Truck Stops* (Vivarin being caffeine caplets that supposedly increase alertness), you'll find that "the truckers' room" is a fixture of most plazas. Sometimes it's family-style service, with men eating at long tables that have the food in the center, but more often they eat in booths, each of which is fitted with a phone jack. Often the walls are decorated with pictures of trucks. So if you are headed

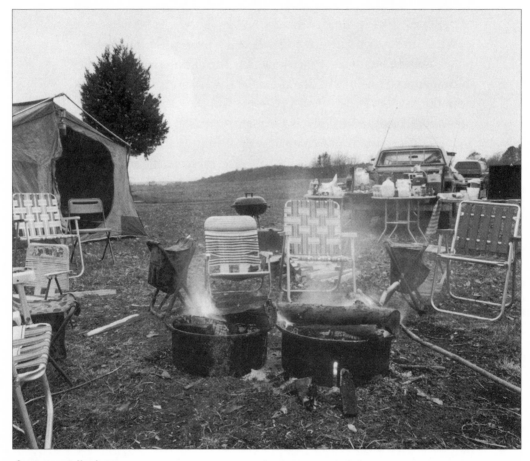

Scout campout, New Jersey

across Kansas, the Beto Junction Travel Plaza will afford you the same privacy that you can find at the Derrick 76 Truck Stop, exit 71 off I-85, Salisbury, North Carolina; or the Ranch Hand Truck Stop, 2 miles north of Montpelier, Idaho; the Giant Travel Center, about 120 miles west of Albuquerque on a lonely, sagebrush-lined stretch of I-40; Dixie Truckers Home, exit 145 off I-55, McLean, Illinois; or the Green Shingle Service and Restaurant, exit 5 off I-90, Fairview-Erie, Pennsylvania. As is often the case in the modern world, however, you can also choose to stay out of the rig and just slide into the Barcalounger, open a cold one, put on the trucker's hat and T-shirt that you bought at the truckers' store, and watch *World's Best Truck Stops* on the Travel Channel.

SMOKE, FIRE, BLOOD, SWEAT, AND BEER

So far we have talked about men's eating. Here is an image of men's cooking. A huge industry has been built over these pots of charcoal, so perhaps it's worth a closer look. Once again: might part of the appeal of this kind of environment be that women don't find it appealing?

Make a fire in a pan. Call it a *hibachi*, if you want; the point is that this is caveman cooking. You throw some rhino meat over the flames and cook it till it's singed. The woman's way would have been to make a fire, put the rhino in the pot, and then put the pot on the fire. That's because women would be concerned about what's in the pot, not how big the fire is. "Playing with matches" has probably been a little boy's peccadillo since the first chemical spark. Little girls have other interests.

Now you can appreciate the genius of George Stephen, who introduced the first kettle-shaped barbecue pot in 1951. Tired of complaining about flat, open braziers that exposed his food to wind, ashes, and charring flare-ups—such as you see here—he decided to put a lid on it. That way the male gets to play with his fire, yes, but the fire also generates enough heat to actually cook, rather than merely char, the meat. Over time, Stephen perfected damper controls, ash catchers, and racks to hold charcoal up where air can circulate,

thereby providing greater draft and more-even heat. His company, the Weber-Stephen Products Company, still holds the patents on the eponymic Weber grill.

Stephen's next innovation was almost as revolutionary. He put legs on the kettle so that the cook could be standing up, be in the company of his male friends, and be only a few footsteps from the beer. Standing there in solitary splendor watching curlicues of smoke ascend from the kettle into the summer sky (and fall back into his face), the modern male has found a safe redoubt. No one but his compatriots dares disturb him. He's part of a modern brotherhood that encompasses the almost 80 percent of American homes with backyard barbecues and a fraternity that stretches back to the first cave chef, who realized rhino tasted better burned than raw.

Charcoal in the kettle was soon replaced by the gas flamethrower. The propane-fueled grill with knobs and gauges is now used by most backyard cooks. You fire it up by making a spark. This method replaced the endless squirting of lighter fluid, which held the minor excitement of singeing a few beer drinkers after you ignored the instructions telling you never to squirt it on burning coals. Another problem with lighter fluid was that it always left a telltale stench of petroleum fumes in the rhino meat—and elsewhere. Now, with gas, you can just grab a hunk of meat the size of Sri Lanka, throw it on, check the number of beers necessary to consume per side, drink them up, and then off it comes. A digital thermometer does the work of sticking your hand down into the fire and counting one-Mississippi, two-Mississippi.

Push-button ignition, volcanic rock briquettes, rotating spits, and all manner of scented chips, turners, forks, brushes, knives, tongs, aprons, stainless-steel marinade injectors, and triangle dinner bells have made this activity rather like the shop in the cellar. Has the barbecue become the new garage?

There are now stores that sell only BBQ rigs. The things themselves have gone into the Land of De Luxe, where flamethrowing has become yet another venue of conspicuous consumption. Retailers say that after one person in an upscale neighborhood buys a grill the size of a Porsche, within weeks a handful more will be

sold in the same area. Here's an idea of what you can buy for about $6,000: Weber's Vieluxe new professional series stainless-steel three- and four-burner unit is so big you just about need a pickup truck to move it around; Jenn-Air's entry into outdoor grilling features gas-powered burners that can pump out a combined 130,000 BTUs—too hot to use inside a house; and Frontgate's Ultimate Grill includes both built-in grills and ready-made tile-and-stucco cooking islands to place them in, the option of gas or wood fire, and an electric elevator mechanism that adjusts the height at which steaks sit above the flames.

As with much else in the male equipment repertoire, brands often overlap. For instance, a golf manufacturer has created a huge barbecue spatula and fork with real golf-club handles and also offers a basting brush that looks like an oversized wooden golf tee. Whiskey distillers like Jim Beam and Jack Daniel's both market barbecue sauces under the names of the bourbons. Men appreciate this kind of linkage. They understand it.

Consider the official Harley-Davidson Grill. This 50,000-BTU stainless-steel, bow-tie burner can sear steaks, as chefs at upscale steakhouses do, and it has all the industrial-strength gizmos you'd expect from the other top-of-the-line rigs. But it has something else as well. On the grill cover is the Harley Bar and Shield logo, so too on the grill hood, and ditto the warming rack. You can buy a branding iron with the same logo to emboss your steaks.

Clearly, this is not just about cooking. It's about affiliation, escape, and display. Admittedly, only about 2 percent of the grilling market is buying these rigs, but it's revelatory of what advertisers call "aspirational goals." As Gussie, a character in Eric Bogosian's play *Griller*, says to rationalize the $3,000 barbecue he buys himself for his birthday, "I grill, I relax. I get mellow. It's like therapy." It's not *like* therapy; it *is* therapy. Barbecuing has become, to use a bit of psychobabble, self-medication.

Remember the scene in *The Right Stuff*, the movie about America's entry into the Space Age, when the seven Mercury astronauts are being feted by Vice President Lyndon B. Johnson at a Texas-style barbecue? They are just standing around having a few brewskis

Barbecues and car parts, New Jersey

with LBJ. The scene captures a moment of reflection among these seven men, a realization that, despite the hurly-burly surrounding them and their individual differences, what is most important is the bond they have come to share. The scene unfolds slowly around the smoke, grilling beef, and beer. No words are spoken; you just hear music drifting along softly as, one by one, each looks at the others, aware that they have now gone tribal.

Barbecuing is no longer just a Fourth of July and Labor Day event, either. Now it lasts all year long, even in the snow. Why? Is it just the fire? I think a central reason is that this activity allows men to speak to each other. Grills are becoming a central part of male clustering rituals because in a barbecue situation men, as opposed to women, who seem to need no pretext to congregate, can speak to each other in terms of barbecue sauce and marinade, cuts of beef, and angles of slicing. Just go into a bookstore and look at the number of books on grilling for men, some with titles like *Diggin' In and Piggin' Out* or *Al Roker's Big Bad Book of Barbecue.* Turn on your television set and notice the number of shows like *BBQ with Bobby Flay* or Emeril's endless tailgating events, which consist of convivial Mr. E pouring on hot sauce to the chant of "Let's take it up a notch." As the revered American gastronome James Beard once wrote about modern barbecue: "Grilling, broiling, barbecuing—whatever you want to call it—is an art, not just a matter of building a pyre and throwing on a piece of meat as a sacrifice to the gods of the stomach" (p. 143).

If there are certain places where men go to cook and to eat, in part to be alone or to be in the company of other men, is it possible that there are certain foods that signal gender separation? If you look at how food is marketed to men, you rarely see claims of healthfulness. The more usual claim is masculinity. Swanson's Hungry Man dinners have the tagline "It's Good to Be Full," a good thing, considering the company's launch of XXL versions of fare such as Salisbury Steak, Classic Fried Chicken, and Angus Beef Meatloaf. Hardee's has been going gangbusters with its Monster Thickburger, two one-third-pound slabs of Angus beef, four strips of bacon, three slices of cheese, and mayonnaise on a buttered sesame seed bun, coming in at 1,420 calories and 107 grams of fat. Prime audience?

Eighteen- to twenty-five-year-old men. Super Size Me. Or what of Vibe, Coors's flavored brew marketed as Zima's "wild cousin." Not the wisest of marketing tactics, to be sure, but it was aimed at the malt liquor drinkers, who are predominantly inner-city men. U.S. troops are supplied with one-eighth-ounce bottles of Tabasco sauce in every Meal Ready to Eat. Men consider it manly to pour it on. To some degree, the allure of a food like beef jerky is that most women don't want to go near it. Spam, straight from the can, is preferred by men. Napoleon said an army travels on its stomach. He didn't say what was in that stomach.

Want to see the same process occur independent of victuals? Observe the huge market, almost entirely male, in smokeless tobacco—snuff and chewing tobacco. *Snuff* is put between the cheek and the gum, while *chaw* is wadded in the cheek. Smokeless tobacco is sometimes called "spit" or "spitting" tobacco because men spit out the tobacco juices and saliva that build up in the mouth. Almost no women want to be near this smelly stuff, let alone consume it. Men go into dugouts or off to deer camp to really chew and spit the stuff in bulk. Could part of the attraction of *going smokeless* to males be that it is repellent to females?

The reason the title *Real Men Don't Eat Quiche* is mildly humorous is because we know that certain foods, like vegetables, sun-dried tomatoes, ciabatta, and *all* tofu, are from Venus, not Mars. On the other hand, consider meat. In fact, Mars himself, the god of war, could tell you the history of men and beef, the connection between blood and violence, and the perceived homeopathic qualities of eating animal flesh. Beef finds its truest expression in the warrior, an über-masculine figure who fights for his tribe. Achilles eats nothing but beef. The Mongol hordes lived on raw meat, or, more politely, *boeuf tartare.*

Meat is central in Anglo-American male culture. In the seventh century, Saint Augustine wrote to Pope Gregory explaining that the newly converted Anglo-Saxons loved their meat so much that they would not eat fish on Fridays. Recall that figure of extreme masculinity and carnivorousness, Henry VIII, a portrait of whom eating a steak and kidney pie used to hang in the old British Library. The

English Beefeater is a national icon for a reason. So too the American cowboy. Some vegetarian feminists believe men eat meat in order to dominate women, but could it also be that the sexes have evolved different tastes as a way of signaling a need for separation?

After he was president and before he had his quadruple heart bypass, Bill Clinton was a goodwill ambassador to various places. He spent some time in Blackpool, England, joined by the actor Kevin Spacey. The *Daily Record*, a local newspaper, on October 3, 2002, related their evening out through an eyewitness:

> Office worker Mary Caldwell was stunned to see the famous pair out for a late-night meal with Labor spin doctor Alastair Campbell. The trio gorged on junk food just hours after the Labor Party conference gala dinner in Blackpool on Tuesday.
>
> Flanked by burly bouncers, they walked into McDonald's on the Golden Mile and ordered up a £15 feast. Clinton, famed for his love of fast food, ordered a Steak Premiere meal with large fries, his actor pal opted for a quarter-pounder meal, while Campbell munched on a Big Mac and fries.
>
> The trio also shared 20 chicken nuggets and washed the meal down with three Cokes. And, after sampling the culinary delights of Blackpool, Clinton was overheard remarking to Campbell: "Aah lurve this place."

<div align="right">(quoted in Kuntz, sect. 7:3)</div>

Dick's tools, North Carolina

13. The Workshop Warren

HAMMER TIME

What is before you here is a smorgasbord of hand tools: wrenches (adjustable, Allen, socket), awls, saws (rip, crosscut, hacksaw), sanders, staplers, clamps, caulking gun, chisels, pliers, drill bits, T square, files (flat, rat-tail, rasp), hammer, mallets, hand plane, knife, nail set, paintbrush, screwdrivers, hand drill, pry bar, sandpaper, snips, drills, soldering iron, staple gun, vise, wire strippers . . . The pegboard holding the tools and the work space are in a basement or a garage. Three questions: how did this stuff get here, why was it so important for men about a generation ago, and where is it now?

Here's how it got there. At the beginning of the twentieth century a subtle shift occurred in the concept of man in the home, *Vir domesticus*, or, as Rutgers historian Margaret Marsh calls it in *Suburban Lives*, "masculine domesticity." In the pre–Industrial Revolution world, the place of man was in the field and the barn. To the Victorians, the proper place of man was in the burgeoning marketplace and perhaps in his private club. After World War I, with the rise of single-family housing, the male found himself in a peculiar

position. He was half in and half out of the house. And he's stayed that way until quite recently, when, as we will see, women have taken hold of exactly those tools we see on the previous page, many of them now electrified, and sent our crabgrass hero out to the barbecue to figure out where to go next.

Here's the startling fact of American home life that in part explains the tools: while the absolute number of owner-occupied homes went up from fewer than three million in 1890 to more than thirty million in 1960, the percentage of dwellings occupied by owners increased from 37 percent to well over 60 percent (Gelber, p. 68). By the end of the 1950s, there were ten times as many homeowners as there had been in the Gilded Age and proportionally far fewer people living in rented housing. Given nothing more than this, it was inevitable that home maintenance, home workshops, Do It Yourself, and—here's where it gets tricky—masculinity itself would be directed toward Mr. Fix-It and his work belt full of tools.

What makes this assertion tricky is that at the end of the Victorian era fixing things in your house would have been considered wimpy, not manly—in fact, an activity to be avoided. The people who used the tools that you see in the photo were tradesmen who had a history of hand labor that extended back to the medieval guilds. Working with your hands was precisely what marked you as "one of them," as what social evolution was moving away from—sweat, calluses, and sunburn. For instance, if you look at early soap ads you'll see that the emphasis is not just on getting clean but on getting whiter, less suntanned. So Pond's Vanishing Cream claimed that it "softens and whitens the skin." Or consider the importance of men's dress shirts a century ago. Pictures of successful men in the early twentieth century show them proudly decorating their chests with all manner of stickpins, watch fobs, chains, and ties, all of which are markers of the distance between them and the working class, between, as it were, them and their own hands. Cuffs and collars were signs that you were not *one of them*, the workers of field or factory. You were the new man, Master of the Universe. They were, in a wonderful Victorian coinage, part of the *mobile vulgus*, the rabble on the move—the mob. They used hand tools; you didn't.

Two cultural developments changed all that and made it possible for a gentleman to roll up his sleeves, whack a nail, and saw a board. The first shift, an aesthetic one called the Arts and Crafts movement, had its intellectual source in the writings of William Morris and critical heavyweights like John Ruskin in England. In North America the revolution was sponsored by the appropriately named "Craftsman" style popularized by Gustav Stickley. Straight lines, exposed joints, natural materials, and, above all, honestly made objects became central. Little wonder that Sears used *Craftsman* to brand its line of hand tools.

In a strange way, the fraternal movement typified by the Masons echoed the noble history of honest hand workers. The Masons even divided their guild history into "operative" Masons, who really did the building of Gothic cathedrals, and then, during the eighteenth century, the "speculative" or "accepted" Masons, who enjoyed the brotherhood without the work connection; hence they were called Freemasons. The Masons wore little aprons, a vestige of their operative stage, testament to the importance of hand-work-well-done. Not by happenstance do these two male movements—craftsmanship and fraternal order—dovetail at the turn of the twentieth century.

The other influence that collapsed the separation between social status and hand labor was the rise of mandatory education. But this institution that was to do the dividing between us and the mob, between literature and pulp fiction, between art and advertising, between classical music and dance hall music, between brainwork and handwork didn't always do the job. Oddly enough, vocational education came from Russia in the late nineteenth century as a way of introducing *shop* to middle- and working-class boys. For the Russians such schooling was a function of necessity; for Americans it was a function of marketplace economics. Vocational ed was the tribute that the arts and sciences paid to reality. Hence courses in woodworking, metalworking, and even mechanical drawing and auto mechanics joined the belles lettres in the curriculum. Such courses were for boys and boys only, however. The girls had home economics. By the 1980s, school-based "industrial arts" had been relegated to vocational-technical schools, axed from regular high

Nord's world, North Carolina

school curriculums by declining enrollments, budget cuts, and a preference for more academic coursework. As we will see, it was about this time that women entered the home workshop.

A key to understanding these tools is that they are hard for girls to use. They are called *hand tools* for a reason and they take *elbow grease* to operate. You have to be strong in forearm and you have to be co-ordinated with the eye. You have to learn how to saw, how to drill a hole, how to plane and file. This is not plug-in-and-go woodworking. It's slow and patient. It takes *time* and *space*.

The *time* came from the shifting concept of the workweek. In the machine age, you did your forty-plus hours and the workweek was over. The weekend is a modern invention, a function of the Industrial Revolution. In an agrarian world you worked whenever you wanted. In the machine age you worked whenever the engines were running. No more "keeping Saint Monday," or not working on Monday in order to drink. Instead, Saturday became the day to get drunk, Sunday the day to get sober, and Monday the day to get back on the job. Hence, Blue Monday.

So if the weekend provided the *time* to Do It Yourself, what about the *work space*? Here man's best friend was not the dog and the doghouse, but the auto and the auto house. The rise of automobile ownership added an attachment to the house, which, by proximity to the internal combustion engine, was drenched in grease, fumes, and maleness. The garage became a fixture in a new kind of mini-estate that existed outside the web of streetcar and rail lines—sub-urbia. The great suburban developments, which really took off after World War II, like Levittown in the East and the thousands of Northern California houses constructed by Joseph Eichler, added to the basement the new male spaces of garage and unfinished attic. To be sure, the unenclosed carport and the shallow-roof attic weren't much to work with, but since everything was connected by plywood and used simple carcass construction, any man who could cut a straight line and hammer a nail could furnish his whole house, from his basement (if he had one) workshop to his chil-dren's attic (if he had one) bedrooms, to decking-out his garage (and he had one).

Do-it-yourself project that always wins praise (Corby's ad, *Collier's*, October 1, 1954).

The missing link was how to do it, and here compulsory education saved the day. For just as mass literacy had made women's shelter magazines (*Ladies' Home Journal, McClure's*) a vast storehouse of decorating tips, so men's technical magazines (*Popular Mechanics, Popular Science Monthly*) provided the construction plans. As tools became less operated by muscle and more often run by Redi Kilowatt (thanks first to the portable hand held drill from Black & Decker and then the Sears Craftsman table saw), the Do-It-Yourself movement became both a craze and an acronym.

Here, have a look at an October 1, 1954, ad from *Collier's* magazine for Corby's whiskey. This guy has more than a power drill and a table saw; he has a lathe, with which he's making that nifty rocking chair. The body text explains:

> If you have one of America's twelve million home workshops, here's a truly rewarding do-it-yourself project: make up some pleasing Corby's drinks next time friends drop by to see your work. Your drinks, like your shopwork, will bring you a round of praise.

What's noteworthy about the "round of praise" is that it's clearly coming from other menfolk, not from his wife. Presumably, she's also impressed. A few months earlier, home improvement had become so trendy that *Time* magazine's August cover featured a caricature of a suburban man riding a lawn tractor while simultaneously using six power tools. The headline read: "Do-It-Yourself: The New Billion-Dollar Hobby."

So what happened to the basement shop, that place for men to hide and have an experience rather like, at least according to the ad

copy, what you would find at "your favorite bar or tavern"? Do we dare mention the dreaded word, scapegoat for all modern troubles, destroyer of the male lair? *Television*, more specifically, cable television, did the job.

When you look at the criticism of television you find one continually repeated refrain: this medium has transformed culture more than all others because it does something unique, it tells secrets, it tells how to do things. These secrets are about history, politics, behavior (especially sexual behavior), sports—you name it. Any kid with a remote-control clicker can access shows that hold sequences he or she would have had to grow into, or learn by careful reading and questioning, not have delivered unexpurgated in sight and sound.

And what are the video images that transformed the male tool warren and made it a safe place for women? What show outed *homo faber* and showed him to be a pretender to the *work*shop and *work*bench, pretender even to *handyman* and *Mr.* Fix-It? What show set up the exploding market for pre-trimmed and pre-pasted Alexander Julian wallpaper, ready-to-assemble vanities and cabinetry, water-based Eddie Bauer and Nickelodeon latex paint to be applied with a Laura Ashley roller, floor tiles that did not require gritty cutting equipment, and all manner of plug-in saws, drills, and shaping equipment? What show turned the light on in the man cave?

No, not *Martha Stewart Living*. The show that exposed the workshop came from what was supposed to be educational television, that kind of television at odds with mob taste and matters vocational—*This Old House*, starring first Bob Villa and Norm Abram and later Steve Thomas and Tom Silva. For almost thirty years *This Old House* has done to D-I-Y what the endless cooking shows have done to gourmet cooking. It has demystified and democratized something usually incredibly mysterious to the other sex. The secrets we saw revealed were not that handyman construction was easy to do, but that it was understandable. We learned not that the words and tools were beyond our ken but that they were within our reach. And, most important, we found out that we could talk about and think about

home craft in a refreshing new way. Just as the kitchen had to give up its secrets, so too did the workshop.

The renovations featured on *This Old House* were huge—walls were regularly bashed, floors ripped up, and plumbing wrenched out—but they were achieved by means of step-by-step components. These components, in truly modern fashion, have now spun off into a multimedia empire. Since 2001, when PBS sold the program to Time Warner, the show has morphed into what the new owner calls a "multimedia lifestyle brand." Today, in addition to magazine, books, and Web site, the brand features a growing TV empire. The original half-hour *This Old House* TV series is now joined by *Ask This Old House* to form *The New This Old House Hour*. There's also another spin-off, *Inside This Old House*, which appears along with endless reruns of the other shows on cable, and a handful of magazines devoted to specific aspects of home repair.

Two ironies have since developed. In the same way that people are watching more cooking shows but doing less actual cooking, the fixer-upper genre is exploding at a time when male homeowners are tackling fewer do-it-yourself projects. Observers blame a variety of forces for this shift: an aging, affluent population; the growth of white-collar jobs; and even the demise of high school shop classes. But the biggest factor may simply be the increasingly busy lives of suburban professionals, for whom home improvement is becoming a task to be outsourced, not savored. Often they watch the shows so they can better understand the work someone else is going to do for them.

And the other development is that D-I-Y, which had since World War I been the preserve of men-in-workshop, has become an aspect of interior decoration and self-esteem and rapidly absorbed into an aspect of affirmative action. You can change your life. So the *Old House* Media Lifestyle Brand moved up from the cellar, down from the attic, and in from the garage to become shows like *Trading Spaces* and *Queer Eye for the Straight Guy*. Both of these wildly successful entertainments gleefully subvert the tool-belt stereotype of Mr. Fix-It. They are joyous. They celebrate transformation. In the former, a perky hostess encourages the womanly fun of making over

someone else's space, and in the latter a team of gay guys encourages the manly fun of making over a straight man's space. Essentially, they turn the Corby's ad on its head.

And in so doing they have both become Media Lifestyle Brands themselves, spinning off a constellation of imitators. In *Merge* and *Love by Design* we see how young marrieds cope with taste differences; in *Make Room for Baby* we follow mothers soon to be in labor laboring over what should be in the nursery; in *Design on a Dime* different designers get a thousand dollars to show what they can do with the same space for that amount of money; in *House Rules* three couples compete in decorating

When the kitchen's done . . . (Motrin ad, 2005)

tasks to win a home; MTV's *Crib Crashers* allows you to decorate a room in the style of your favorite celebrity (usually a rap artist or sports hero), and on *Help Around the House* we seem to spend lots of time finding out how simple jobs can be when they are broken up into small parts. Two cable networks run this stuff in endless loops: HGTV and DIY. What these shows all have in common is that they celebrate the redemptive joys of starting over, living afresh, and they are, in case you haven't guessed it, D-I-Y from the female POV.

Whereas the male went to the shop for peace and quiet (perchance to hide), his wife goes to express herself (perchance to come out of hiding). In the 1950s, the male bought those tools you see pictured by going into a usually dark hardware store presided over by mysterious old men in aprons who seemed to call nothing by its appropriate name. A nail was a *ten penny*; a screw was a *hexagonal-*

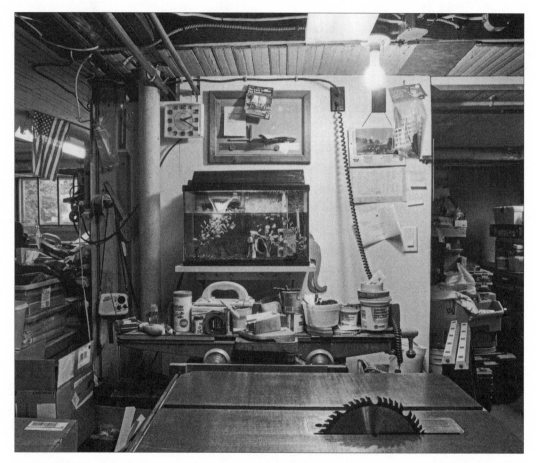

Dave's table saw, New Jersey

recess shallow head. The hardware store, like the barbershop, the locker room, the deer camp, and the garage, was gendered space, all right, and the gender was not female. Again: No Gurls Allowed.

But now, take a trip to Home Depot or Lowe's, and what do you see? The aisles are bright and wide, and although stuff is stacked, high most objects are within reaching range (2.4 meters), the branded objects are in colorful packages, and the space is relatively uncluttered. Women all over the place. And not just behind the cash registers. They are wearing the orange aprons, and they don't talk about *ten-penny* nails when *big nails* will do. Here, in a potpourri of statistics, is what's happened:

- Nearly three-quarters of American women ages 25 to 49 express more confidence in their ability to do home improvement projects today than five years ago, and they are eager to learn more (Roper ASW)
- More women would rather do projects themselves (26 percent) than let their spouse do them (23 percent) (Harris Interactive)
- The majority of home improvement purchases are decided on and made by women (statistics from Ryobi Tools and Imre Communications)
- 55 percent of women consider themselves to be qualified do-it-yourselfers (Sears Craftsman survey of more than 1,000 women)
- 90 percent of women are comfortable using power tools, 77 percent actually own some power tools, and 57 percent prefer store clinics to any other learning process (Lowe's survey)
- More women own their own houses; in fact a 49 percent increase in home purchases by women occurred from 1989 through 2001; 57 percent of single women now own their own homes (National Association of Realtors)
- 37 percent of women surveyed said they would rather do home improvements than shop (28 percent) or cook (25 percent) (Yankelovich Partners)
- Women are now responsible for 38 percent of do-it-yourself product purchases (American Hardware Association)
- In dual-income households women initiate about 80 percent of all home improvement projects (National Hardware Show)

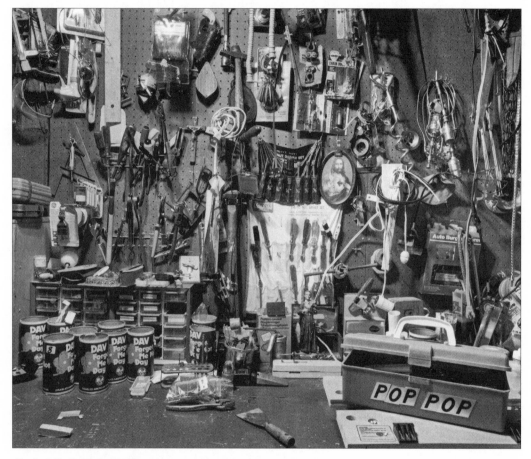

Pop Pop's Peg-Board, New Jersey

- 45 percent of women said they'd purchased hand tools in the last twelve months, and 26 percent said they did all or most of the routine maintenance in their households (Home Depot survey)

The hottest area now in hardware is "gender-based tools," also called "fashion-forward tools." So Barbara K Enterprises, founded in 2002, sells tool kits, from a thirty-piece do-it-yourself line that includes basics such as a claw hammer and a two-in-one level, ergonomically designed to fit women's hands, to more-specialized arrangements like the picture-hanging kit and dorm-room survival kit for Missy. "No Pink Tools" is Barbara K's motto. Tomboy Tools is a direct-sales company in Denver that sells tools the same way Tupperware is sold. The women make a party of it. Rubbermaid Tough Tools are aimed at casual do-it-yourselfers, who most often are women. RotoZip Tool Corporation launched Solaris, a power saw that is smaller, lighter, and more compact than the original design. Solaris even comes in trendy colors. Black and Decker has all kinds of tools for women, keeping its DeWalt line for the men. And if you ever wondered why Sears started advertising "The Softer Side of Sears," now you know. Ironically, the company was caught on the wrong side of D-I-Y, having cast its lot with men back in the 1950s. So it now lightheartedly calls Tool Territory a "toy store for men" and runs ads under the headline "Over 18,000 tools. Collect them all." In one television commercial we see a young couple with the man admiring different types of drill products as the woman hands him a small black drill and says, "Why don't you just get this one?" Stunned, he gasps, "I'm beginning to think you don't even know me!"

And so one more male lair has been removed from the inventory of hiding places. Do-It-Yourself Divas have colonized the space that Rosie the Riveter passed by in order to get back into the kitchen. Such an irony that the big-box stores, long criticized for being cold and heartless piles of stuff out by the interstate, should instead be far more compassionate and transformative than the local hardware store. No wonder women have taken to shopping for plumbing fixtures just as they would shop for shoes. If you ever want to know why you shouldn't be using a 20-amp circuit breaker on a 14/2 wire

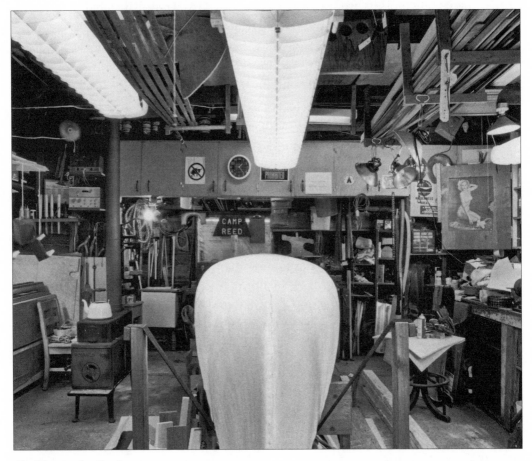

Charlie's canoe shop, New Jersey

or what goes nicely with ceramic disk faucets, just ask one of those eternally kindly salespeople. Home Depot's motto is "You can do it. We can help" and they mean it—as their "Do-It-Herself Workshops" attest. Who needs a man when you've got Home Depot?

So what's a guy to do? Not much. In truth, it seems that the fellows really didn't care that much about life alone in the shop. According to a Harris poll, most men secretly ranked home improvements just slightly above visiting their spouse's family or shopping for shoes with their spouse. Now that the women are in the tool room, the men have moved to the Barcalounger to watch *This Old House* with a cold brew in hand. What do you make of this possibly telling statistic: about the same amount is now being spent on residential repair and remodeling as on consumption of beer—about $200 billion? In a move to generate some synergy from these trends, the Maytag Corporation, which has had a history of knowing what women want, a few years ago introduced the SkyBox, a personal vending machine that can hold up to sixty-six 12-ounce cans or thirty-three longnecks. The SkyBox even has shelves to hold favorite snacks: chips, pretzels, peanuts, or Slim Jims. But it'll take more than the SkyBox to get the modern male back into the workshop. First, *she's* got to go.

Jim's hidey-hole, Vermont

14. On the Job

HIDING OUT IN THE OFFICE

This is where I work in the summer. It's not much in the way of an office, but it's just enough. What makes it just enough is that the space is all mine and my wife and daughters have trouble getting in. We call it the "hidey-hole," and it's decorated, as you may be able to see, so women won't feel at home. The bed seat to the right is hard and the pillows are lumpy. There used to be a Gary Larson cartoon on the door that said something like "Of course it's a mess; whadya expect of a rat's nest?" Other memos on the door reassert the puerile treehouse theme: No Gurls Allowed. And there's a stick-on decal from some do-good organization saying that if there's a fire, save the baby and pet inside, but I've changed that to "geezer." The walls are covered with magazine ads that I've been too lazy to file away, and there's stuff like clothing and tools hung on the walls. On the ceiling are large pasteboard Nissan car ads that I've acquired along the way and didn't want to throw out.

The hidey-hole is built on a cement pad that used to support an aboveground septic tank. When the little summer community that

The Royal Balmoral and the Royal Oxford sheds (Royal Outdoor Products pamphlet)

this camp is part of decided to install a central sewer system, the tank was removed, and I built the study (10 feet by 15 feet x 8 feet—about the size of Thoreau's cabin or Saint Francis of Assisi's cave) to replace the tank. Needless to say, people who are uncomfortable in this space often remark that although the box may be different the use remains the same.

I know that this space is special to men. Not only do I entertain occasional passersby who tell me how nifty it is, but whenever I go to big-box stores like Lowe's or Home Depot I note those little prefab sheds in front getting smaller and smaller like Russian dolls. These sheds are supposed to be for tools, but I suspect they are also so the man of the house can find a house he really can be man of. If you watch late-night television on ESPN or Spike or the Discovery Channel, you will often see these sheds advertised. The small ones are rectangular; the large ones look like Quonset huts. They often come with a door and little windows, just like a child's playhouse. Sometimes they are done in the style of a log cabin. In the ads, they are invariably populated by men.

In the American Southwest, when stud horses and bulls have done their business they are often taken out to an enclosure where they bide their time and "cool their heels." In cowboy patois, these enclosures are called *loafing sheds*. I think that's the appropriate descriptor of these prefab sheds, as they appeal to the middle-aged male looking for privacy, a place to loaf. If you can call it an office, so much the better.

Back at my supposedly full-time job in Florida I have what is called a real office. It's about the same size as the hidey-hole, with a single window that was designed by CPAs to be hermetically sealed shut. With the energy crisis in the 1970s it was retrofitted with a center panel that opens. There are some filing cabinets and full-wall

bookshelves. There's a chair for a student to sit on while complaining about a grade and a relatively magisterial chair for me that has all kinds of controls on it to make it "ergonomic." The chair even has a wonderful name: it's the Leap chair by Steelcase.

On the ceiling are all manner of fire and temperature sensors and those fluorescent lights that tell you yet again: this is office space. Supposedly the lights are in concert with the ambient light coming in the window, but it's usually too bright to get any work done. You cannot turn them down, only off and on. An office, whether a single room, a partitioned cubicle, or a completely open floor, is usually lighted by those ceiling-mounted fluorescent lights. Behind my back is the usual stuff thumbtacked to the wall, and there are in-and-out baskets to give the place a sense of getting things done. As well, there is a ratty chair and an adjustable reading lamp.

This space, both in its summertime disarray and in its formal supplied-by-the-state setting, is commonly called *an office*. The concept far predates modern business. Not by happenstance is there a link between religious space and the hidey-hole. Before the Industrial Revolution, the Church was responsible for most non-manual labor. Not only did *office* refer to the church service (an authorized form of divine service or worship like the Mass), the rank of station in the church (as the office of archbishop), the quality of religious acts (for example, the office of forgiveness), the ecclesiastical courts (the Holy Office was the department of the Roman Catholic Church responsible for final appeals, especially in heresy trials), but, most important, *office* referred to the precursor of the modern hidey-hole, the office of the confessional.

With the Industrial Revolution this concept of privileged space, sacred space, closed-in space was lifted up and deposited down on the organization of manufacture. One of the first instances of self-conscious private office space was in a pottery complex called Etruria, built in the 1770s by Josiah Wedgwood. He and his chief merchandiser, Thomas Bentley, closed doors between themselves, not out of spite but from a new appreciation of division of labor. Certain things happened on this side of the door; other things happened on that side.

Although the concept of office was linked to the entire enterprise, as in the *front office* or the *head office*, the private office became the place of decision making, of planning, of organization. By the mid-nineteenth century, clerks who had worked side by side with their bosses were slowly separated from them. The secretary, a religious rank that literally meant "keeper of secrets," moved to an outside desk, giving the supervisor still more privacy. Of course the number of such secret keepers and the size of the supervisor's private space soon became a display of corporate rank.

About the same time that the office became private and personal, the importance of job titling was recognized. What is the job called? Who is in this office? Take my job, for instance. By the early twentieth century, titles like instructor, assistant professor, associate professor, and full professor started to appear, as did corporate titles like vice president, comptroller, and director. The physical office announced the relative importance of each of the ranks. At my school every tenured faculty member has such an office. Only about half of them are really used. It would be inconceivable to suggest that we share offices and heresy to suggest that a full professor share with an assistant professor.

The name on the door became the crucial signifier not just of who's inside but of where he or she is on the food chain. For instance, my name is on the outside of the door to my office. It's *my* office. My place to hide. Some wag suggested that the names of non-tenured colleagues should be held in place by Velcro, but you get the point. The name itself implies importance. As the old Bigelow carpet ad used to say, "A name on the door deserves a Bigelow on the floor." The carpet means you are not tracking dirt; you are not doing manual labor; you are clean, cerebral. The carpet on my floor is, alas, hardly deep pile; rather, it's a variety of something that would go nicely beside an outdoor swimming pool. My colleagues squabble not over views but over square footage, because there are so few other separation devices. Corner offices rule.

In this context of generating privacy, the office desk itself becomes central, literally and figuratively. The early Victorian business desk was the rolltop. If you were ever looking for a place into which to

disappear, here it is, as any child will soon show you by opening and closing the lid and dropping down between the massive pedestal legs that contain the drawers. When the personal computer was introduced in the 1970s, the nomenclature of files, locks, folders, and especially security was ultimately lifted from the rolltop. You opened up and closed down your computer just as you did a rolltop. The password was your key.

In a sense, the rolltop desk is a bit more than a laptop computer because everything can be put inside, including almost yourself. You can't hide behind a laptop. But the *laptop* does pay possible homage to its ancient predecessor. The *rolltop* design came from the French *bureau*, or writing table that has drawers and slots. The bureau developed that strange pull-down or tambour front in the eighteenth century as the need for security increased. This transformation took place in France, where dealing in secrets was at the heart of statecraft. The earliest rolltop was made for the master of skulduggery, Louis XV, and it needed a specialist to open and close it. Over time the strips of wood on the quarter-cylinder roll were glued to a canvas backing, lighter oak replaced mahogany, and that made the operation much easier.

The open pigeonholes inside the rolltop were designed for filing everything from love letters to business correspondence. They are the CPU (central processing unit) of the desk. What's in the pigeonholes is what makes the literal rolltop so important. The etymology of *pigeonhole*, incidentally, shows the quicksilver nature of metaphor: the same people who were using the slots for filing papers were also building dovecotes and training a new kind of urban bird, the White Racing Homer, to carry the kind of secret information that might be stuffed into this desk and then locked up tight.

By the end of the nineteenth century, the rolltop with its pigeonholes had become an extension of a new functionary, the desk clerk, who did his own copying and filing. What really changed the office and made it modern was, however, not the need for secrecy; it was the need for copies, more and more copies. The process of endless duplication became primary office work on both sides of the Atlantic, as Dickens and Melville duly noted. Recall Bartleby the scrivener and

Two desks: rolltops from Montgomery Ward, 1895, and standard double-pedestal flat-top executive, 1920s

Bob Cratchit at their desks, like monks transcribing the text not of glorious redemption but of dreary business.

The invention of telegraphy only speeded up the carrier-pigeon process and made the rolltop yet more anachronistic. Just as lightbulbs rendered candles and kerosene lamps obsolete, the telephone allowed instantaneous and direct communication between workplaces as well as within a single company. Speed became not just a concept but an organizing principle of work. Enter the clock and with it the attendant studies of efficient motion, which culminated in the transformative conclusions of Frederick Taylor's *Principles of Scientific Management* in 1911. What was copied by hand was soon reproduced by typewriter, carbon paper, mimeograph, and then, much later, by photocopy. Exit the rolltop.

While these innovations made management more efficient, they just about wrecked the workplace as gendered work space. Gone along with the rolltop was the male clerk. In his place was a whole new constituency of office worker, the female transcriber. Thanks to universal education (1870s), which made literacy common, thanks to periodic wars (especially World War I) that constricted the supply of men, and thanks to yet more office machinery like the dictagraph (later the Dictaphone) that was layered over stenography, the landscape of the office profoundly changed. The office often became one large floor of desks. Up front, peering over all the workers, was the supervisor, usually perched on a raised platform and able to separate workers from shirkers. The flattop desk, or the drop-down typing desk, made such observation easier. The female typist became the pigeon, the desk her pigeonhole.

"Soft" service companies such as banks, insurance companies, and governments joined hard-goods manufacturing companies as entities dedicated to wringing the last ounce of labor not just from the factory floor but from the office desk as well. By 1920, clerical work, which was an almost exclusively male occupation in 1880, had become equally divided. And in some occupations, like telephone operator, census taker, postal sorter, and currency cutter, the clerks were all female. Men had proved undependable. Or untrustworthy.

The office was transformed not only by the changes in the copy technology but also by the fact that offices could be piled up one on top of the other like so many Lego blocks. The office building, made possible by two almost simultaneous developments—the elevator and the steel frame—completely reversed the accepted rule of value: the closer to the ground, the better. Now the higher up the office, the higher up the executive food chain, the higher the rent, and the more expansive the view. *Top floor*, *penthouse*, and *executive suite* became vague homologues. In New York City a thirty-story office building was completed in 1899, a forty-seven-story office building was completed in 1908, and a sixty-story office building was completed in 1913. By the early twentieth century, office buildings in Manhattan and along the Chicago Loop were unprofitable if they were under seven stories tall. The office building became the cathedral of capitalism, with the high priests huddled at the top.

And as the lower offices became just another dreary aspect of mill work, the home reasserted itself as safe haven. The male

Masters of their domain (commanding office views from AT&T and Gulf Refining, 1930s and 1940s).

Men who live for tomorrow

FOR certain scientists of the Gulf Refining Company, the present does not exist. Their eyes are on the future— for their duty is to forecast tomorrow's motoring needs.

These men must bring to their tasks a gift for scientific prophecy and a genius for perseverance. Theirs is a task in which release most live happily toward with imagination.

"Will changing engine design call for a

radically different motor fuel? These men must develop and perfect it. Will tomorrow's streamlined cars call for an oil able to resist airplane speeds? These men must make such oil a fact.

Already the results of their foresight have been notable. For one of the Gulf Research Laboratories came the Alchlor process of refining motor oil—probably the most significant single achievement in the history of lubrication.

From these laboratories came Gulf's process for retarding gasoline deterioration. From them, too, came a process which cut the cost ten times over of an essential industrial chemical.

Gulf products could be kept abreast of the times without the Gulf Research Laboratories. But in any contest for leadership, the laurels must go to the organization that walks with eyes fixed ahead.

GULF REFINING COMPANY

who was subordinate at work became dominant at home. In the office he wore the special attire of rank and watched the clock. At home he wore what he pleased and set the schedule. But even that lair was problematic, for the female who rarely "worked" outside the house became the chargé d'affaires of home life. Before 1860 the Western male was as likely to choose the furniture for the living space; after the turn of the century, *she* took over. Here is Elsie de Wolfe, who along with Edith Wharton was a doyenne of American domestic taste:

> We take it for granted that every woman is interested in houses—that she either has a house in course of construction, or dreams of having one, or has had a house long enough to wish it right. And we take it for granted that this American home is always the woman's home: a man may build and decorate a beautiful house, but it remains for the woman to make a home of it for him. It is the personality of the mistress that the house expresses. Men are forever guests in our homes, no matter how much happiness they may find there. (p. 5)

Should you ever have wondered why the early twentieth century was also the Golden Age of the men's club, now you know. Men developed a third place—not work, not home, but the Woodsmen of the World, the Moose, the Masons, the Elks, the Improved Order of Red Men, and all the other fraternal safe harbors.

One of the intriguing ironies of the office/home separation is that the higher the office in executive rank in the office building, the more it resembles the home. The corporate president rules from a room that often looks like a domestic living room. As the

great curmudgeon Thorstein Veblen observed in *The Theory of the Leisure Class* (1899), the successful male tends to deflect conspicuous consumption by having his wife and servants wear the plumage that he denies himself. So in late Victorian times the footman and butler were decked out to the nines, the wife was decorated like a doll in birds' feathers, and the office—his hiding space—was designed to look just like the home he was spending so little time in. The corporate man put comfy chairs, antique desks, lamps, paintings, carpets, and the like into his lair, while his wife was doing the same at home.

One of the most interesting places to see this was in the executive offices of the J. Walter Thompson Company, an early and prosperous advertising agency. In the 1940s, as offices were slowly being transformed into the male version of what home life should be (secretary as wife, underlings as children, boss as parents), Stanley Resor, the innovative CEO, encouraged top execs to have their wives decorate their offices. He himself replaced the conference room with an exact replica of an elegant country house sitting room and created a facsimile of a colonial dining room complete with wide, rough-hewn floorboards. The point was that you were working at home, with family, even though you were in the heart of Manhattan, twenty stories up in the Graybar Building, where the pastoral views were of the side of Grand Central Terminal. Many executives spent the night in their offices.

Perhaps the best example of the executive office as hidey-hole is the Oval Office. The office in which the president works is not located in the White House proper. It is in the building for executive offices, commonly called the West Wing. In 1909, when William H. Taft was president, an Oval Office was built in the center of the West Wing. In 1934 President Franklin D. Roosevelt had the West Wing enlarged and had the Oval Office relocated to the southeast corner of the wing. It was then that FDR added all the framed pictures of family, the antique surrounding furniture, the sofas, the sash window with mullions, the wainscoting, leather-bound books, and the portrait of paterfamilias George Washington by Charles Willson Peale over the fireplace. FDR understood the importance of

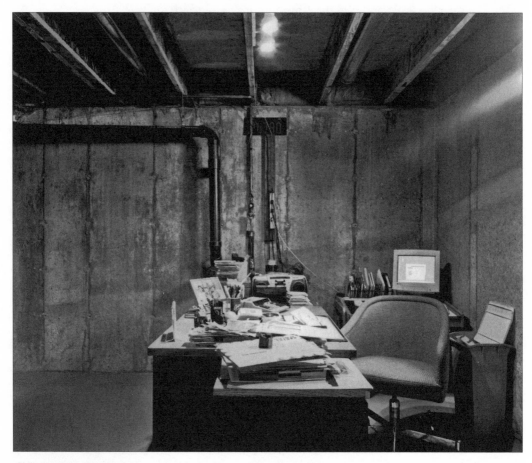

Rick's basement office, New Jersey

mimicking home space, of taking us into this room for the fireside chat, of showing just enough of his private space to make us think we were special.

This lesson has not been lost. When the president speaks to the nation on television about personal matters, it is usually from this room. It's just like being in Dad's den, except that on the ceiling is a bas-relief of the presidential seal. Not for nothing did President Clinton consider this a trysting spot. It was his turf. And not for nothing were so many people distressed. He was doing this not in *his* office but in *our* house!

The office became a progressively more comfortable experience as the traumatic damage caused by the copying systems was assimilated. But then in the 1960s came the computer. Not the big UNIVAC, which meant workers had to be literally wired together, but the PC and the loose network that fed a smart terminal. Just as typewriters had forced the redesign of desks decades earlier, computers and related equipment transformed office space again. A new specialty of design called *office landscaping* (from the German word *Bürolandschaft*) was developed in West Germany in the 1960s. This purely functional plan uses uniform lighting and freestanding screens to provide comfortable vision for the worker and space flexibility in the office.

But soon that was beside the point. For by hooking the computer up to the phone line or the coaxial cable, you could remove the workstation from the office entirely. In fact—aargh!—it could be taken home. With a wireless modem, it soon became possible to transmit data from one computer to another while having coffee or a beer.

There is currently a huge industry of clairvoyants-for-hire trying to envision what this will mean to the office. Will such Wi-Fi hot spots become the new fraternal orders? If you listen to Starbucks' advertising, you will see that Starbucks intends to become what is called in marketing "the third place." Not home, not work, but the third place. And if you listen to some sociologists, like Ray Oldenburg in *Celebrating the Third Place*, you may become convinced that the office is kaput and that cafes, coffee shops, beauty parlors, general stores, bars, and hangouts will become the next hidey-holes.

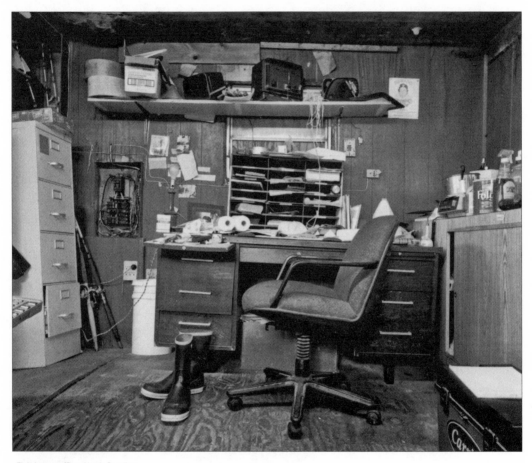

Fish house office, North Carolina

I don't think so. I think the demise of the office has been greatly exaggerated by those who think that the office is just work space, not hiding place. Some years ago, Jeb Fowles, another sociologist, wrote a fascinating book called *Mass Advertising as Social Forecast: A Method for Future Research*. His thesis is that advertising does not stimulate desire as much as reflect it; it's more a mirror of generalized aspiration than a lamp of specific desire. Therefore, ads are a good predictor of shifts in lifestyle. If you look at specific ads from the 1950s, you'll get a pretty good picture of general life in the 1960s. With this in mind, watch the current ads on the daytime business shows from the financial networks like MSNBC, Bloomberg, Fox News, and CNN. One of the recurring themes is the happy male working at home. All alone. By himself. The sponsor is usually a discount brokerage house. Our hero is working online and has no need to go into the—ugh!—office.

So in a typical TV ad, this one for Fidelity Investments, we see a middle-aged man in sports clothing moving around what looks to be a well-appointed office—books, potted plant, polished antique desk, deep carpet. Computer monitors are blinking, and from time to time he's on the keyboard. It soon becomes clear he's trading. And successfully. Now it's day's end, and he's closing out his positions. Just as he finishes, the office door opens and in comes his perky ten-year-old daughter, who jumps into his loving arms. He's been working at home! He carries his daughter out of his home hidey-hole and enters the world of his loving wife and kids.

Is this the future? I'm not sure. I think the desire for private space, for separation, for movement away from the putative comforts of home accounts for such conundrums as long commute times in single-driver cars and the amount of needless business travel. Cocooning, nesting, staying connected, hiving, homeshifting—call it what you will, the idea, at least for the male, may prove to be better than the reality. For many men, going to the job is a function not of need but of desire. Command Central for most men is not the little room off the kitchen. And although "it looks like an office" may strike women as criticism, to many men it's just what they want—a

desk behind a door, a little world made private, at some distance from the wife and kiddies.

There are two interesting, although dubious, places to observe the male's connection with his desk and chair: first, *The Office*, a dense and dour BBC television show, and second, an observation (perhaps apocryphal) about how out-placement firms are organized. *The Office* is probably the most accurate and perceptive current ethnography of the modern work space. It's so on point that many people find it impossible to watch. In the spirit of *Spinal Tap*, *The Office* is a mockumentary about a "typical workplace" that just happens to be appropriately located in a town called Slough, outside London. True to the history of the office, this office sells office supplies, most specifically paper. Work is organized around staplers, files, desks, computer screens, and the omnipresent telephone and its answering machine. Corporate lingo hangs in the air, a dreary dirge filled with the language of anxiety: *redundancy, downsizing,* and the eerie *rightsizing*. This office is a ship of fools, captained by the insufferably pompous and inappropriate David Brent (played by Ricky Gervais, who co-wrote the show) and the crew, most importantly Gareth, an officious team leader who is territorial about his space, and Tim, an unambitious sales rep who, while the smartest person in the office, is maddeningly self-defeating. They all use the office space as hideout.

In a sense, all characters are a foil to Tim. He is the modern Everyman, linked by employment to a pompous boss (who has an office with a name on the door and inspirational sayings on the wall) and an idiot coworker (whose desk adjoins his and whose never-ending bickering is clearly a way to pass the time). Even Tim's office love life with the receptionist is doomed by his own self-willed isolation. Tim could get promoted, but he refuses. He could go back to university, but he never applies. But here's the kicker (and it's true for all the major characters): the office is not what they want to escape *from*; it's what they escape *to*. While the office may be a dysfunctional family of anxious males, it's the best family they've got.

And the other observation: a few years ago, Renee Loth, a reporter for the *Boston Globe*, recalled that she had read (was it an

urban legend?) of an out-placement firm that dealt with upper-level executives. In a telling bit of commentary, she explains what supposedly happened when these once high-powered men were out on their own:

> The firm offered support for the erstwhile managers as they embarked on their job searches, providing a warren of cubbyholes equipped with phones and tasteful artwork in a pathetic imitation of the aeries where these executives had once been masters of the universe. A pecking order quickly emerged: The unemployed who showed the most initiative and got in early nabbed the one cubbyhole by the window. (p. 10)

While this might well be apocryphal, it has the same ring of truth as the BBC's *The Office*. As pathetic as the territoriality of the male worker may be, it is not to be easily dismissed, as commentators from C. Wright Mills to Studs Terkel can attest. Men want their space. But why? And it is here, mixed in with status displays, pecking orders, and modes of aggression, that we might also consider the need to hide, to get away, to be alone, to be momentarily safe. While the home may be a refuge from work, modern work is often a refuge from home.

I'm reminded of a poem by Robert Frost called "The Wood-Pile" (1912). One winter the poet is out deep in the woods, far from any habitation. He comes across a neatly stacked woodpile, a perfect cord of hardwood. He wonders how and why a man would come this far to do this work that had no ostensible purpose. Frost concludes that whoever cut, split, and stacked this cord of wood did it for the solitary joy of working alone. In a sense, the woodsman hid in this woodpile, covered himself in the work. We rarely think of work as a place to hide, but it may be that the Benedictine monks, whose motto is *Labore est orare* (To work is to pray) may have also implied *Labore est latere* (To work is to hide). After all, for the ancients the *oratorium* was a place for private prayer (work) and for personal separation (reflection). In a sense, the modern office still serves this purpose.

Men's ministry room, New Jersey

15. Male Bonding for God
MEGACHURCH AND PROMISE KEEPERS

PART I: THE MEGACHURCH

Take a look at any medium-sized city of today. In almost every city over 200,000 there is a church growing like Topsy, doubling its membership every few years. These new churches result from a strange confluence of marketing, population shift, consumer demand, consumption communities, entertainment economy, a yearning for epiphany, and, as we will see, the ancient and awkward desire of men to bond. These churches even have a new name: they are called *megachurches*.

While scholars may call them "postdenominational churches" or parts of the "new apostolic reformation," megachurches are more commonly called "full-service" or "seven-day-a-week" churches. Detractors call them "shopping-mall" churches. Since the baseline criterion for megachurch size is ten thousand members, those who are still less impressed call them "McChurches" or "Wal-Mart Churches."

What these churches call themselves is more interesting. Here are the names of some of the largest: Wooddale Church, Over the Mountain Community Church, Mountain Valley Community

Church, In the Pines Community Church, Saddleback Valley Community Church, Willow Creek Community Church, the Fellowship of Las Colinas, Mariners Church, Calvary Chapel, the Church of the Open Door, Community of Joy, House of Hope, Gateway Cathedral, New Life Fellowship, Seneca Creek Community Church, Cedar Run Community Church, Sea Breeze Community Church. As opposed to their brethren who proudly proclaimed their presence by posting small signs on the outskirts of town notifying all passersby that a Methodist or Episcopal or Presbyterian church was nearby, these places have something in common: they whisper no word of a denomination. But note the reiteration of *community* in their names.

To a considerable degree the new megachurch is a stand-alone community dedicated to filling exactly those needs that the old-line church off-loaded. By taking on roles as various as those of the Welcome Wagon, the USO, the Rotary, the quilting bee, the book club, the coffee shop, the country club mixer—and, of course, the traditional family and school—these "next churches" have become the traditional commons/villages that many Americans think they grew up in and can now find only on television. They are the First Church of Mayberry RFD. Here's another role they've taken on: that of the Masons, the Odd Fellows, Moose, Elks, Lions, Improved Order of Red Men, and the rest of the single-sex fraternities that have been pretty much decimated by the rise of television, the Internet, the automobile, and the new bogeyman, feminism. When you get inside these fortress churches you find bunkers of small cells of men.

On the surface, the allure of the megachurch is that it also self-consciously subverts the church you grew up in—your parents' church. In the old-style church you sat on hardwood pews. You were quiet. You got dressed up in scratchy clothing. It was dark. From time to time, you knelt and prayed. When you sang it was usually to the words and music of some minor poet of the late eighteenth century. You had trouble reading the tiny words in the beat-up hymnal, and the music was dolorous, even morbid. The minister was in control, and he wore this control not only in his black clerical garb but in his pacing of the ceremony. Now let us sing, now let us pray, now let us put some money into the shiny plate, now let us sing and pray

again, now let us get outta here. The only male groups were the deacons, old men shuffling around collecting money in golden plates, and the Boy Scout troop, youngsters tying knots in the cellar.

The megachurch turns all this upside down. You sit in stadium seating, just like at the Cineplex, except there are no drink holders. Casual clothing barely describes the dressed-down look. In fact, there is almost an aggressive insistence on informality, as if to show the genuine nature of voluntary spirituality. Music is overwhelming, coming not from a pipe organ but from a synthesizer or, better yet, a real live band. The band foregrounds instruments like the saxophone and drums, precisely those instruments that were once condemned as sensual and vulgar. When the congregation sings, the words are flashed on large drop-down Jumbotron screens. Instead of moving through interminable verses, the songs essentially double back on themselves like bubble-gum music or advertising jingles. It's like easy listening Top 40 tunes—refrain, text, refrain, refrain. Almost half the service is just at the edge of dance music. You lift your arms heavenward not just out of adoration but because it's a move borrowed from the dance floor.

In a strange reiteration of the medieval service in which an exemplum called a *morality play* was performed in the apse by what were called *humour characters* (essentially stereotypes who represented sins forever pestering the heroic Everyman), in the megachurch service a playlet often precedes the sermonette. So if the day's topic deals with some form of coping with workaday problems, as it most often does, we first have the problem dramatized for us. Trouble with the spouse, anxiety about the job, friction with the kids, making ends meet—such is the subject matter addressed by the music, the playlet, and, to a lesser extent, the sermon. The chicken-soup-for-the-soul sermon lasts about as long as a few commercials.

The service is packaged, just like a television show, and it's fast. It's one step ahead of the remote-control finger. On the way out you can often buy a CD or audiocassette of exactly the same service you just saw. After all, the service was projected onto those huge drop-down screens, just as the football game is played out on the scoreboard screen, and the electronic altar allows instant replay.

As you can see, the megachurch gains much of its energy by subverting what it meant to be denominational. Often the minister will even chirp, "Well, this is not your father's church." And he's right. The service is not coming from afar, there are no hymnals, no robes, none of the accouterments of headquarters in either the Vatican or Memphis. This is freestanding religion, just us *doing church*. You are never lost during the service. Karaoke Christianity.

In this context the minister is usually an evangelical entrepreneur, not in the tradition of pant-blowing Elmer Gantry or sleazy televangelist Jim Bakker, but as a kind of Jay Leno, whose job it is to pack 'em in over the weekend so that some of 'em will stick it out during the week. In fact, in most megachurches the weekend services are the loss-leader (often candidly called Christianity 101 or Christianity Lite) that leads to the real business—the midweek service. That's where the money is made, where tithing occurs. That midweek church is, as you might imagine, rather like "your father's church." Pay up or be shamed.

To get all this dehydrated community to sprout, you need the right seed, the right consumer. And who is that consumer? Men. Women want to do church and they will take the kiddies. But men are the keystones. As Kenneth L. Woodward, religion reporter for *Newsweek*, detailed some years ago, although there's a man up front in the pulpit, up to 80 percent of the people in the pews are women. Religion in America may be man's work in public, but in private it's run by, and for, women. "In short," he says, "religion in American life is not only privatized; it is also domesticated, identified with the side of life away from work, from the civic and the public; away from the side which, rightly or wrongly, is identified with the masculine" (p. 12).

The exit of men is hardly a new observation, but it is becoming more and more the norm, especially in the traditional denominations. How to get those men back is the dilemma of what is called the Church Growth Movement, a consortium of those denominations. Sociologist Rodney Stark demonstrates in *The Rise of Christianity* that early Christian communities were disproportionately female, and a few years ago cultural historian Ann Douglas demonstrated (in a book of the same name) how the "feminization of American

culture" was played out in American Protestantism. After all, the church valorizes exactly those things that women want and men are not so sure of: to wit, marriage, fidelity, and family life.

You can see why men want to stay home. They want to watch the game. They don't want to talk about virtue. They don't want to be told they are sinners. They don't like to kneel and pray. They want to rest up, not be hit up. And they don't like to sing from books that are hard to read, in tunes that are hard to follow. In fact, many men don't want community if it means being a "family man." On Sunday they want to hide in the cellar, the garage, the game, the office, the Barcalounger, the den, the deer camp. But if you can find a way to get them into your church, they are super potent (and super dangerous). The oxymoronic Army of One. Those guys with face paint at the football game. They make the crowd; they give it excitement and purpose.

Should you even wonder about the relationship between male bonding and denominational growth, simply consider the Mormon Church, or the Church of the Latter Day Saints, or simply LDS, as the church now prefers to be known. Although theologically fraught (most notably by the ability of Joseph Smith to read the Golden Tablets while the vision of everyone else was mysteriously occluded, and the behavior of Angel Moroni, who appears at mysterious times), LDS has been the fastest-growing denomination in all Christendom. But why? You have doubtless seen those nice young men in the white shirts who come knocking on your door to talk to you about your life? Sometimes they are on bicycles, but always they are so neat and tidy. Admittedly they are out proselytizing for membership, but what they are really doing is bonding with a group of about fifteen other young men. For two years they move through what amounts to basic training, in which they link up not with women but with other males. Rather like kids in the kibbutz, they stay linked for life.

The insight that men are the key to church community—in many ways the tipping point of megachurch growth—was discovered some years ago by Bill Hybels, impresario of Willow Creek Community Church. Willow Creek is the über-megachurch outside Chicago,

and still the trendsetter. In 1975, as a twenty-three-year-old, Hybels wondered why so many people claimed belief yet so few went to church. So for six weeks, eight hours a day, six days a week, he and some members of his youth fellowship went door to door asking questions worthy of George Gallup (Sammons, p. 1). The questions flowed into each other, so he knew how to follow the concerns of his respondent upstream to the spring of anxiety. Here's the conundrum he was trying to solve: if so many are self-called Christians, why do so few go to church? Do so many sports fans stay away from the game? Do so many shoppers avoid the mall? Why the disconnect between claim and attendance?

The answer was surprising. The impediment to family faith was, in a word, *men*. They balked. Here's how he discovered this. He started his questions with: "Do you actively attend a local church?" If the answer was yes, he politely went on to the next house. Why waste time? If the answer was no, however, he asked, "Why not?" and charted the responses. Here are the common refrains: "Churches are always asking for money." "Church services are boring, predictable, routine, and irrelevant." "All you do is stand up and sit down." "I don't like being shamed." When he could speak to just men, he found out their hidden reason: men don't like being religious in public. It's not that they are not eager for the epiphanic experience, it's that they prefer that it not be displayed. In the company of women, men don't want to be seen being told to sing, lift their hands, lower their heads, say stuff, or give anything. They don't like losing control. They like the sense of voluntary activity, of doing something, of questing, exploring the edge on their own or in a tribe of Just Us Men.

If there is one marketing secret Hybels learned, it is this: Men are the crucial *adopters* in religion. If they go over the tipping point, women follow, children in tow. But men are exquisitely sensitive to the very thing women seem to like in church, namely, authority. When they have to cede too much independence, they won't budge. They get spooked. And Hybels knew exactly how to comfort them. He gave them a new name. His parishioners were known as *seekers*. And he gave the service a new subject: *felt needs*. In looking over

his sermons for the last decade (they are listed on the church's Web page), you can see an almost Dr. Phil inventory of subject matter. Male adjustment is key: adjusting to your children, to a spouse having an affair, to apathy, to abortion, to debt, to divorce, to drugs, to competition, to being lonely, to not measuring up, to repetition, to sloppiness, to lust, to anger, to being passed by, to racism, to growing older, and, well, to just about everything that men especially would prefer not to speak about in public.

Hybels took the niche marketing approach a stage further. He even renamed his target. He called his seeker *Unchurched Harry*. If you can get these Harrys to melt down and reconstitute, you end up with *Iron John*. *Iron John* is not an unconsidered term, for men in groups will go through blistering fires to be forged together. These are the guys who charge the hill to blow up the pillbox or drill down the well to rescue someone who's trapped. The special men's sections of Willow are called *Iron on Iron*. All right, all right, the forge of Iron on Iron is in reality a group of portly men who get together to talk over breakfast, but it shows how difficult it is to get men to congregate.

What Hybels understood is that while men may putter in private, they seem to crave the public company of other men. They like it when it's organized for them. So the church has seminars like "How a Man Grows in Christ" and "Building Purity"—always without women. Usually the groups meet in clusters of six to eight men, but there are occasional meetings with upwards of a thousand. This move from squad to battalion is the key to male affiliation. As the brochure says, Willow is "committed to turning irreligious men into fully devoted followers of Christ" because, as any political leader can tell you, the conversion experience is far more potent for males than for females.

If you want to appreciate Hybel's talent with men, just observe this note sent to the Listserv of those lightly affiliated with the church.

From "Bill Hybels" <weekends@willowcreek.org>
To <enews@arrow.willowcreek.org>
Subject Boiling Point -
Date Wed, 2 Oct 2002 143040-0500

Dear Enews Friends,

Sorry for breaking into your day but I just had an idea that I thought you might be able to help me with. This weekend I will be continuing with my series "Life at the Boiling Point." I will describe how serving people in the name of Christ adds heat to our spiritual lives, and gets us closer to the "boiling point." I would like to end the message with some true life stories from people who have experienced significant spiritual growth as a result of putting on a serving towel and volunteering in the name of Christ.

Would you be willing to write a brief paragraph describing the spiritual benefits that have come your way since you decided to put on a serving uniform and get into the game? Your story has the potential to inspire many thousands of people. I will protect your anonymity, as well as be sure to give God all the glory in the deal. How about it?

Thanks!

Bill

P.S. Our enews communiqués have had to be one-way up to this point (so that I can do my day job!). But this time I would really appreciate hearing from you, so please just click on reply and let it rip!

There is such a sense of muscular and manly Christianity to this query. The male recipient is being asked to help a fellow in distress, the subtle shift from "putting on the serving towel" to the more manly "serving uniform," the allusion to "getting into the game" and the invoking *teamwork*, as well as the final "let it rip"—it all speaks, to me at least, of guys helping guys. It's hard to resist.

When you look at Willow Creek men's groups (http://www. willowcreek.org/mens.asp), you find that along with divorce, affairs, self-help, couples counseling, singles groups, ministerial and evangelical clubs, there are places on the church grounds (or *campus*, as it is called in man-friendly lingo) for men to be with just men. Here are some: Accounting Groups do the books; Campus Operations, which includes setup, parking, cleaning, and tending the grounds; a section called CARS, which deals with the maintenance, detailing, and repairing of cars for the needy; Faithful and True for Men, which offers "support and encouragement to

men seeking to maintain sexual purity and integrity in a sexually charged world"; Pastor of the Day, offering "a listening ear and spiritual direction to those who call or come to church with spiritual questions or concerns"; the more predictable Sports Ministry (basketball, volleyball, football, golf, and 5K runs); Men's Ministry (talk about life); Front Door Team (tours and greeting); and the predictable Production and Programming (sound system, staging, camera, lights). There is also a High Road Riders group that meets to ride motorcycles.

The key, of course, is that as the men came into the church to bond with other men, to hide out, to recover, to be ministered to, to seek the Way, no word is ever uttered to the effect that women were being excluded. Ironically, the church is the last institution that can serve as a bastion of men-only conviviality. Where else can men meet together just to talk, work on cars, go on field trips, discuss business, play games, tell jokes, and generate camaraderie, with the total support of their women? No one from NOW is lurking outside the door of men's church groups wondering why it's just men inside. No one in the megachurch universe is filing a gender-based grievance or arguing for affirmative action.

The sensitivity of the megachurch to male concerns is at the heart of its explosive growth. Most churches can deliver the redemptive feeling, forgiveness, and salvation. Most penitents are already prepared to make the pledge. Play music and they'll come forward. But few churches can provide lasting community for men, a place to go to be one of the guys. A poster hangs outside Bill Hybel's office. It reads: "What is our business? Who is our customer? What does the customer consider value?" These questions are lifted not from Saint Paul but from Paul Drucker, the patron saint of management, and they affirm the reversal of the usual gatekeeper/epiphany-dispenser mentality in favor of a consumer-sensitive response. The genius of the megachurch is that while most other denominations are working on integrating the sexes and losing market share, these new churches are foregrounding some segregating of the sexes and finding explosive growth.

Promise Keepers, Wachovia Center, Philadelphia

Now it is precisely this insight into the desire of men to separate from women and bond together that lies behind one of the more interesting extensions of the megachurch—the aggressively men-only *intentional* church group called Promise Keepers. Although it claims to be nondenominational, PK is drawn primarily from the evangelical low-Protestant movement. This audience is indeed huge, for a while in the millions. And it is transitory; it evaporated almost as quickly as it appeared.

Started in 1990 by Bill McCartney, a burly University of Colorado football coach, Promise Keepers surged along with the megachurches throughout the 1990s. The group made no secret about who was excluded—women—but the exclusion was in the name of revitalizing the family—the promise that the committed male would replace the casual husband. What woman could argue with that? In one of the most repeated quips, a PK wife proudly said, "I sent a frog up there and they sent me back a prince." From a first meeting that drew ninety-one men, in a few years PK was routinely filling up football stadiums with more than seventy thousand. By the late 1990s the promises became a bit clearer. And scarier. More than a million men were eager to "promise" not just to return home but to "take back" any number of institutions that had been hijacked by "liberals," aka feminists. These men were coming home all right, not as helpmates but as God's Apocalyptic horsemen.

In the late 1990s the movement lost steam, partly because its self-dealing agenda was simply so transparent: anti-gay, anti-abortion, anti-feminist. What also crippled the organization was that in a desire to draw a more diverse (read: African American) crowd to show that it was not also anti-black, the high attendance fees (almost seventy dollars for a two-day session) were waived. Unmotivated spectators poured in. They came for a look and then passed right by. In other words, Promise Keepers had the temporary fate that some megachurches are now having: the distance between the front door and the back door is too short. You come, you look around, but what happens next? Many of the men who joined the march in

Washington, D.C., in 1997 (shades of the 1995 Million Man March or Louis Farrakhan's Nation of Islam) just kept marching away, back to the television, the office, the Barcalounger, the garage, the barbershop, the deer camp. . . .

But after the turn of the twenty-first century, with the resurgence of exactly the politics that caused them to lose market share—namely, the reelection of George W. Bush in 2004 and his idea of family values—Promise Keepers is showing modest signs of rebounding. This is happening in the so-called red states of the mid-continent. The organization had scaled down from a high of about five hundred full-time employees to about one hundred, but is slowly hiring more. In 2005 the group bumped up the number of tour stops to twenty, including the University of Arkansas football stadium, its largest venue since 1999.

Putting so-called family values aside, holding in abeyance the often repugnant subterfuges of PK (like the selective reading of Scripture), and bracketing the passive aggression of a group that is forever claiming that it must "take back" this or that role that has been co-opted by women, how important is it that this group has provided a secure lair for men in a world increasingly devoid of men-only space?

I think it's crucial. Promise Keepers is all about male bonding. Following the model of 12-step programs, these men are expected to find a male *faith partner*, with whom they share their temptations and weaknesses. Supposedly, each Promise Keeper shares his deepest fears and secret sins on a daily basis with this compatriot. Obviously, the purpose is to make each man accountable to another for keeping his promises. Less obvious is that this mandates separation from spouse and bonding with the *faith-partner* buddy. And since it takes a year for most men to develop that trust, the time frame is open-ended. Then these male partners are to form small male-bonding groups in order to spread the movement through local churches. PK thus provides a nifty synergy with the megachurches, encouraging and reinforcing greater male participation in congregational life while at the same time giving the men carte blanche to private space.

The group even has a seven-point mission statement called *The Promises*. Along with promises to love Christ, be pure, support marriage, help the local church, practice racial tolerance, and make the world Christian is this, Promise Number Two:

> 2. A Promise Keeper is committed to pursuing vital relationships with a few other men, understanding that he needs brothers to help him keep his promises.

The invocation of brotherhood, the idea of sacred promises to be kept, and the sense of separation from the Other (aka the female) are crucial. These men are on a mission and woe to whoever comes between them.

When you attend the stadium meetings you can see this sense of Us-versus-Them being inculcated. Like football cheering in which the fans in one section of seats compete with those in the other sections to see which can yell loudest, so the individual brotherhood groups compete by cheering "We love Jesus, what about you?" or " We are the brotherhood, we are connected." or just "Jesus, Jesus, Jesus." From time to time the men are asked to hug a neighbor and promise to "watch his back." The sections do the Wave, just like drunken undergrads do, although the Promise Keepers are doing it for the glory of God and the salvation of the family. And there is a lot of high-fiving, as in all male conviviality rituals.

As does the megachurch, the Jumbotron screens and superamplified music of Promise Keepers gatherings allow men not just to lose their inhibitions about raising their hands and gyrating their bodies, but also to dance—if not *with* each other, then at least *near* each other. After all, the exuberance of bonding is a reflection of the glory of God. So here are men who might wince at the sweat lodge and drum rituals of Robert Bly doing exactly the same kind of chanting and prancing that might be considered a little girly.

There are no girly men in the eyes of God, however. They are all Arnold Schwarzeneggers. The Jesus of PK is not the Warner Sallman Jesus of presentation Bibles. That image of Christ, you may remember, was hung in almost every American school until the Supreme Court ordered it removed. The neurasthenic Christ was

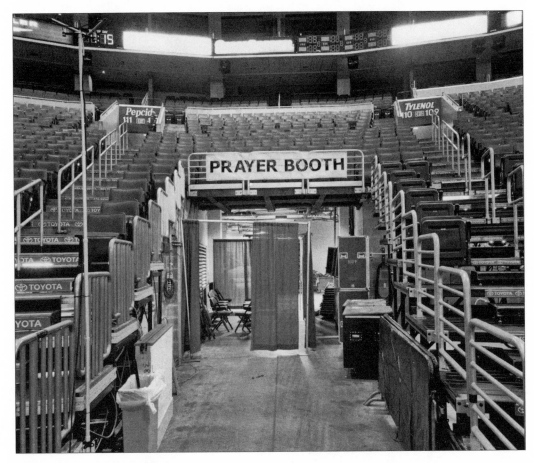

Prayer booth, Wachovia Center, Philadelphia

passive in the onslaught of adversity. But the Christ of the Promise Keepers is more like the Terminator. Certainly, he's the star-quarterback Jesus. He's take-charge, take-it-back Christ. The stadium meetings have such hifalutin titles as the "Stand in the Gap" rally or "Uprising: The Revolution of a Man's Soul." There are no women around to cock an eyebrow and opine, "Where did this Christ come from?" or "How come you guys are dancing with each other?" The purgative of mass confession (we have made a mess of things) combined with the elixir of not just forgiveness but divine selection (we are the chosen ones) can turn even the most repressed and uptight male into a dervish.

So who are these meek men made dynamic dervishes? According to a survey conducted by the National Center for Fathering and cited in *U.S. News and World Report*, the median age of Promise Keepers attendees is thirty-eight. Though 88 percent are married, 21 percent have been divorced. Fifty percent report that their own fathers were "largely absent" when they grew up (65.7 percent said this absence was because of work). Fifty-three percent said they knew how their fathers felt toward them, and only 25 percent were satisfied with themselves as fathers. Thirty-four percent attended Baptist churches. Eighty-four percent were white (Shapiro, p. 68).

These are the same guys who used to be the core of the Masons: middle-aged, middle-class men yearning for connection not just with each other but with the Imperial Potentate; with, I hesitate to say, disapproving dad. Of course the language is not the secret voodoo of a fraternal order or the psychobabble of therapy, but, as one might guess, the jabberwocky of sports. Not for nothing was this movement started by a man still called The Coach, and it's not happenstance that the meetings take place in football stadiums and are held together with the kind of cheers and rituals well known to the weekend spectators.

These men of PK are NFL tough. They can envision life as a football game. They've even seen this game hundreds of times. They know the broadcast patter: how much punishment he can take; great second effort; he bulls his way for extra yardage; you can't stop him—you can only hope to contain him; it's decision time—they're

knocking on the door; the defense is tough in the red zone; this game is being won in the trenches; he's slow getting up; they have to stop the big play; they're marching down the field; it all depends on where they spot the ball; they've got to punch it in here, and the litany of win one for the Gipper. In this world, women are cheerleaders. They are on the sidelines. They shout: Go Team!

Admittedly, the sports trope is hardly new. At the turn of the century, evangelist Billy Sunday, a former baseball star, rallied "back-slid" Christians with robust sports metaphors. Billy Graham, who feels equally at home in a stadium and on a golf course, has assured audiences that "Jesus was the greatest athlete who ever lived." His son and evangelical heir, Franklin Graham, does the same thing, even decking himself out in the sports jersey of whatever town he's converting. But the intense PK focus on football lingo is startling. This is the stuff of muscular Christianity, literally. Put me in, Coach.

Joining the Fellowship of Christian Athletes, as it were, not only makes you a player but also allows you to spend bench time with your pals. You've shown yourself to be a man's man; now you can just kick back and relax. You've confessed, you've cried, you're vulnerable; now you can be alone for a while. You made the team. No one can touch the Godly Man. Do not disturb.

Because in my day job I am an English teacher, I am always curious about what people read. And, assuming you can judge a book a bit by the title, the PK bookshelf is substantial and revelatory. Here's a bit of the Real Men in Spiritual Recovery genre as it often invokes the sporting world: *With God on the Golf Course*; *Reel Time with God*; *With God on a Deer Hunt*; *Faith in the Fast Lane*; *15 Minutes Alone with God for Men*; *A Look at Life from a Deer Stand*; *What a Hunter Brings Home*; *Where the Grass Is Always Greener*; *Every Man's Battle: Meditation for Men*; *A Man After God's Own Heart*; *The Ultimate Fishing Challenge*; *The Ultimate Hunt*; *As Iron Sharpens Iron: Building Character in a Mentoring Relationship*; *Wild at Heart: Discovering the Secret of a Man's Soul*; *With God on the Open Road*; *Fight on Your Knees: Calling Men to Action Through Transforming Prayer*; *A Man's Role in the Home*; *4th and Goal: Coaching for Life's Tough Calls*; *The Power of a Praying Husband* (Audiobook, Prayer Pak, and Study Guide); *Real*

Men Don't Abandon Their Responsibilities; What Makes a Man?; Tender Warrior; Locking Arms; A Call to Manhood; The Masculine Journey; What God Does When Men Pray; and for those who are too busy to read but still care: *Minute Meditations for Men* and *Men of Character: Quotes from Godly Men.* There's even a slick bimonthly magazine, *New Man,* which features advice on safe sex ("it's called *marriage*") and columns on fitness and finances.

All the liberal criticisms of Promise Keepers are true enough. The *Village Voice* attacked "the sanitized multiculturalism" and called its "policy of racial diversity so overt that it reeks of insincerity." *Gentlemen's Quarterly,* hardly known for having an opinion on anything more complex than a Windsor knot, did a major piece on Coach McCartney called "Triumph of His Will," a reference to a famous Nazi movie of almost the same name. *GQ* calls the coach "a lop-eyed loon" and "a raving lunatic." *New York Times* columnist Frank Rich, who can be counted on to lower the boom on this kind of rabble-rousing, sneers at the group and their "Robert Bly-esque hunger to overcome macho inhibitions" (all quoted in Leo, p. 18). And this is tame compared to what Patricia Ireland, past president of the National Organization for Women, was saying in the 1990s.

While it is easy to take potshots at such men and their smiley-face approach to the complexities of their discontent, it may be that what we see in the megachurch and Promise Keepers is something embedded deep in the institutionalization of religion: not just the creation of gendered space but the protection of such space. I think of the series of Great Awakenings in this country—surges between 1740 and 1743, 1800 and 1840, 1857 and 1858—and wonder if the end of the twentieth century was simply yet another chapter in men's struggle to find meaning with other men. Note that these movements are intense and short-lived, almost as if male culture is trying to get some concern off its chest so it can then go back to business. And note how this kind of chest-beating disappears during wartime, when the real thing subsumes this postured aggression.

But maybe there is something still more historical and resonant about these melancholy men. Christian religion, and perhaps all religion, asserts the sanctity of the family, the importance of sexual

repression, and the deflection of desire, and is seemingly run by clerical men for women with children. Yet, ironically, it also provides an avenue of escape for church leaders. The institution that communicates family values to wayward men also provides for those men who apparently accept the control: a place to congregate, to rest up, to hide. Women go to convents to do good work. Men go to monasteries to get away from women.

Could there be a connection here with the monastic orders of the Holy Roman Church (the Benedictines, Franciscans, Jesuits, and the other celibate groups) in which supposed sexual abstinence also meant induction into male tribalization? In other words, if you want the camaraderie of just-us-men, you can have it. Just park your libido at the door. Nobody ever claims that monks are unfairly excluding women in their fraternal orders, probably because we imagine that the monks must be in such self-abnegating pain. If we saw them partying and cavorting (as in truth they often were) we might well demand they come out of hiding.

In a sense, one sees this in parodic form in the monasteries of Mount Athos, the Holy Mountain, situated on the easternmost finger of land that sticks out from Greece into the northern Aegean Sea. Here in some forty Greek Orthodox monasteries (many of them now decrepit) is a culture still inhabited solely by men. For well over a thousand years, "no smooth faced person" has been allowed to violate its sanctity. Supposedly. Although there are now only about 1,700 brethren, what is interesting is that this has become one of the most popular tourist attractions in Greece. Cruise ships dock nearby. Thousands of male pilgrims come each year not just to pray or observe the rare icons but to live simply surrounded by just men. Only 134 male visitors are allowed each day, they pay a rather hefty fee, and they can stay only three days. The waiting list is long. Could it be that one of the secular strengths of religion is that, like Mount Athos, it provides a protected island of single-sex separation in a sea of what looks to be sexual togetherness?

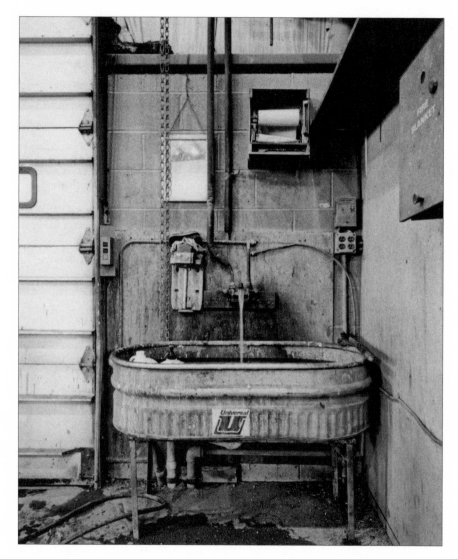

Work sink, New Jersey

Conclusion

When I first conceived of this project I often thought of it as an architectural folly. A *folly* is a fanciful structure like a pagoda or grotto on an estate, more a tribute to the squire's silliness than to any compelling need. So when you see the word emblazoned on a sailboat—like *Fred's Folly*—you know that Fred is at least aware that he doesn't really need the boat. It's just for fun. In fact, the etymology is French; a *folie* is something that delights, nothing more. Many country houses in France still bear the name La Folie. As I mentioned in the introduction, this is not what I am supposed to be doing—it's a folly. Or at least it started that way.

But as I got deeper into Ken's photos and the scenes they unfolded, I realized that as silly and even dreary as men's space seems to be, it carries with it some of men's deepest concerns and anxieties about gender. What does it mean to be male or female, gay or straight, mature or pubescent? Where do we go to find ourselves, be ourselves? Who's there when we arrive? Who's not? How long

do we stay there? What happens to us in that space? What happens if we stay too long?

Advertising copywriters have a saying that before you can sell an object you have to figure out its sex. This may sound strange to English speakers, but Romance languages give gender to objects with the definite article. Many objects in English have a gender (not all objects, by any means) attributed by the grammar of use.

This insight was provided for the automobile business in the late 1950s by the often loony Dr. Ernest Dichter in his infamous observation "A sedan is a wife, but a convertible is a mistress." Foolish, yes, but if you look at car ads you will almost always see a curvy sports car next to a curvy woman. The implied promise is Buy the car, get the girl. Or, Forget the girl, drive the car. This also explains, to a degree, why SUVs are designed and portrayed as reptilian Rambos. They are pure macho, barely disguised aggression. With such cars the sexual message is "Don't mess with me, I'm outta here—after first running over you." Cars are not alone in having sex appeal. It's why Mr. Clean is out in the kitchen lending a hand while Mrs. Butterworth is in the dining room pouring pancake syrup from the grandma-shaped bottle.

In writing this book I came to appreciate that space often follows the same logic as objects: it's often gendered. And whether we like it or not, understanding the sex of space might help us understand the often paradoxical and even testy uses of territory as a way of marking off privacy boundaries, edges of the self. Like other animals, we are territorial and we squabble when invaded. Appreciating this may help us understand how profound and dramatic has been the redistribution of space in my lifetime. All told, it has been an amazingly peaceful battle in the war of the sexes.

In my lifetime we have experienced the most far-reaching redistribution of sexual territory of any time in modern history. Only the French Revolution comes close. And that this redistricting happened with relatively little squealing and no Reign of Terror is a tribute to the good faith (and possibly self-interest) of all parties.

The observation that men want, and perhaps even need, private space is not new or startling. American men, for instance, have

always headed for the hills, gone off to the frontier, down to the cellar, or out to the golf course when the pressure was on. In the generating text of American literature, Mark Twain's *Huckleberry Finn*, Huck even violates an interracial taboo and runs off with Jim rather than submitting to the territorial ways of women. Or think of the men-without-women themes of Hemingway, complete with euphoric interludes in which males bond while hunting or fishing. But then in the mid-twentieth century a sea change seemed to occur.

To be sure, this shift came about as a direct result of the women's movement. But I think it was also a result of the sensitivity of American *commercial* culture. Men were tired of predictable manliness. Many secretly wearied of being only where the boys are. The concept of manhood profoundly expanded as the woman's movement took hold. Today, an astonishing array of masculine identities compete for men's attention and their disposable income. A middle-class man of whatever color or religion can choose between rough-tough machismo or aching sensitivity. Any man—whatever his ethnic or racial background—who can afford it can mix and match masculine identities according to whim and situation. At work, he can dress the Yuppie; at the gym, the bodybuilder; at home, jeans and work shirt. On weekends, he can outfit himself as an urban rugged individualist, tooling about town in Jeep and safari jacket.

Or he can dress in velvet and polish his bling. Recall that a century ago a gay male was often pilloried. Now being gay is just another lifestyle choice, and many straight men adopt queer fashion as a mode of expression. Witness the metrosexual.

Generation X and Y men are still more varied. All I have to do is look out over my class to see tinted hair, earrings, and even eyeliner. As I write this, Proctor and Gamble has just purchased Gillette, the Ur-men's company. One of the proffered reasons is that the next big market will be skin care for men. It's only a matter of time before ads appear featuring some big Palooka touting a skin cream saying, "Sure, I know it costs more, but I'm worth it!" I have overheard my male students talking about diets. Next thing you know, they'll be going to the bathroom in pairs and describing shopping trips to Lowe's as therapeutic.

It's such an irony that the goal of the Victorian male—to become the "self-made" man, the man who "pulled himself up by his boot-straps"—should become the goal of the modern male, who can create himself anew each weekend by changing his shirt and shoes. Consumption has become an aspect of production. You can buy a new persona. Two generations ago the male was stuck. And that was one of the attractions of the hiding place, lodge, temple, loyal order, and tribe. There you changed out of your street clothes. You put on funny hats and special uniforms. To paraphrase Napoleon, men will do amazing things in order to wear ribbons. You could let loose and prance around, albeit in hiding. But not for long. And only in hiding. Maybe what we are seeing is the male voluntarily coming out of hiding and going shopping.

Anthropologists tell us that the last thing fish would ask if their aquarium was drained would be, "Where's the water?" Space is like that. We just assume that it has always been the way it now is. Compare the ads of the 1950s with those of today and you'll see how space has changed along with sexual self-image. The end of the twentieth century has been positively transformative in the politics of redistribution. The quickly shifting construction of gender is no academic claptrap; it's transforming our world.

I don't mean to belittle the anxieties of those males who are caught in the process. I'm not forgetting the wounded Promise Keepers, the displaced workers of the *Full Monty*, the nervous men of David Mamet plays, the silverback gorillas of the Archie Bunker clan, but I am saying that if you go back two generations you'll see how stagnant and dingy the aquarium water was. All you have to do is look now at universities, courthouses, executive offices, armed forces, and, as we have seen, almost every male-only stomping ground, to see what's churning.

We are now, it seems to me, in something of a refractory period. There doesn't seem to be much space left to aerate, let alone to colonize. I don't mean to sound like Gus in Harold Pinter's *The Dumb Waiter*, who cries at the end, "We've got nothing left! Nothing! Do you understand?" but only to state the obvious. As I mentioned at the outset, a better title might have been "Where Men Hid," for

the Masonic temples, deer camps, basement shops, and saloon bars have either shriveled up or are being reconfigured. Men still hide, to be sure, but culture is not so determined by those places. And the next generation seems positively blasé.

If the Iron Johns are mildly anxious about losing some of their space, some women are also anxious about their putative gains. Back in the late 1980s, Canadian author Margaret Atwood wrote *The Handmaid's Tale*, a novel depicting a fundamentalist takeover in parts of the United States. One of the first ominous signs of women's loss of space comes when barbed wire and barricades surround the new Republic of Gilead. Women there are forced back into narrow roles as wives and baby makers under the total control of their husbands and other male leaders. As NOW's Patricia Ireland wrote in an op-ed piece, a reporter found that there was a marked difference in how various English-language readers reacted to Atwood's fictional scenario. Women in England said, "Jolly good tale." Women in Canada said, "A frightening prospect." Women in the United States said, "How long do we have?"

The answer is, Plenty of time. And that's because the impact of feminism and consumer culture has been far more profound than just settling gender boundaries. The revolution in *what's mine* and *what's yours* opened racial and religious space as well. Look around. Almost every job in every field is now open to everyone, at least in theory. Women can become heads of gigantic high-tech companies like Hewlett-Packard. And they can get fired, just like men. Blacks run immense financial companies like Merrill Lynch and American Express and vast communications combines like Time Warner. A black woman runs the most white-shoe of advertising agencies, Young and Rubicam. Or at least she did when I first wrote that. Blacks and women can be found at every prestigious university, not just on the faculty but high up in the administration. Jews are the heads of industrial corporations where they would not have been considered for interviews in the 1950s. Asians lead the technology world to an astonishing extent, and Hispanics are a potent force in media, law, and other fields. Intensely hierarchical and time-bound cultures like the Muslim world are understandably rattled by what this culture threatens.

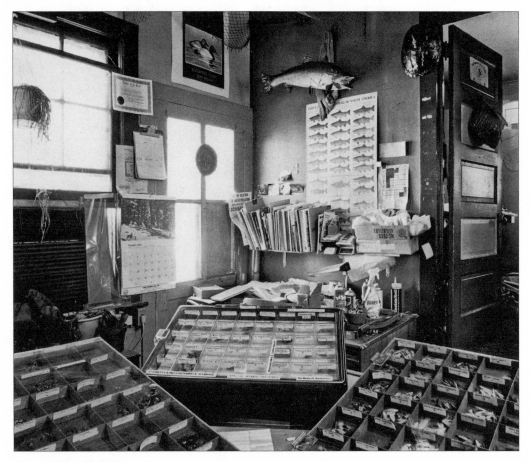

Shannon's Fly and Tackle, New Jersey

Don't get me wrong. This ever-fermenting culture has profound problems. It is wasteful, careless, ahistorical, amoral, hedonistic, and all the rest. And who knows how it will all work out? I certainly don't. But it seems more equitable than most other cultures.

An occupational hazard of academics is that they always think they are standing at some important crossroad. A few years ago, political scientist Francis Fukuyama contended in his controversial "The End of History?" that "the ineluctable spread of consumerist Western culture presages not just the end of the Cold War, or the passing of a particular period of postwar history, but the end of history as such: that is, the end point of mankind's ideological evolution" (pp. 3–4). Okay, such predictions are not new. "The End of History" (as we know it) and the "end point of mankind's ideological evolution" have been predicted before, by philosophers like Hegel, who claimed it had already happened in 1806 when Napoleon embodied the ideals of the French Revolution, and by Marx, who said the end was coming soon with world communism. What legitimates this modern claim is that there are fewer and fewer abrupt changes in and between cultures. And the unique cultures that still exist are big news, literally. For better or for worse, American commercial culture, with all its attendant confusions, is well on its way to becoming world culture.

Does this possibly presage the beginning of the end of gender, at least as we have known it? When the narratives of masculinity become so transnational and inclusive, could the culturally imposed concept of gender itself eventually disappear? And so too some of the hiding places? Under all the talk of *outdated masculine scripts, e-race-ing masculinity, restaging masculinity, dismembering masculinity*, and the like, there is this ineluctable truth: our sense of "manhood" and the places in which it was created and transmitted has profoundly changed. Mars has shrunk.

Whatever it becomes, the mass-mediated world of the increasingly powerful Consumerist Revolution is drawing us ever closer together. Privileged spaces are being squeezed as Venus and Mars seem to be spinning into a shared orbit. Gendered space is disappearing as male (and female) behavior is itself becoming blurred.

The man cave is becoming slightly anachronistic. Is some form of male liberation next? Doubtless, men will continue to separate in order to bond, but perhaps the need for this bonding is already becoming less intense. The study of this reconfiguration of the *manly pursuit* is no idle folly, however. How space and gender evolve is worthy of study lest Oscar Wilde's dreary prediction prove true: "The brotherhood of man is not a mere poet's dream: it is a most depressing and humiliating reality."

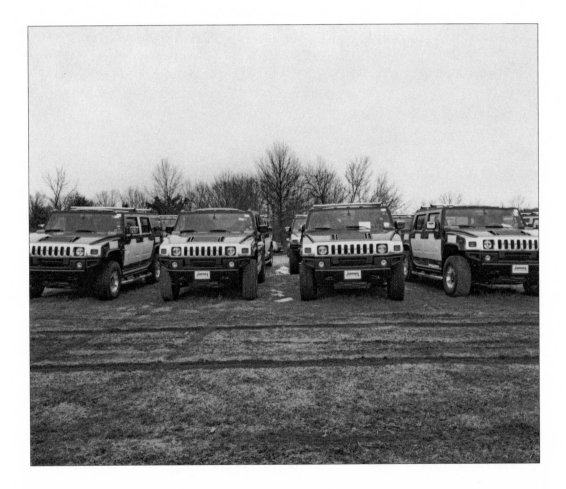

Bibliography

Axelrod, Robert. *The Evolution of Cooperation*. New York: Basic Books, 1984.

Barlow, Ronald. *The Vanishing American Barbershop*. St. Paul, Minn.: William Marvy, 1996.

Beard, James. *Beard on Food*. New York: Knopf, 1974.

Bly, Robert. *Iron John: A Book About Men*. New York: Vintage, 1992.

Caulkins, Earnest Elmo. *"And Hearing Not."* New York: Scribner's, 1946.

Coppinger, Raymond, and Lorna Coppinger. *Dogs: A Startling New Understanding of Canine Origin, Behavior, and Evolution*. New York: Scribner's, 2001.

Csikszentmihalyi, Mihaly. *Finding Flow: The Psychology of Engagement with Everyday Life*. New York: Basic Books, 1997.

de Wolfe, Elise. *The House in Good Taste*. 1913; reprint, New York: Arno Press, 1975.

Douglas, Ann. *The Feminization of American Culture*. New York: Knopf, 1977.

Elias, Norbert. *The History of Manners*. Trans. Edmund Jephcott. New York: Pantheon, 1982.

Faludi, Susan. *Stiffed: The Betrayal of the American Man*. New York: Morrow, 1999.

Farrell, Warren. *The Myth of Male Power: Why Men Are the Disposable Sex*. New York: Simon and Schuster, 1993.

Faulkner, William. *Big Woods*. New York: Random House, 1955.

——. *Go Down, Moses*. New York: Random House, 1942.

Fitzgerald, Matthew. *Sex-Ploytation: How Women Use Their Bodies to Extort Money from Men*. Willowbrook, Ill.: April House Publishing, 1999.

Fowles, Jeb. *Mass Advertising as Social Forecast: A Method for Future Research*. Westport, Conn.: Greenwood, 1976.

Fox, Robin. "The Inherent Rules of Violence." In Peter Collett, ed., *Social Rules and Social Behaviour*, 133–149. Oxford: Basil Blackwell, 1977.

Fukuyama, Francis. "The End of History?" *National Interest* 16 (Summer 1989): 3–18.

Gelber, Steven. "Constructing, Repairing, and Maintaining Domestic Masculinity." *American Quarterly* 49 (1997): 66–112.

Gilbert, Sandra M., and Susan Gubar. *Madwoman in the Attic: The Woman Writer and the Nineteenth-Century Literary Imagination*. New Haven, Conn.: Yale University Press, 1979.

Goldberg, Herb. *The Hazards of Being Male: Surviving the Myth of Masculine Privilege*. Issaquah, Wash.: Wellness Institute, 2000.

Goodrich, Robert. "Go West, Creatives ..." *Back Stage*, August 11, 1989.

Gorn, Elliott. *The Manly Art: Bare-Knuckle Prize Fighting in America*. Ithaca, N.Y.: Cornell University Press, 1986.

Hall, Donald. *Fathers Playing Catch with Sons: Essays on Sport (Mostly Baseball)*. San Francisco: North Point Press, 1984.

Harwood, W. S. "Secret Societies in America." *North American Review* 164 (April 1897): 617–25.

Hawthorne, Christopher. "House at the End of the Line." *New York Times*, December 18, 2003.

Ireland, Patricia. "Promise Keepers: Beware of Feel-Good Male Supremacy." *Washington Post*, September 7, 1997.

Jones, Preston. *The Last Meeting of the Knights of the White Magnolia*. New York: Dramatists Play Service, 1976.

Keillor, Garrison. *The Book of Guys*. New York: Viking, 1993.

Knight, Esmund. "Lassie Come Home." *Saturday Evening Post*, December 17, 1938, 10–11.

Koppett, Leonard. *The Man in the Dugout: Baseball's Top Managers and How They Got That Way*. New York: Crown, 1993.

Kuntz, Tom. "Bubba Can't Bypass the Past." *New York Times*, September 12, 2004.

Leo, John. "Fairness? Promises, Promises." *U.S. News and World Report*, July 28, 1997, 18.

Loth, Renee. "Office Politics: At Work." *Boston Globe Magazine*, September 10, 1995, 10.

Marsh, Margaret. *Suburban Lives*. New Brunswick, N.J.: Rutgers University Press, 1990.

Meredith, Robyn. "Strip Clubs Under Siege as Salesman's Haven," *New York Times,* September 20, 1997.

Mill, John Stuart. *The Subjection of Women*. 1869; reprint, New York: H. Holt and Co., 1885.

Montali, Larry. "Where We Go: Portraits of the Places Men Without Women Inhabit." *Esquire*, March 1999, 52.

Nathanson, Paul, and Katherine K. Young. *Spreading Misandry: The Teaching of Contempt for Men in Popular Culture*. Montreal: McGill-Queen's University Press, 2001.

O'Brien, Richard, and Hank Hersch. "Scorecard." *Sports Illustrated*, June 9, 1997, 19.

Oldenburg, Ray. *Celebrating the Third Place: Inspiring Stories About the "Great Good Places" at the Heart of Our Communities*. New York: Marlowe, 2001.

Pereira, Joseph, and Ethan Smith. "A Christmas Derailed?" *Wall Street Journal*, November 17, 2004.

PR Newswire, Survey: "Dogs and TV Go Together" (Dayton, Ohio), January 14, 2004.

Purgavie, Dermot. "One Man and His Dog." *Mail on Sunday* (London), June 26, 1994, 6–11.

Putnam, Robert. *Bowling Alone: The Collapse and Revival of American Community*. New York: Simon and Schuster, 2000.

Rose, Robert. "Wrenching Decision: Snap-on Tools Drops Its Girlie Calendars—Some Auto-Body Guys Are Broken Up; Mr. Brenski Goes in Search of a Spare." *Wall Street Journal*, December 21, 1994.

Sammons, Mary Beth. "Full-Service Church: For Willow Creek Faithful, Secular Success Is God's Work." *Chicago Tribune*, April 3, 1994, Tempo.

Savitskie, Jeffrey. "Elks, Lions, and Moose: Social Herds Are Thinning." *USA Today*, March 4, 1996.

Serrin, William. "Four Star Truck Stop." *New York Times*, March 2, 1983.

Shapiro, Joseph. "Heavenly Promises." *U.S. News and World Report*, October 2, 1995, 68–70.

Sommers, Christina Hoff. *The War Against Boys: How Misguided Feminism Is Harming Our Young Men*. New York: Simon and Schuster, 2000.

Spain, Daphne. *Gendered Spaces*. Chapel Hill: University of North Carolina Press, 1992.

Staples, Brent. "Lessons in Brutal Honesty at the Barbershop." *New York Times*, October 13, 2002.

Stark, Rodney. *The Rise of Christianity: A Sociologist Reconsiders History*. Princeton, N.J.: Princeton University Press, 1996.

Staten, Vince. *Do Bald Men Get Half-Price Haircuts? In Search of America's Great Barbershops*. New York: Simon and Schuster, 2001.

Taylor, Frederick. *Principles of Scientific Management*. New York: Harper and Brothers, 1934.

Thurber, James. *The Thurber Carnival*. 1945; reprint, New York: Modern Library, 1957.

Tiger, Lionel. *The Decline of Males: The First Look at an Unexpected New World for Men and Women*. New York: St. Martin's Griffin, 2000.

——. *Men in Groups*. New York: Random House, 1969.

Trusty, Sherman. *The Art and Science of Barbering*. 1969; reprint, Los Angeles: Wolfer Printing Company, 1971.

Veblen, Thorstein *The Theory of the Leisure Class*. 1899; reprint, Boston: Houghton Mifflin, 1973.

Vecsey, George. "Baseball Talk: Dugout Style." *New York Times*, October 10, 1982.

Wegner, Robert. *Legendary Deer Camps*. Iola, Wisc.: Krause Publications, 2001.

Woodward, Kenneth L. "Gender and Religion." *Commonweal*, November 22, 1996, 9–24.

Where Men Hide

Columbia University Press

Publishers Since 1893
New York Chichester, West Sussex

Copyright © 2006 Columbia University Press
All rights reserved

Library of Congress Cataloging-in-Publication Data

Twitchell, James B., 1943–
 Where men hide / James B. Twitchell ; photographs by Ken Ross.
 p. cm.
 Includes bibliographical references.
 ISBN 0-231-13734-6 (cloth : alk. paper)
 1. Men—Psychology. 2. Men—Socialization. 3. Men—Attitudes. I. Title.

 HQ1090.T95 2006
 305.31—dc22

 2005051943

♾ Columbia University Press books are printed on permanent and
durable acid-free paper.

Printed in the United States of America
Designed by Linda Secondari with assistance from Vin Dang

c 10 9 8 7 6 5 4 3 2 1